GREAT PACKAGE DESIGN

Editor and Co-Art Director
DK Holland, Lewin/Holland, Inc.

Designer and Co-Art Director
Cheryl Lewin, Lewin/Holland, Inc.

Assistant Designer and Assistant Editor
Kristin Lilley

Copy Editor
Philip F. Clark

Cover and Chapter Divider Photographer
Richard Levy

AKNOWLEDGEMENTS

In an age where creating the competitive edge in the packaging can make or break a product, great design can be the fulcrum that moves the market. Hence, this book.

The world is chock full of bad package design. Manufacturers are too quick to rely on old hackneyed packaging principles and not enough on good design. Competition in all areas has gotten stiff and environmental needs require that packaging be more thoughtfully designed. And so it's time to rethink what goes on in the design process.

To give manufacturers the benefit of the doubt, we assume they have not been able to *find* good designers, who do tend to be rather invisible. Here they are! We also assume that manufacturers think that designers are expensive and temperamental and will give them a hard time. This is not *necessarily* true as the reader will see from the interviews with designers we've included in the book.

I must thank Paula Scher for the title *Great Package Design*, which gave us the challenge that led to brutal editing, even in the final days. "Is this great?" became a major criteria for inclusion in this book. As my partner Cheryl Lewin observed, "We kept raising our standards notch by notch as we had to make tougher and tougher choices." This was especially difficult because the 'greatness' of package design is somewhat subjective. I'm delighted to say that Cheryl and I had almost three times the number of acceptable designs needed to make a book.

In order to include the best and brightest examples of packaging we drew on one of our greatest international design resources, New York City. Kristin Lilley and Margaret Benkard were my two tireless assistants. Together we scoured New York for the newest bottles, tins, tags, and boxes of the highest quality design. Altogether we covered over 80 shops, supermarkets and department stores—from Grand Union to Macy's and from Balducci's Market to the Museum of Modern Art Gift Shop.

When we found a package we were interested in, most often we talked to the manager or owner of the store to find the manufacturer if the address wasn't right there on the label (80 percent of the time it was!). One goal was to make this book a resource for designers to find manufacturers and for manufacturers to find designers. Therefore, we included the index at the back of this book.

In addition, we sent out hundreds of letters to members of The American Institute of Graphic Arts (AIGA) who were known to have designed packaging. We were also given leads that helped us to find some hidden talent from around the world. Some of the packages we selected were not designed by professional graphic designers but rather by the creators of the products. This added a welcome dimension to the book.

Interspersed throughout *Great Package Design* are interviews—with designers, manufacturers, retailers. This is the universe we explored that creates and gets products to market.

Thanks go to designers Chuck Anderson of Charles S. Anderson Design Company, Byron Glaser and Sandra Higashi of Higashi Glaser Design, Mary Lewis of Lewis Moberly Design Consultants, Paula Scher of Pentagram, Kay Stout of Landor Associates, creative director Peter Allen of Apple Computers, Inc., entrepreneur Paul Hawken of Smith & Hawken, and store owners Bailey of Mythology, Joe Barreiro of Kate's Paperie, and Katherine Tiddens of Terre Verde Trading Company for all their help in developing a well-rounded perspective on the world of packaging. Also, thanks again to Joe Barreiro of Kate's Paperie for opening his treasure chest of handmade papers for use on the dividers of this book.

It is largely due to Kristin Lilley's unending good nature and intelligent management that this book has been published at all. She took on *Great Package Design* as an intern project while studying in the Communications and Package Design graduate department at Pratt Institute where I teach. Kristin's thesis is on international package design, so it was a symbiotic venture.

As we got further into the project we handed over the assist ant design responsibilities to Kristin, who never missed a beat under my partner Cheryl Lewin's artful direction. EJ Gallegos, our executive assistant, was a big help in gener on the book as was Wutina Prichavudhi, also a Pratt graduate student, in assisting Kristin.

Working alongside Cheryl, Richard Levy photographed the cover and dividers and showed incredible patience. H applied his talent generously to help make the photogra special in and of itself.

Philip Clark was, as always, tireless in his quest for perfe copy. I counted on Philip to put in his usual 1000 percen and was not disappointed.

Cheryl Lewin's ability to discriminate intelligently betwee great and not-so-great design was an invaluable asset throughout the project. This book ties together largely due to Cheryl's design sensibilities in layout, color, and composition. Cheryl helped make this book fun for me.

Finally, thanks to Tad Crawford, publisher of Allworth Press, and Stan Patey and the excellent staff at Rockport Publishers, for sticking with me on this project through all its trials and tribulations on the way to being a beautiful book.

DK Holland

Rockport Publishers, Inc.
146 Granite Street
Rockport, Massachusetts 01966
Telephone: (508) 546-9590
Fax: (508) 546-7141
Telex: 5106019284
ROCKORT PUB

Allworth Press
10 East 23rd Street
New York, New York 10010
Telephone: (212) 777-8395
Fax: (212) 777-8261

Distributed to the book trade and art trade in the United States and Canada by:
North Light, an imprint of Writer's Digest Books
1507 Dana Avenue
Cincinnati, Ohio 45207
Telephone: (513) 531-2222

Distributed to the book trade a art trade throughout the rest c the world by:
Rockport Publishers, Inc.
Rockport, Massachusetts
ISBN: 1-56496-128-1
Printed in Hong Kong

Kay Stout, Vice President
Landor Associates

KAY STOUT HEADED THE LANDOR CREATIVE TEAM THAT
REDESIGNED MCDONALD'S FAST FOOD PACKAGING TO BE
MORE ENGAGING AND ENVIRONMENTALLY FRIENDLY.

GLOBAL MARKETING

ケイ・スタウト──世界有数で、賞なども受けているパッケージ・デザイン会社、Landor Associatos において、グローバル・マーケティング担当の副社長。コカ・コーラ・フィフス・アベニュー、マクドナルドなどのプロジェクトなどを、中心になって手掛ける。

どのようにグレート・パッケージ・デザインを定義しますか？

デザイナーとして思うのは、よいパッケージングとは、シンプルかつ機能的であり、好感を持たれつつ、「買って欲しい」といえているものであると思う。そのうえグレート・パッケージングとなると、それだけでなく、ハートに語りかけなくてはならない。合理的でしかも訴えかけるビジュアル・ボイスともいえよう。つまり、おもしろがらせ、楽しませ、アピールをし、興味をそそり、びっくりさせ、何かを感じさせ、喜ばせ、誘い、そそるものであろう。

ブランドというものは、まずパッケージによってシンボライズされ、優先権を手にする。しかしそれは実際の商品がもつ性能や質を正しく伝えるものでなければならない。デザイナーとして、常に消費者の購入の誘発を考えているが、製品自身がその期待を裏切るようでは、仕事にはならない。

新しい考えや革新的なデザインは、主流以外の製品でしばしば成されている。大きなブランドの製品は主として保守的である。さらに大きなブランドはもっと保守的なのである。それはリスクが上がるにつれ、関わってくる問題であるからだ。

現在私がやっていきたいことは、その特別な製品と同様、市場性の高い主流の製品にも、革新的で訴えかけるデザインをしていくことだ。

毎年10,000以上の製品が市場に参入しているなかで、パッケージングが消費者の注意を引くのはわずか1/10秒である。情報伝達がここでの鍵となっている。だがそれが独創性を阻むものでない。結局私たちはビジュアルな面で戦っている。よいデザインとスマートなマーケティングは両立できる。ただ難しい課題であるというだけだ。新しいアイデアが、必ずしもブランドの意図を圧倒してしまうわけではないことを認識してもらうには、おびただしい教育が必要だからだ。

パッケージに関して行政側がきびしくなってきています。規制は大切だと思いますか？

はい。残念ながら、メーカー側に製品について正直に伝えさせるために、規制は設けられているし、それが仕事の障害になるときもある。が、公平に伝えていくためには、社会的にも、メーカー側とも、うまくやっていくことがデザイナーの責任だと思っている。

行政による規制は、情報伝達の複雑さを増加させるが、一方でまた、誤解を招くような謳い文句や、意味のない情報を排除していく。コレストロールをまったく含んでいない製品では、まず"コレストロール フリー"が謳われている。ただ今では、"100％天然"というのは、濫用され過ぎていて意味がない。

また最近では環境問題も消費者の関心事である。だが誤解を招いていたりもする。リサイクルを謳っていても、実際にはそのシステムがなかったりする。例えば、あるプラスチックはリサイクルできるはずだが、実際リサイクル可能な団体はほとんど無い。

製造者に協力して、環境を考え、好意的なパッケージングを作っていければ、もはやグレート・パッケージングの域を越えて、スマート・パッケージングとなるだろう。

ブランド・メイキングの将来はどうでしょうか？

今日のように、製品が似かよったり、同じだったりしていくと、ブランド・メイキングは変化しつづけるだろう。私が思うに、その結果として、少量生産化や、またより少量にして商品のユニーク化を計り、ライフスタイルや価値基準の多様化が進むだろう。ナイキはもはや、テニスシューズだけを売っているのでなく、生活様式を売っているのである。ブランドのペルソナと製品の特性に焦点を合わせている。彼らはオレンジジュースすら売りかねない。

私たちは多くのマーケット・リーダーと働き、市場に出る前に、数か月あるいは数年という単位で、トレンドに関わる好機会に恵まれている。これはデザイナーにとってまさに刺激的なことだと思う。というのも、特徴の書かれたチェックリストに対し、"モード"を作り上げていく、自由を与えられているのだ。

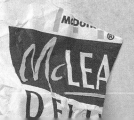

DESIGN FROM THE HEART

ウラ・スケア——Pentagram のニューヨーク・
フィスにて、グラフィック・デザイナー／パ
トナー。近年、Rain Forest Tropical Nuts and Fruits の
パッケージングのデザインで、the Package Design
uncil よりゴールド・メダルを受賞。

デザイナーの役割りについて詳しく述べてい
だけますか？

パッケージとは家に持ち帰れるもの。もし素敵な
、製品に付加価値を与える。さらに耐久性がある
なら、そのあとで再利用がなされるもの。商品生
者は、そのように消費者に喜んでもらうことを励
にすべきだと思う。今日アメリカでは、不幸に
うまくデザインされたパッケージは高級品のもの
とされてしまっている。これは大量消費社会にお
る、一般的な認識だろう。しかし、日本など多く
成功例が証明しているように、認識は変えられる
のだ。

どういうわけか、中南米向けの製品は"ぶかっこ
"とされている。中南米人はよくデザインされて
るものを好まないという仮説もあるが、そんな市
意識に迎合するデザイン会社には憤りを感じてい
。そんな皮肉は気をめいらせるが、戦っていかな
ればならない。

製品、消費者、一般的な市場、そしてその製品が
ていく環境の把握が、私の責任だ。それらに基づ
、市場研究を考えにいれたパッケージを作ると同
に、さらに自然環境への影響を考える責任もある。
い捨てのパッケージなら、再生紙や、微生物によ
て無害な物質に分解しうる、生物分解性のものな
を使えば、環境にやさしい。また、パッケージに
久性があるのなら、見た目がよければ、取って置
れたり、何かに利用されたりできる。

がパッケージング・プロジェクトを動かして
くのでしょうか？

特定の集団を選んでテストをするのはよくない。
ういう試みは消費者に、素直な反応を強いる。つ
り、その試みの結果がよくなくても驚かれないの
ある。しかし悪いことにそれによって、意見が固
られてしまう。会社における集団としての意見は、
化への懸念が基盤にある。そこでデザイン会社が、
化を作り出すことでなく、コンセンサスを作り出
ことに手を貸してしまうことがしばしばある。そ
では魅力的なものは作り出せず、相対的にいいいか
んになってしまう。

パッケージングにおける進展は大規模会
社では難しいとお思いですか？

ゴールはもはやパッケージングの向上でも、
市場のシェアでもない。ゴールは仕事を完成さ
せるということだ。仕事をやりとげるとは、
組織構造のなかの人々とつきあい、時には不
快にさせることでもある。しかし、そのように
本当に必要とされる重要な変化を作り出すのとは
反対に、的はずれの微々たる変化をさせることや、
実際にそうでなくとも製品を「新しい」とか、「進歩
した」などということによって、済ませてしまうこと
がしばしばなされている。クライアントにきちんと
成し遂げるようにいうのは、デザイン会社の責任かも
しれない。だが、デザイン会社はクライアントを失
うのを恐れて、そのように 振る舞いたがらない。

しかしそれは小規模のデザイン会社やクライア
ントには通じませんよね？

はい。たいてい小規模のクライアントでは、その
製品を考案した人が、製品を持ってデザイナーのと
ころに訪れるものだ。そしてその製品の考案者は、
必要なものについて明確なビジョンを持っているも
のだ。だからデザイナーとクライアントは１対１の
レベルで話せ、おおよそ良い結果が得られる。とこ
ろがこのような関係は会社が大きく、代表者が強い
ビジョンを持っている限り不可能である。そのよう
な強いリーダーは良いデザインを買いがちである。
これはパッケージングだけでなく、すべてのデザイ
ンにいえることだ。

代表者がビジョンをもっていない大規模会社では、
結局高い料金でデザインではなく、"プロセス"を
デザイン会社から買うことになる。

では大規模会社は、手のかかる不必要なプロセ
スを踏んで、結局ただ高い料金を払っているだ
けだということですか？

パッケージの外観を改めると、$2,000か、$200,
000か、かかる。それはデザインにではなく、わかり
にくい、いんちきのプロセスにかかるのである。こ
のプロセスはふつう製品を向上させない。私はデザ
イナーが欺瞞的なプロセスでなく、デザインをする
ことでペイされることを望む。

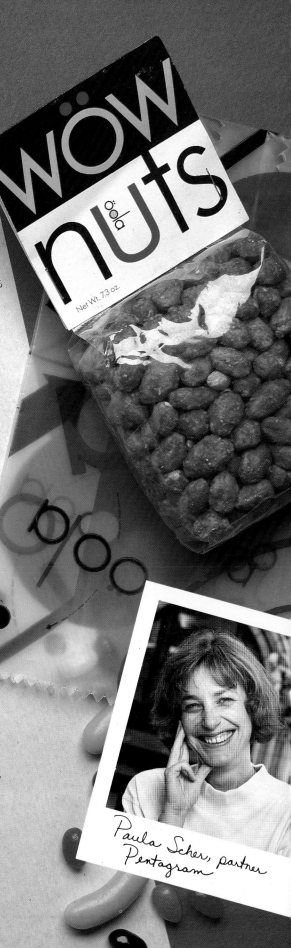

Paula Scher, partner
Pentagram

PAULA SCHER DESIGNED THE AWARD-WINNING
PACKAGING FOR ÖOLA, A CHAIN OF SHOPS IN THE
U.S. THAT SELLS CANDY AND NUTS BY THE POUND
(SEE PAGE 34).

Chuck Anderson is the principal of Charles S. Anderson Design Co. in Minneapolis, Minnesota. He is the designer and illustrator of many award-winning package designs, including El Paso Chili and Classico pasta sauce.

Your style is so distinctive. Do you ever find that you compete on the shelf with other packages you've designed?

No. I guess we haven't done enough packages for that to be a problem. Plus we are always trying to evolve our design approach and try different things. So we hope to never run into ourselves.

When clients come to you, they obviously want your style. How do you convince them to gamble, to be daring?

Sometimes we can't. We couldn't agree with a chocolate bar manufacturer out of Boston recently. They wanted a package to look like Classico Pasta Sauce, something we worked on nearly six years ago and have no desire to go backwards and revisit. We told the client that we would listen to his input and direction and try to give the package the feel he was after, but that we were not going to mimic our older work. We didn't get the project. Many clients, however, have liked the work we've done but also have enough faith and curiosity to want to see what's next when we work on their package.

Can you think of instances when great design helped or hindered sales?

W. Park Kerr, President of The El Paso Chile Company, called us to design a package for his authentic line of hot, medium, and mild salsas. He insisted I fly down to El Paso, Texas and take a donkey ride with him through the desert to experience some of the "real" Southwest.

Even though we were going up against some great competitors, we still got the product. Later, I found out that I was the only designer who was fool enough to take the donkey ride and that's why we got the job.

We came up with the brand name Desert Pepper Trading Company and then, after a survey of competitors on the grocery shelf, began working on the design. Park would call every day expressing his fears. "Damn, you guys are expensive!" "If this salsa doesn't sell, I'm out of business." "You have to guarantee this will sell." "It has to be the greatest package ever created." "If this doesn't sell, I'm a dead man." "I need to sell this to make money to pay you guys." "If this doesn't sell, I want my money back." Etc.

Six months later when we finished the design and Park introduced it at the Food Show, he called us back. "We've got a big problem with this package. I just took over half a million dollars in orders in two days. That's more money than all 20 of our existing products sell in an entire year. I need to order a million lids for the jars to fill the orders, and I can't afford them. You have to lend me $25,000. This is all your fault."

Does high design connote high price?

Although I'm sick to death of the Classico Pasta Sauce packaging we designed, it did help a pretty average red sauce go from zero to 90 million dollars in sales in two years, with very little advertising to back it up. In supermarket testing it had a 50% shelf pick-up rate, which means that half of the people who walked down the spaghetti sauce aisle stopped and picked it up. And as far as the design connoting a high price, this sauce actually was higher than the competition. In other words, the design is what made it seem worth the price.

*Chuck Anderson, principal
Charles S. Anderson Design*

CLOUD NINE MASS MARKET CHOCOLATE BARS ARE SOLD IN THE U.S. THEY WERE DESIGNED BY CHUCK ANDERSO(SEE PAGE 17).

MARKING BY DESIGN

ary Lewis is a partner in the internationally acclaimed
package design firm, Lewis Moberly Design
ultants in London. She is well known for the design of
te label packaging for Boots, ASDA and Safeway.

does marketing influence your design?

not regard marketing as some separate entity. Design
onds to a marketing brief. Therefore design and
keting are intrinsically linked. Marketing is less an
ence, more the day-to-day grist of a designer. Good
gners are often instinctively good marketers. As with
ything else, there is good marketing and bad
keting. The designer needs to recognize both. The
gner can rise above the marketer using vision, ideas
creative skills. Marketing is interesting when it is a
tive process. Playing strategic warfare can be almost as
h fun as creating a new design.

at compels a client with a private label to
esign?

ay's private label retailer has brand status. Unlike the
nufacturer's brand this is the "walk in" brand. Retailers
he U.K., and to some extent on the continent and in the
., are using packaging design to create their brand
sonality.

co was the first supermarket in the U.K. to do this in the
ly Eighties. Burdened with an image of "pile it high, and
it cheap," they turned to design to raise the credibility
heir total offering. Discreet corporate endorsement en-
ed consumers to buy in the secure environment of the
re without embarrassment.

er the last decade stores like Tesco have turned their
age around through the tactical use of design. Today,
ailers can and do use design in a much more confident
e, to express their own confident personalities. Consum-
expect product quality on a par with the brands and
kaging that makes shopping a pleasure rather than a
re. Aping the brand leader or posing as the cheap and
erful alternative is a thing of the past.

Although retailers have understood the power of design to
build their image, many of them need to define their image
more precisely. In an increasingly competitive marketplace
the retailers' brand proposition is critical. In the Nineties
we can expect greater differentiation and tightly targeted
design. As shelf space shrinks and choice increases, concise
and clear information projected in an imaginative way will
be the challenge for the package designer.

What restrictions do you deal with when designing
a packaging system?

The packaging designer rarely works without restrictions of
some kind. The brand will have its own "restrictions" in the
form of visual equities that must be retained, a handwriting
that must be recognized, and a history or tradition that
must be respected and valued.

The form of the packaging may be a restriction: existing
production lines, product stability, shelf space, recyclability
and consumer accessibility. Hierarchy of information is a
consideration, not a restriction, but nevertheless has to be
tackled along with pace, by which I mean the way the con-
sumer approaches the category, the brand, and finally, the
variant. Too often this is overlooked and clients request all
guns to be fired in unison. This leads to groaning packs des-
perate to tell their story, but drowned in their own noise.

Information graphics are becoming increasingly important
in package design. Unfortunately, this information is often
presented in an arid or "bolt on" manner; rarely is it an
integral part of the emotional appeal of the package. All
questions and issues have to be raised at the analytical
stage and solved before design begins.

This sounds very logical in theory. In practice it can be
different. At Lewis Moberly, along with rigorous analysis,
highly creative designers will be beavering away instinc-
tively, intuitively and freely. This is important, because at
the end of the day the emotional is as important as the
rational. In packaging design you need both to succeed.

LINDEN LADY INDIVIDUALLY-WRAPPED CHOCOLATES
ARE SOLD IN UPMARKET SHOPS IN GREAT BRITAIN.
THEY WERE DESIGNED BY MARY LEWIS (SEE PAGE 12).

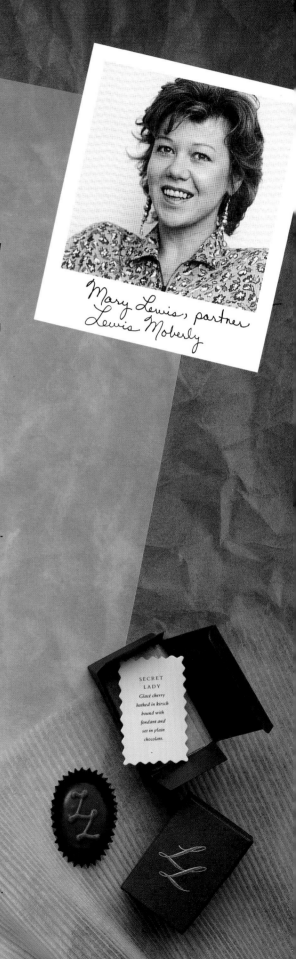

*Mary Lewis, partner
Lewis Moberly*

SECRET
LADY
*Glacé cherry
bathed in kirsch
bound with
fondant and
set in plain
chocolate.*

Velde
GEDI

For he on Honey dew hath fed
And drunk the milk of Paradise

GOATS CHEESE

20g

Moillon

Juvenet

GEDI CHEESE
TEL 01 449 0695
G

For he on H
And drunk the

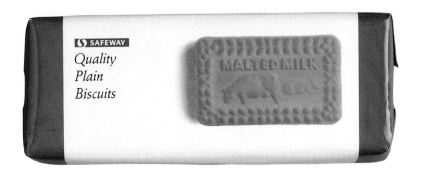

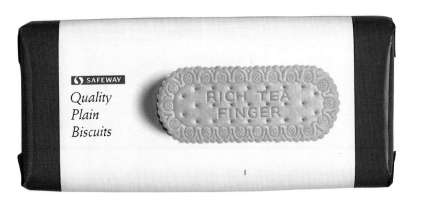

PRIVATE LABEL BISCUIT
PACKAGING FOR SAFEWAY.
SOLD IN SUPERMARKETS IN THE
UNITED KINGDOM, THE
PRODUCT'S TARGET AUDIENCE
IS HOUSEWIVES.
DESIGN FIRM,
LEWIS MOBERLY, LONDON;
CREATIVE DIRECTOR,
MARY LEWIS;
DESIGNER,
BRUCE DUCKWORTH;
ILLUSTRATOR,
ANDREW MCNAB.

OPPOSITE PAGE:
GOAT CHEESES DESIGNED FOR
AN UPMARKET TARGET
AUDIENCE. SOLD IN GOURMET
STORES IN GREAT BRITIAN.
DESIGN FIRM,
NEWELL AND SORRELL, LTD.,
LONDON.

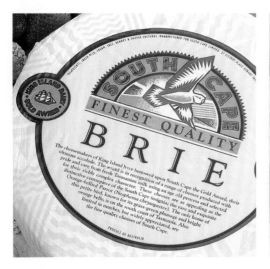 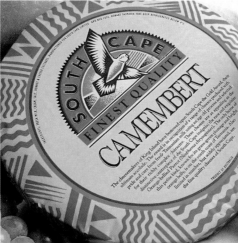 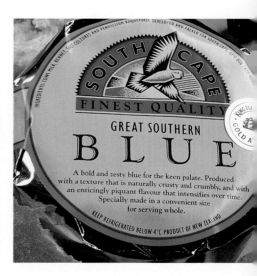

LINE OF CHEESES DESIGNED
FOR AN UPMARKET TARGET
AUDIENCE. SOLD IN GOURMET
STORES IN AUSTRALIA.
**DESIGN FIRM, KEN CATO,
AUSTRALIA.**

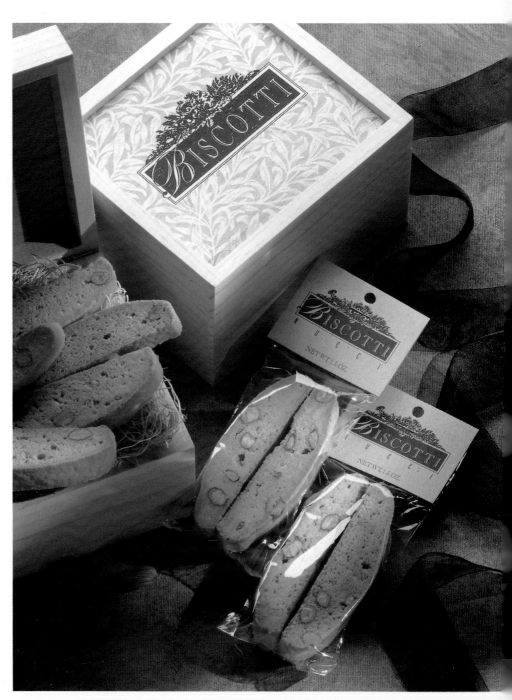

OLD WORLD GOURMET RECIPES
FOR AN UPMARKET U.S.
AUDIENCE. BISCOTTI NUCCI WAS
DESIGNED ON A BUDGET.
THE RECYCLED PAPER BOX IS
REUSABLE.
**DESIGN FIRM, MORLA DESIGN,
SAN FRANCISCO. CREATIVE
DIRECTOR, JENNIFER MORLA;
DESIGNERS, JENNIFER MORLA,
JEANETTE ARAMBURU.**

SPECIALTY COFFEE
PACKAGES DESIGNED FOR
SAFEWAY DISTRIBUTED
IN GREAT BRITIAN.
**DESIGN FIRM,
LEWIS MOBERLY, LONDON;
DESIGNER, MARY LEWIS.**

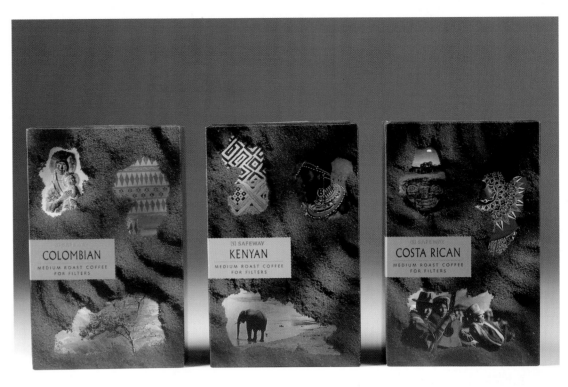

CONDIMENT PACKAGING
FROM THE SOUTHWESTERN
UNITED STATES, DESIGNED
WITH A TEX MEX FEEL. SOLD
IN THE UNITED STATES BY
EL PASO CHILI COMPANY.
**DESIGNER, LESLIE PIRTLE,
NEW YORK, NEW YORK.**

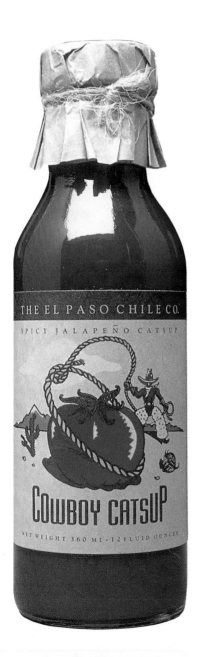

OPPOSITE PAGE:
JUBILAEUM BOTTLE AND GIFT
BOX PACKAGING SYSTEM FOR
JIM BEAM BRANDS.
DESIGN FIRM,
THE DUFFY DESIGN GROUP,
MINNEAPOLIS, MINNESOTA.

PACKAGE DESIGN FOR
BLOOMINGDALE'S PRIVATE
LABEL BELGIAN CHOCOLATES,
FOR CHRISTMAS '89.
DESIGN FIRM,
ROBERT VALENTINE INC.,
NEW YORK, NEW YORK;
ART DIRECTOR AND DESIGNER,
ROBERT VALENTINE.

CORPORATE IDENTITY,
PACKAGING AND GRAPHICS FOR
LINDEN LADY CHOCOLATES.
DESIGN FIRM,
LEWIS MOBERLY, LONDON;
ART DIRECTOR AND DESIGNER,
MARY LEWIS; PHOTOGRAPHER,
ALAN DAVID TU.

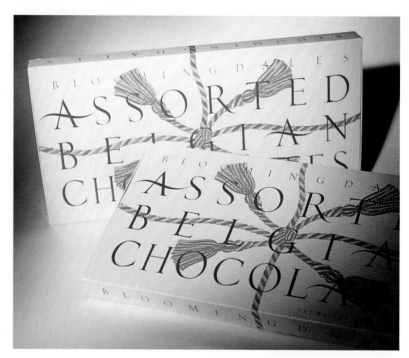

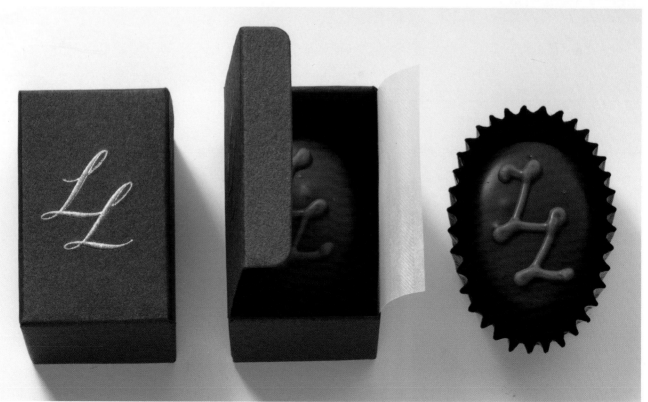

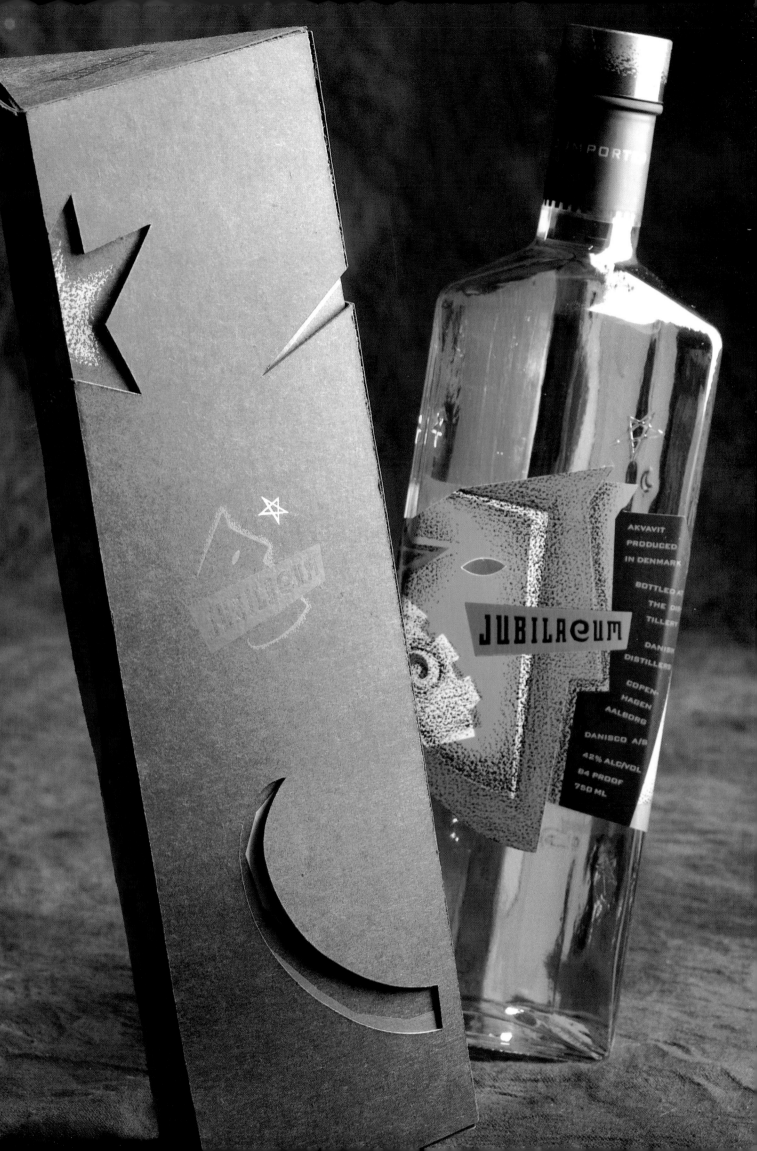

SAFEWAY SHORTBREAD
ROUNDS DESIGN CONCEPT
REFLECTS THE SCOTTISH
ORIGINS OF THE PRODUCT.
A STITCHED CLOTH LABEL
CARRIES THE COPY.
**DESIGN FIRM,
LEWIS MOBERLY, LONDON;
ART DIRECTOR, MARY LEWIS;
DESIGNER,
BRUCE DUCKWORTH;
PHOTOGRAPHER,
LAURIE EVANS.**

BOEMBOE'S SNACK PRODUCTS
ARE GATHERED FROM ALL OVER
THE WORLD, WHICH IS
REFLECTED IN THE PACKAGING
DESIGNS FOR EVERY COUNTRY.
**DESIGN FIRM,
MILFORD-VAN DEN BERG
DESIGN, B.V., HOLLAND;
CREATIVE DIRECTOR AND
DESIGNER, DANNY KLEIN;
ILLUSTRATOR,
HANS REISINGER.**

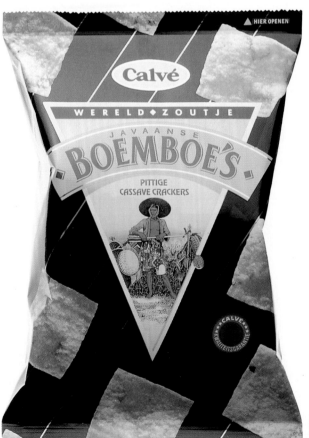

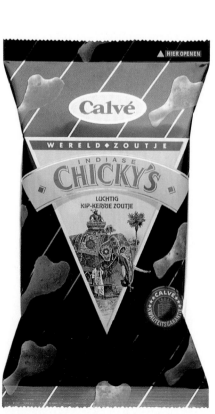

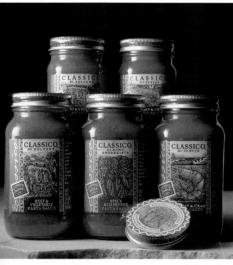

PACKAGING SYSTEM FOR
CLASSICO SPAGHETTI JARS AND
LABELS. THE JAR IS DESIGNED
AFTER AN OLD-FASHIONED
BELL JAR.
DESIGN FIRM,
THE DUFFY DESIGN GROUP,
MINNEAPOLIS, MINNESOTA.

HAM I AM/HOGWASH,
BEEFISH GIFT PACK.
DESIGN FIRM,
SULLIVAN PERKINS, DALLAS,
TEXAS; ART DIRECTOR,
RON SULLIVAN; DESIGNERS,
CLARK RICHARDSON,
ART GARCIA.

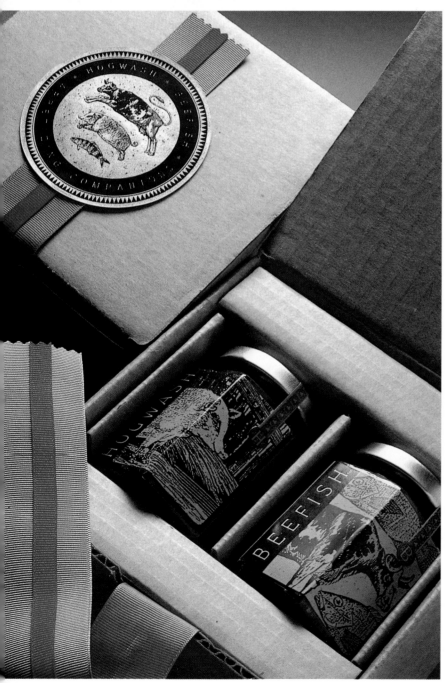

15

KNAPP VINEYARDS LABEL
DESIGNS FOR ESTATE WHITE,
AND CHAMPAGNE.
**DESIGN FIRM,
LOUISE FILI LTD.,
NEW YORK, NEW YORK; ART
DIRECTOR AND DESIGNER,
LOUISE FILI; ILLUSTRATOR,
PHILIPPE WEISBECKER.**

MONSTER CANDY AND CARDS
WERE DESIGNED AS A
HALLOWEEN PROMOTION FOR
THE FRENCH PAPER COMPANY'S
NEWLY RELEASED PAPER,
FRENCH RAYON.
**DESIGN FIRM,
CHARLES S. ANDERSON,
MINNEAPOLIS, MINNESOTA;
DESIGNERS,
CHARLES S. ANDERSON,
DANIEL OLSON;
ILLUSTRATORS,
RANDALL DAHLK,
CHARLES S. ANDERSON.**

PACKAGE DESIGN FOR PALAIS
D'AMOUR FOOD PRODUCTS.
GERARD D'AMOUR IS A
LOCAL BEEKEEPER AND
PRODUCER.
**DESIGN FIRM,
CHARLES S. ANDERSON,
MINNEAPOLIS, MINNESOTA;
ART DIRECTOR, DESIGNER,
AND ILLUSTRATOR,
HALEY JOHNSON.**

16

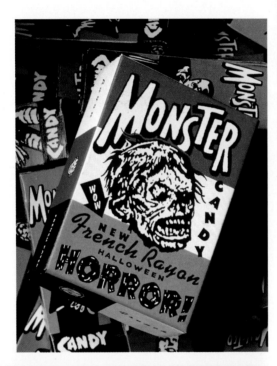

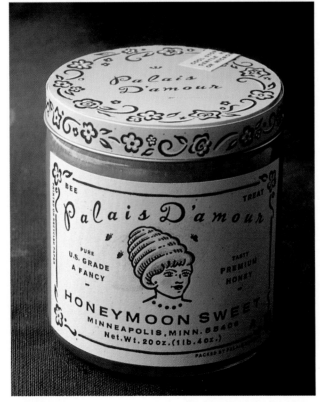

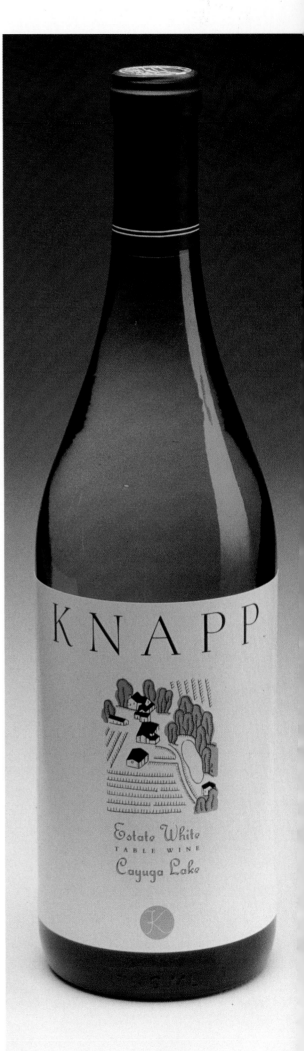

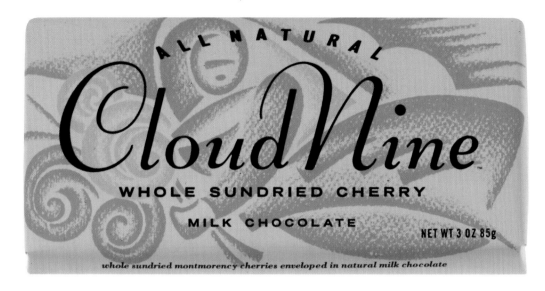

ALL NATURAL

Cloud Nine™

WHOLE SUNDRIED CHERRY

MILK CHOCOLATE

NET WT 3 OZ 85g

whole sundried montmorency cherries enveloped in natural milk chocolate

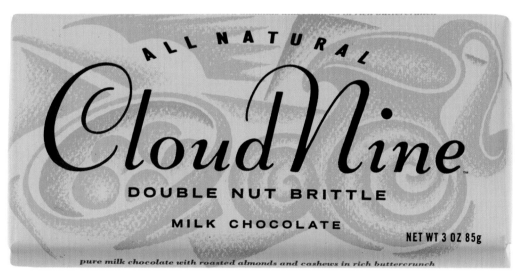

ALL NATURAL

Cloud Nine™

DOUBLE NUT BRITTLE

MILK CHOCOLATE

NET WT 3 OZ 85g

pure milk chocolate with roasted almonds and cashews in rich buttercrunch

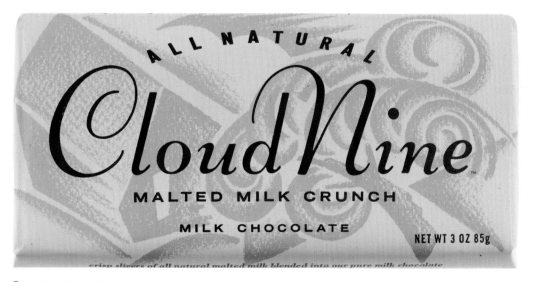

ALL NATURAL

Cloud Nine™

MALTED MILK CRUNCH

MILK CHOCOLATE

NET WT 3 OZ 85g

crisp slivers of all natural malted milk blended into our pure milk chocolate

PACKAGING DESIGNS OF
CLOUD NINE® ALL-NATURAL
CHOCOLATE BARS. THE
WRAPPERS ARE RECYCLED AND
PRINTED WITH VEGETABLE INKS.
DESIGN FIRM,
CHARLES S. ANDERSON
DESIGN COMPANY,
MINNEAPOLIS, MINNESOTA;
ART DIRECTORS AND
DESIGNERS, HALEY JOHNSON,
DANIEL OLSON; ILLUSTRATOR,
HALEY JOHNSON; CREATIVE
DIRECTOR, MIRANDA SUTTON.

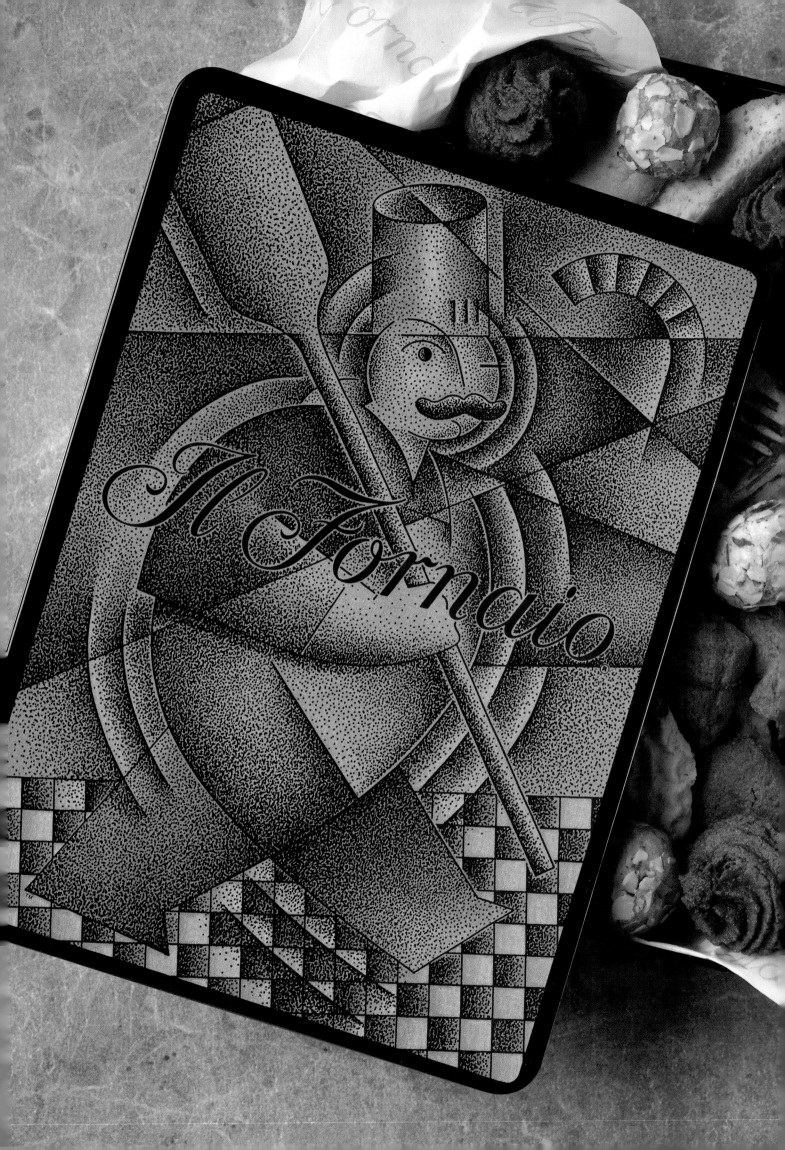

A SERIES OF PACKAGED TAKE-
OUT FOOD ITEMS SOLD IN
IL FORNAIO RESTAURANTS, A
REGIONAL CHAIN AND BAKERY
SPECIALIZING IN NORTHERN
ITALIAN CUISINE.
DESIGN FIRM,
MICHAEL MABRY DESIGN,
SAN FRANCISCO; DESIGNER
AND ILLUSTRATOR,
MICHAEL MABRY;
DESIGN DIRECTOR,
HILARY WOLF, IL FORNAIO;
DESIGN ASSISTANT,
MARGIE CHU.

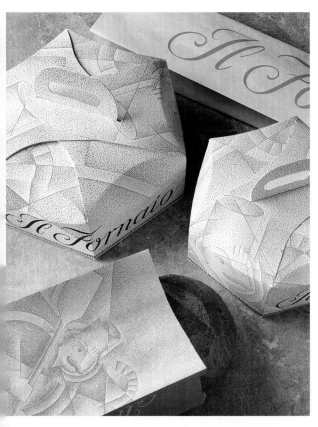

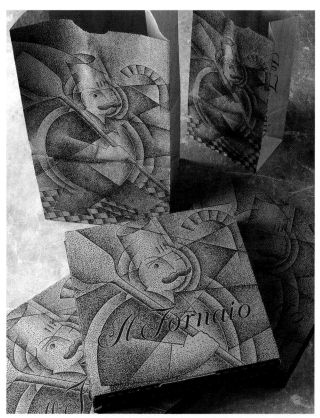

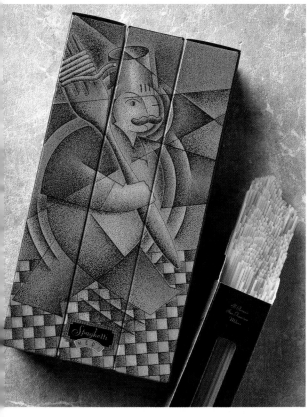

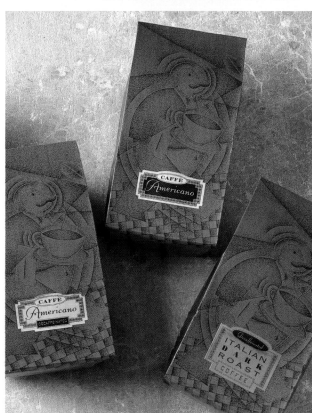

LABEL DESIGN FOR MESSINIA
SUPERIOR-QUALITY EXTRA-
VIRGIN OLIVE OIL.
**DESIGN FIRM,
LOUISE FILI LTD.,
NEW YORK, NEW YORK;
ART DIRECTOR AND DESIGNER,
LOUISE FILI; ILLUSTRATOR,
MELANIE PARKS.**

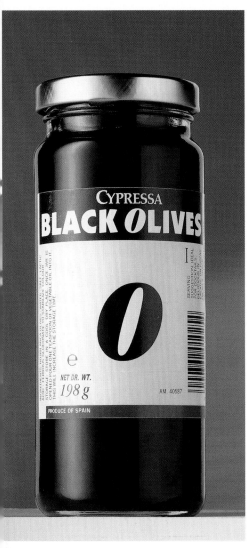

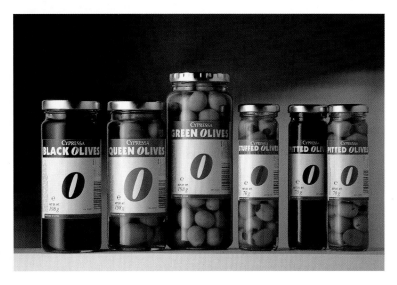

CYPRESSA OLIVES PACKAGING
DISPLAYS THE PRODUCTS IN
ALL THEIR GLORY. A SIMPLE
TYPOGRAPHIC DEVICE IS USED
TO DIFFERENTIATE VARIETIES.
**DESIGN FIRM,
CARTER WONG LIMITED,
LONDON; ART DIRECTOR AND
DESIGNER, PHILIP CARTER.**

NAME DEVELOPMENT, BRAND
IDENTITY AND PACKAGE DESIGN
OF SAVOIR FAIRE, A GOURMET
LINE OF CONDIMENTS AND
CRACKERS FROM FRANCE.
**DESIGN FIRM,
LANDOR ASSOCIATES,
SAN FRANCISCO, CALIFORNIA;
DESIGNERS, LANDOR
NEW YORK DESIGN STAFF.**

21

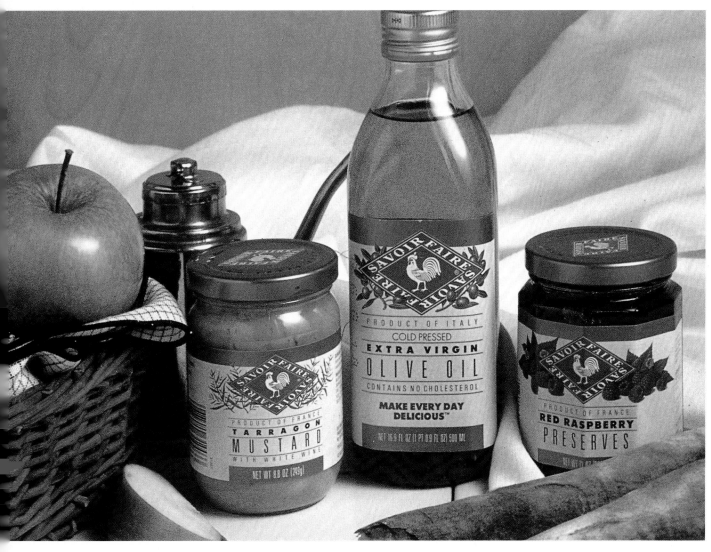

OPPOSITE PAGE:
PACKAGING DESIGN FOR THE
HOT BAGEL COMPANY, LONDON.
**DESIGN FIRM,
NEWELL AND SORRELL, LTD.,
LONDON;
CREATIVE DIRECTOR,
JOHN SORRELL;
DESIGNER, DOMENIC LIPPA.**

PACKAGE DESIGN FOR
JUST DESSERTS.
**DESIGN FIRM, PRIMO ANGELI,
INC., SAN FRANCISCO,
CALIFORNIA; DESIGNER,
PRIMO ANGELI.**

BEER BOTTLES AND LABEL
DESIGNS FOR GORKY'S CAFE
AND BREWERY, LOS ANGELES.
**DESIGN FIRM,
30/SIXTY ADVERTISING AND
DESIGN, LOS ANGELES,
CALIFORNIA; DESIGNERS,
HENRY VIZCARRA,
ESTAY HUESTIS.**

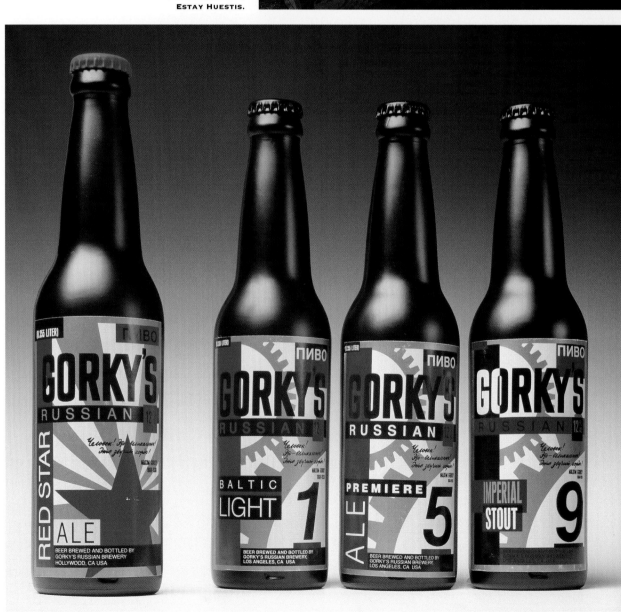

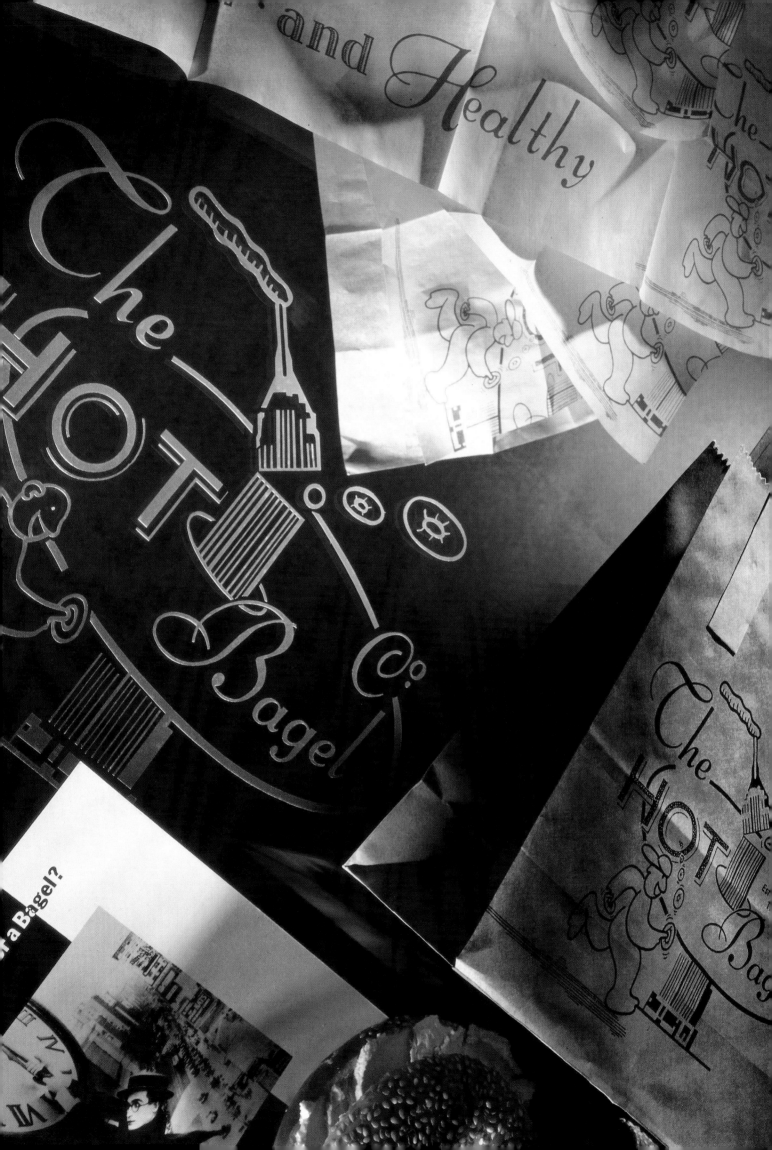

WINE LABEL DESIGNS
COOKBOOK, AND MURAL FOR
ARCADIA RESTAURANT
NEW YORK. THE ARCADIA
MURAL AND COOKBOOK IS A
HARDCOVER VOLUME OF THE
RESTAURANT'S SEASONAL
RECIPES BY ANNE
ROSENZWEIG. IT INCLUDES THE
COMPLETE MURAL IN A FOLD
OUT FORMAT. THE MURAL
DEPICTS THE FOUR SEASONS
ALONG THE HUDSON RIVER. IT
IS 2 1/2' HIGH X 70" WIDE. IT
WAS PAINTED IN THE STUDIO
AND LATER INSTALLED ON SITE
DESIGN FIRM
PAUL DAVIS STUDIO
NEW YORK, NEW YORK
DESIGNERS, PAUL DAVIS
JOSE CONDE, MYRNA DAVIS
ARTIST, PAUL DAVIS

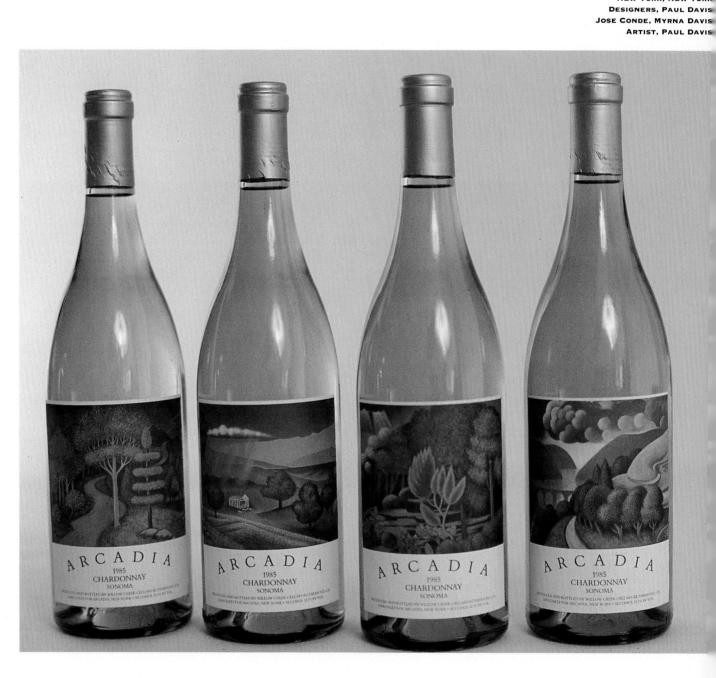

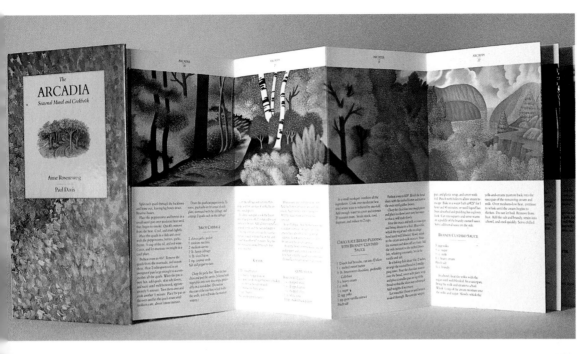

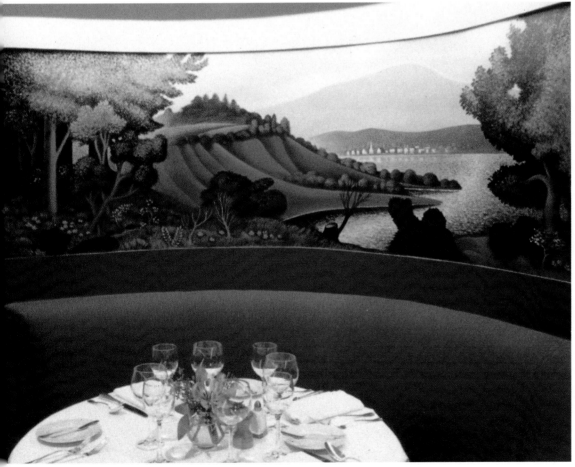

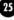

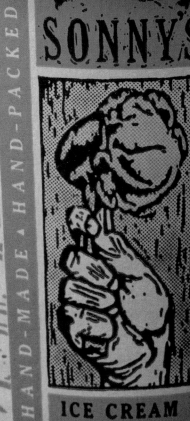

VANILLA

SONNY'S

HAND-MADE • HAND-PACKED

FAMILY-OWNED • SINCE 1945

ICE CREAM

ONE PINT

PEANUT

CHIP

BUTTER CHOCO

SPUMONI

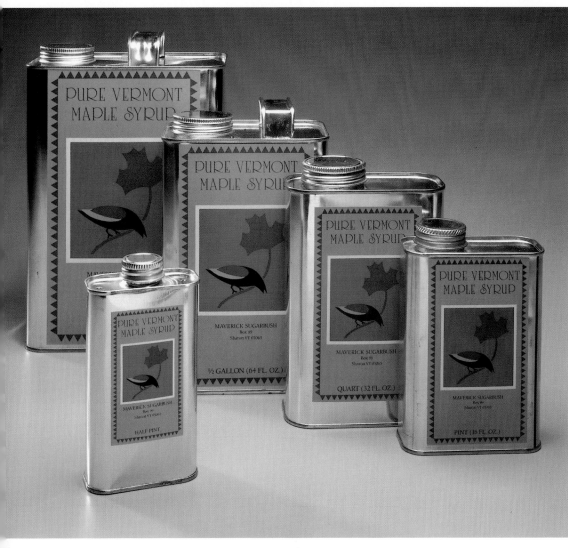

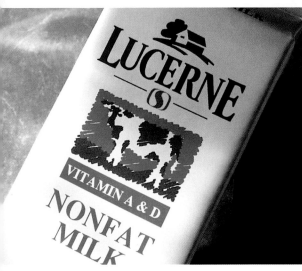

PACKAGE DESIGN FOR
VERMONT MAPLE SYRUP.
THE DESIGN DEPARTS FROM
TRADITION USING A NON-WINTER
THEME, PRINTED ON
A BUFF-SILVER CAN.
DESIGN FIRM,
KATE EMLEN GRAPHIC DESIGN,
LYME, VERMONT; ART
DIRECTOR, BOB CHAMBERLIN;
DESIGNER AND ILLUSTRATOR,
KATE EMLEN CHAMBERLIN.

PACKAGING DESIGNS OF
LUCERNE DAIRY PRODUCTS,
FOR SAFEWAY, INC., WALNUT
CREEK, CALIFORNIA.
DESIGN FIRM,
LANDOR ASSOCIATES,
SAN FRANCISCO, CALIFORNIA;
DESIGN DIRECTOR,
MICHAEL LIVOLSI;
CREATIVE DIRECTOR,
KAY STOUT.

POSITE PAGE:
CKAGING SYSTEM FOR
NNY'S ICE CREAM.
SIGN FIRM,
E DUFFY DESIGN GROUP,
NNEAPOLIS, MINNESOTA.

TEA TIN DESIGN FOR THE 100TH
ANNIVERSARY OF LIPTON TEA,
FOR THOMAS J. LIPTON, INC.
**DESIGN FIRM,
PRIMO ANGELI INC.,
SAN FRANCISCO, CALIFORNIA;
DESIGNER, PRIMO ANGELI.**

PACKAGE DESIGNS FOR SMA
OILS IN TIN CONTAINERS. THE
ILLUSTRATION ON THE OUT-SIDE
SHOWS THE NATURAL
INGREDIENT.
**DESIGN FIRM,
MICHAEL PETERS LIMITED,
LONDON; ART DIRECTOR,
GLENN TUTSSEL; DESIGNER
AND ILLUSTRATOR,
NEIL WOOD.**

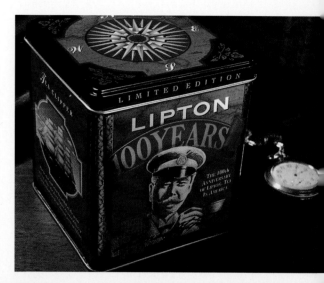

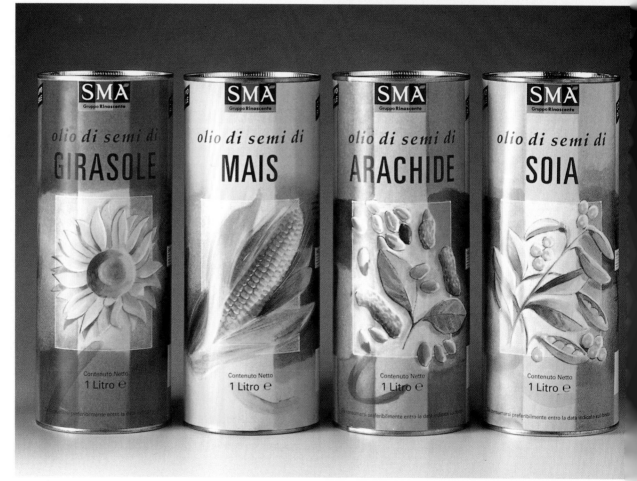

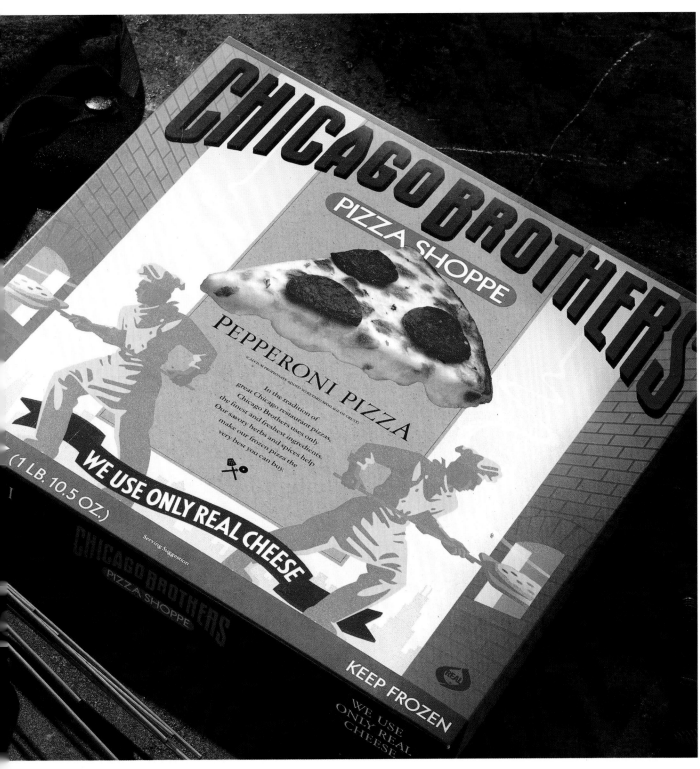

CAGO BROTHERS PIZZA
KAGE DESIGN REPOSITIONS
S PRODUCT AS THE
MIERE TRADITIONAL FROZEN
ZA BY EVOKING THE HEARTY,
VORFUL COOKING ASSOCIAT-
WITH ITS NAMESAKE CITY.
DESIGN INCORPORATES
OVATIVE ILLUSTRATION IN
ATEGORY OF PACKAGING
MINATED BY PHOTOGRAPHY.

DESIGN FIRM,
JOSH FREEMAN/ASSOCIATES,
LOS ANGELES, CALIFORNIA;
CREATIVE DIRECTOR,
JOSH FREEMAN;
DESIGNER, GREG CLARKE;
ILLUSTRATOR, LAURA SMITH;
PHOTOGRAPHER, JAY AHREND.

OPPOSITE PAG
BOTTLE DESIGN FOR TSARIT
VODKA, FOR D'AMICO A
PARTNER
DESIGN FIR
MICHAEL PETERS LIMITE
LONDON; ART DIRECTC
DESIGNER, AND TYPOGRAPH
GLEN TUTSSEL; ILLUSTRATC
HARR WILLO

BLOOMINGDALE'S POPCORN
TIN FOR "VIVE LA FRANCE"
IN-STORE PROMOTION.
DESIGN FIRM,
ROBERT VALENTINE INC.,
NEW YORK, NEW YORK;
ART DIRECTOR AND DESIGNER,
ROBERT VALENTINE;
ILLUSTRATOR,
JEFFREY ADAMS.

PACKAGING FOR LYONS CREATES
A DISTINCTIVE LOOK WITH
PHOTOGRAPHY AND
MARBLEIZED BACKGROUND.
DESIGN FIRM,
MICHAEL PETERS LIMITED,
LONDON; ART DIRECTOR,
GLENN TUTSSEL; DESIGNER,
MARY WICKENS.

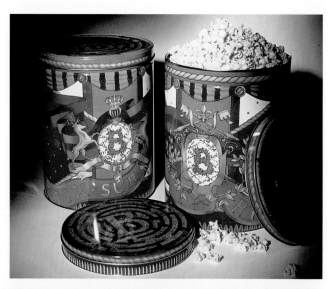

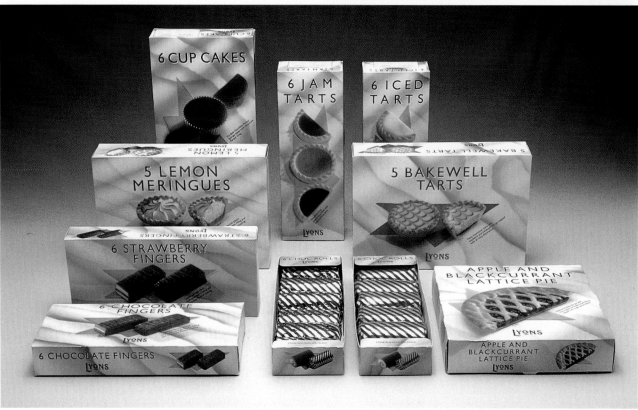

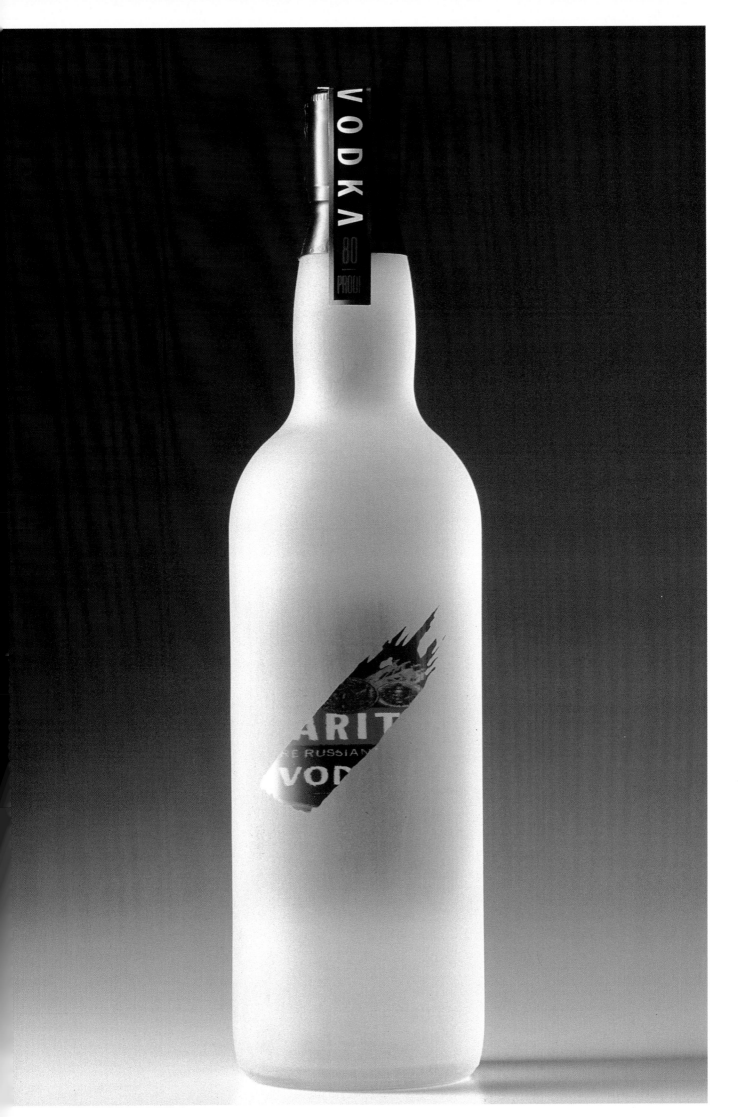

CHOCOLATE MINT ALMONDS

CRUNCHY, WHOLE, TOASTED CALIFORNIA ALMONDS LAVISHLY COATED WITH RICH BITTERSWEET CHOCO-LATE AND FINISHED WITH MINTED WHITE CHOCOLATE.

COCOLAT
BERKELEY, CALIFORNIA 94710

COCOLAT

BITTERSWEET CHOCOLATE RAISIN BARK

SWEET, SUNRIPENED RAISINS IN RICH, BIT-TERSWEET CHOCOLATE FOR CONNOISSEURS AND SERIOUS NIBBLERS. IRRESISTIBLE.

COCOLAT
BERKELEY, CALIFORNIA 94710

TRIPLE CHOCOLATE ALMONDS

CRUNCHY, WHOLE, FRESH TOASTED CALI-FORNIA ALMONDS LAV-ISHLY COATED WITH RICH, BITTERSWEET AND MILK CHOCOLATES AND DUSTED WITH THE FINEST DUTCH COCOA.

COCOLAT
BERKELEY, CALIFORNIA 94710

OPPOSITE PAGE:
RECYCLED, REUSABLE PAPER
WAS USED FOR THE PACKAGING
OF COCOLAT GOURMET
CHOCOLATES.
DESIGN FIRM, MORLA DESIGN,
SAN FRANCISCO, CALIFORNIA;
ART DIRECTOR, CREATIVE
DIRECTOR, DESIGNER,
JENNIFER MORLA.

PACKAGE DESIGNS FOR A
VARIETY OF TRADITIONAL
HARRODS BISCUITS.
DESIGN FIRM,
IAN LOGAN DESIGN COMPANY,
LONDON; DESIGNER,
ALAN COLVILLE;
ILLUSTRATION, BRIAN COOK;
ART DIRECTORS, IAN LOGAN,
STUART GATES, HARRODS.

PRESENTATION DESIGN FOR
MORRIS OF RUTHERGLEN
FORTIFIED WINES. THE DESIGN
PROGRAM INCORPORATES THE
HISTORY AND TRADITION OF THE
COMPANY IN AN ATTRACTIVE
GIFT PACKAGING.
DESIGN FIRM,
BARRIE TUCKER DESIGN PTY,
LTD., EASTWOOD, AUSTRALIA;
ART DIRECTOR AND DESIGNER,
BARRIE TUCKER; DESIGNER,
ILLUSTRATOR AND
TYPOGRAPHER, JODY TUCKER.

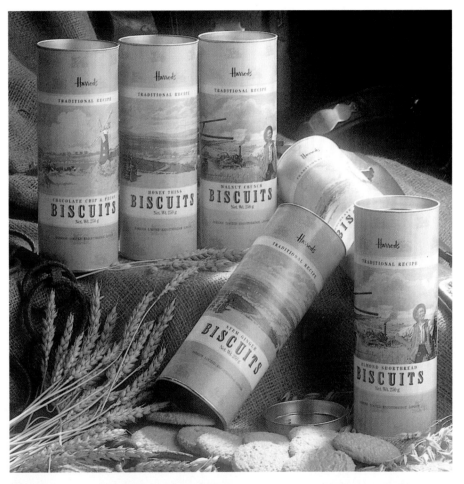

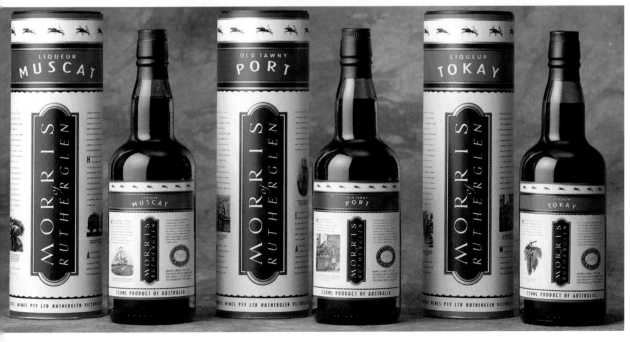

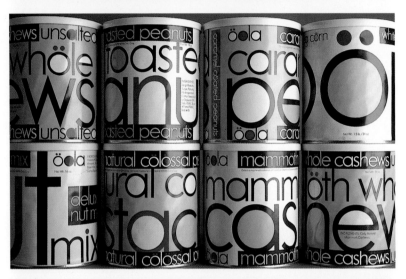

PACKAGING DESIGN FOR ÖOLA
CORPORATION, A CHAIN OF
SWEDISH CANDY STORES IN
AMERICAN SHOPPING MALLS.
**DESIGN FIRM, PENTAGRAM,
NEW YORK, NEW YORK;
PARTNER AND DESIGNER,
PAULA SCHER.**

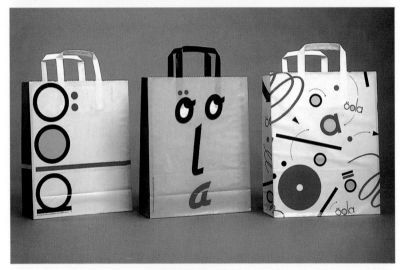

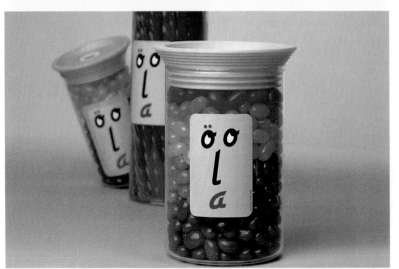

...CAO FANTASIE CHOCOLATS
...E ICE CUPS WITH A UNIQUE
...NT-COCOA FLAVORING.
...SIGN FIRM,
...LFORD-VAN DEN BERG
...SIGN, B.V., HOLLAND;
...EATIVE DIRECTOR AND
...SIGNER, DANNY KLEIN;
...LUSTRATOR,
...NS REISINGER.

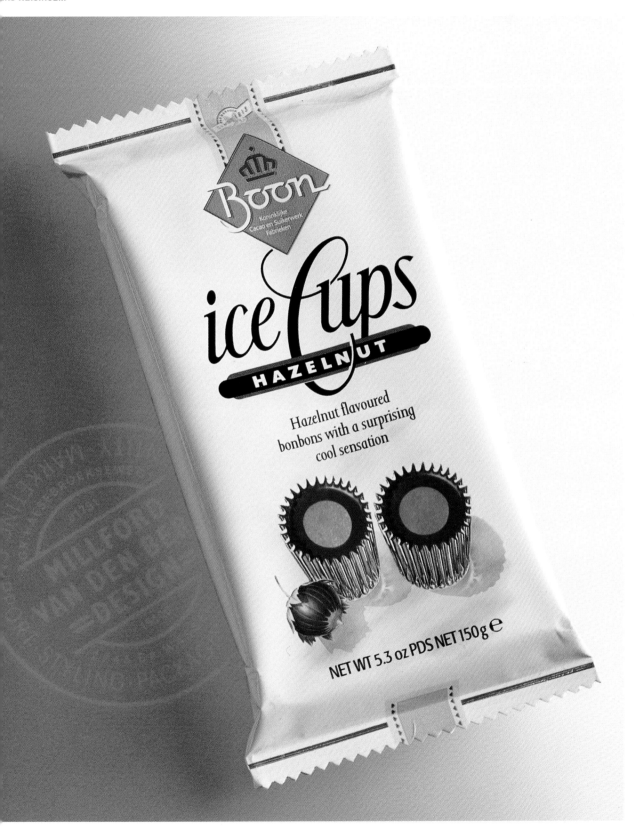

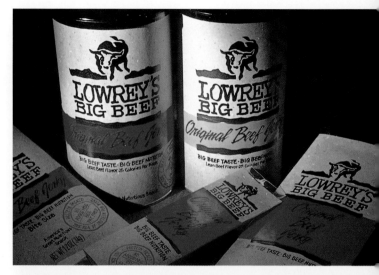

PACKAGE DESIGN
FOR LOWREY'S BIG BEEF, AN
ESTABLISHED LINE OF BEEF
JERKY PRODUCTS.
**DESIGN FIRM,
LANDOR ASSOCIATES,
SAN FRANCISCO, CALIFORNIA;
DESIGN DIRECTOR,
ELLEN SPIVAK; CREATIVE
DIRECTOR, KAY STOUT.**

LEEUWIN ESTATE AND
PRELUDE LABEL DESIGNS FOR
AUSTRALIAN VINTNER. THE
DESIGN IS CONTEMPORARY,
YET MAINTAINS THE BRAND'S
PREMIUM POSITIONING.
**DESIGN FIRM, CATO DESIGN,
AUSTRALIA; DESIGNER,
KEN CATO.**

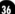

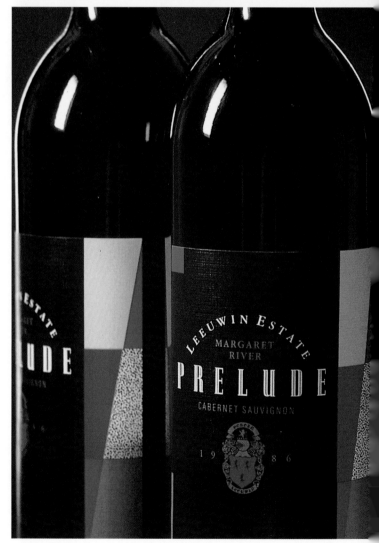

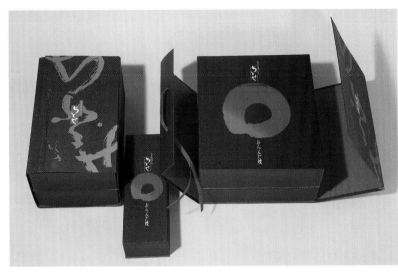

PACKAGE DESIGNS FOR CHITOSE
OLANDA-YAKI SWEET BEAN
CAKES USE A TRADITIONAL
STYLE OF JAPANESE
PACKAGING.
**DESIGN FIRM,
SHIGERU AKIZAKI, TOKYO;
DESIGNER, SHIGERU AKIZUKI.**

THE CHITOSE COMBINATION
BAKE SET IS DESIGNED AS A
GIFT BOX THAT CAN BE FILLED
WITH THE CUSTOMER'S CHOICE
OF VARIOUS SWEETS. THE
DESIGN USES A TRADITIONAL
JAPANESE PACKAGING STYLE.
**DESIGN FIRM,
SHIGERU AKIZUKI, TOKYO;
DESIGNER, SHIGERU AKIZUKI.**

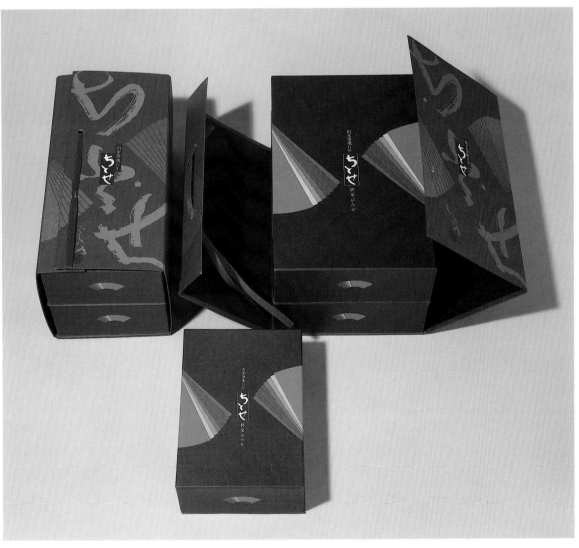

OPPOSITE PAGE:
PACKAGE DESIGN FOR
INTERCITY BRAND OF FOOD
SERVED ON BOARD INTER-CITY
TRAINS. PRODUCT REFLECTS
HIGH QUALITY.
**DESIGN FIRM,
NEWELL AND SORRELL LTD.,
LONDON.**

BOTTLE AND LABEL DESIGN OF
BELOLIVE OLIVE OIL.
**DESIGN FIRM,
B E P DESIGN GROUP,
BRUSSELS, BELGIUM;
CREATIVE DIRECTOR,
BRIGITTE EVRARD;
ART DIRECTOR AND
ILLUSTRATOR,
CAROLE PURNELLE.**

BLUE BELL SPUMONI ICE
CREAM, PACKAGE DESIGNS
FOR BLUE BELL CREAMERIES,
INC., BRENHAM, TEXAS.
**DESIGN FIRM,
METZDORF STONE, NEW YORK,
NEW YORK; ART DIRECTOR AND
DESIGNER,
LYLE METZDORF.**

TRADEMARK DESIGN FOR
DIMARE COMPANY, FRESNO,
CALIFORNIA. THE PRODUCT
IS A NEW BRAND OF FRESH
PRODUCE.
**DESIGN FIRM,
LANDOR ASSOCIATES,
SAN FRANCISCO, CALIFORNIA.
DESIGN DIRECTOR,
DAN ANDRIST; CREATIVE
DIRECTOR, KAY STOUT.**

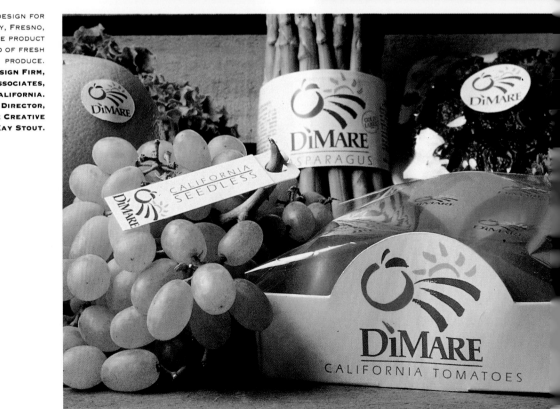

Entre deux Villes

VIN DE PAYS ROUGE
PRODUCE OF FRANCE

INTERCITY

10.5% Vol

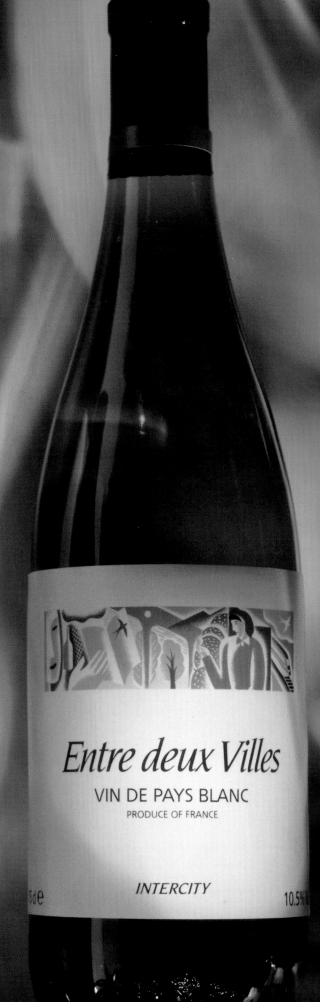

Entre deux Villes

VIN DE PAYS BLANC
PRODUCE OF FRANCE

INTERCITY

10.5%

MICROWAVABLE · NO NEED TO REFRIGERATE

 PILAU RICE

Pilau rice with whole spices

SERVING SUGGESTION · SERVES ONE · FREE FROM ARTIFICIAL COLOURS, FLAVOURS & PRESERVATIVES

MICROWAVABLE · NO NEED TO REFRIGERATE

 BEEF MADRAS

Beef with sultanas & coconut in a hot spicy sauce

SERVING SUGGESTION · SERVES ONE · FREE FROM ARTIFICIAL COLOURS, FLAVOURS & PRESERVATIVES

PPOSITE PAGE:
OOTS COMPANY EVENING
EALS:PILAU RICE AND BEEF
ADRAS. THE MEALS ARE
CROWAVE SPECIALTIES
RGETED AT THE BUSY
ORKING WOMAN.
ESIGN FIRM,
EWIS MOBERLY, LONDON;
RT DIRECTOR, MARY LEWIS;
ESIGNERS,
CILLA SCRIMGEOUR,
ARY LEWIS; PHOTOGRAPHER,
SS KOPPEL.

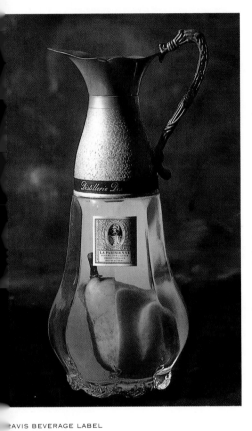 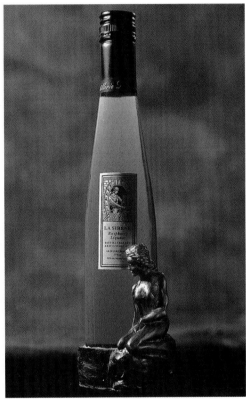 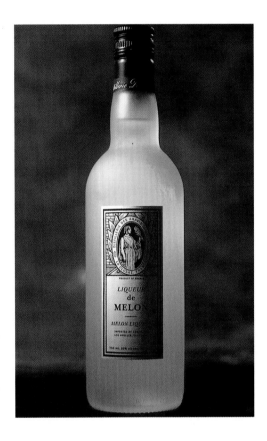

AVIS BEVERAGE LABEL
SIGNS ARE BASED ON THE
AGERY FOUND ON HISTORIC
GRAVED FRENCH POSTAGE
AMPS.
SIGN FIRM,
ARLES S. ANDERSON,
NNEAPOLIS, MINNESOTA;
T DIRECTORS AND
SIGNERS,
ARLES S. ANDERSON,
NIEL OLSON;
USTRATORS,
NDALL DAHLK,
ARLES S. ANDERSON,
NIEL OLSON.

QUAKER OATS' MIAUW
CATFOOD PACKAGING.
**DESIGN FIRM,
MILFORD-VAN DEN BERG
DESIGN, B. V., HOLLAND;
CREATIVE DIRECTOR AND
DESIGNER, DANNY KLEIN;
ILLUSTRATOR,
HANS REISINGER.**

PACKAGING FOR ALMONDINA
BISCUITS IS MADE OF PROTEC-
TIVE, CRUSH-PROOF GIFT BOXES,
FROM RECYCLED MATERIALS.
**DESIGN FIRM,
YZ ENTERPRISES,
MAUMEE, OHIO;
DESIGNERS, WILLIAM MEYER,
RICK ZABORSKI,
YUVAL AND SUSAN ZALIOK;**

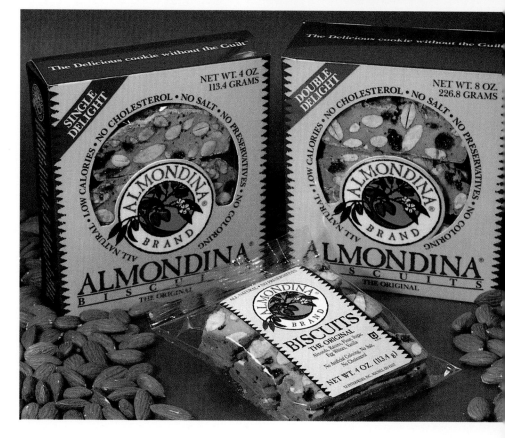

PACKAGING DESIGN FOR PINTO
BEANS IS HAND-MADE, ONE-
OF-A-KIND THAT SUGGESTS A
HOME-MADE PRODUCT.
DESIGN FIRM,
SIBLEY/PETEET DESIGN,
DALLAS, TEXAS;
ART DIRECTOR, DESIGNER AND
ILLUSTRATOR, REX PETEET.

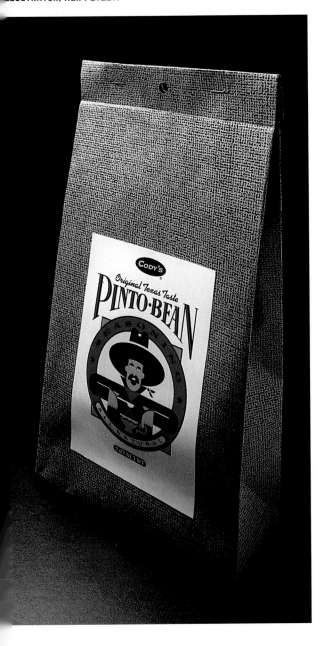

OPPOSITE PAGE: THE LABEL DESIGN FOR BLACK MARLIN WINE IS PRINTED DIRECTLY ONTO THE BOTTLE GLASS. **DESIGN FIRM, ZULU ADVERTISING & DESIGN, AUSTRALIA; DESIGNER, TIMOTHY CLIFT.**

HOTTER THAN HELLVETICA PICANTE SAUCE BOTTLE DESIGNS WERE PART OF A FUNDRAISER HELD BY AIGA/TEXAS AT THE NATIONAL CONFERENCE IN CHICAGO. **DESIGN FIRM, DOWNTOWN DESIGN, AUSTIN, TEXAS; DESIGNER, DAVID KAMPA; ART DIRECTOR, KELLEY TOOMBS.**

CRAWFISH PACKAGING FOR ECRIVISSE ACADIENNE STORES IN NEW ORLEANS. **DESIGN FIRM, TOTH DESIGN, INC., CARLISLE, MASSACHUSETTS; DESIGNER, MICHAEL TOTH; PHOTOGRAPHER, MYRON.**

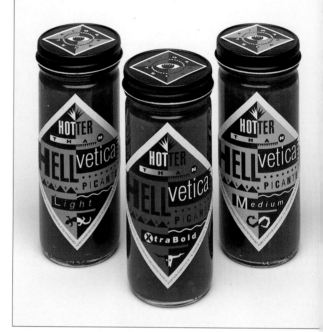

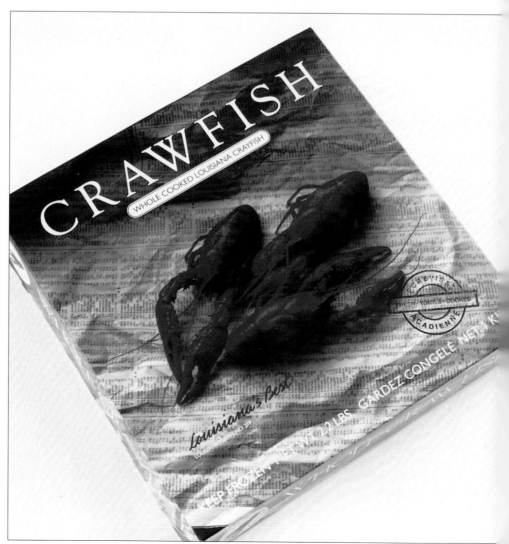

BLACK MARLIN

HUNTER RIVER VALLEY

SEMILLON

750ml

SAUVIGNON BLANC 18%

22%.

OF AUSTRALIA

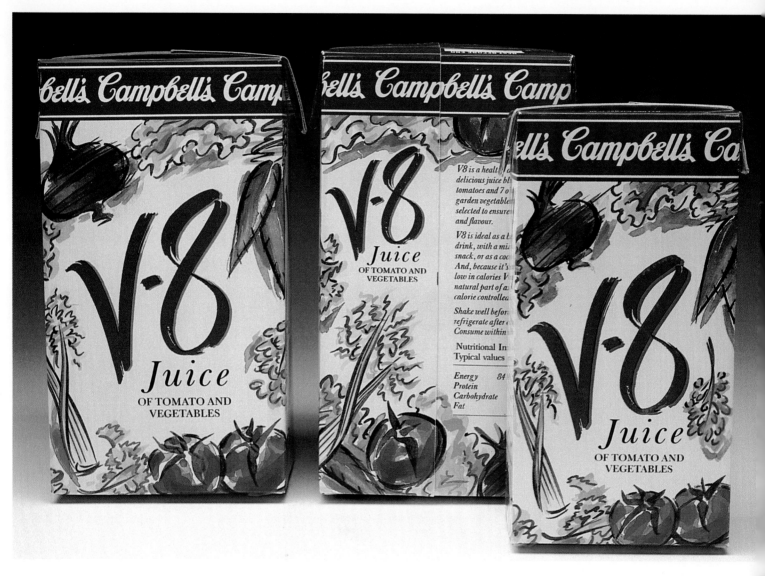

CAMPBELL'S V8 JUICE IS
COMBINATION OF VEGETABLE
IN A CHILLED DRIN
DESIGN FIR
MICHAEL PETERS LIMITE
LONDON; ART DIRECTO
GLENN TUTSSEL; DESIGNE
MARK LLOYD; ILLUSTRATO
MALCOLM ENGLIS

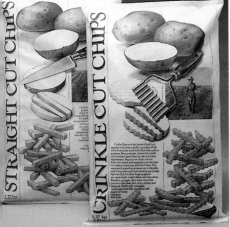

ARGYLL FOODS' CORDON BLEU
IS A RANGE OF FROZEN CUT
POTATO CHIPS.
**DESIGN FIRM,
MICHAEL PETERS LIMITED,
LONDON; ART DIRECTOR AND
DESIGNER, GLENN TUTSSEL;
ILLUSTRATOR,
BOB HABERFIELD.**

CORDON BLEU VEGETABLES
SHOW NATURAL INGREDIENTS
RIGHT ON THE PACKS.
**DESIGN FIRM,
MICHAEL PETERS LIMITED,
LONDON; ART DIRECTOR AND
DESIGNER, GLENN TUTSSEL;
ILLUSTRATOR,
BOB HABERFIELD.**

UNCLE DAVE'S KITCHEN
PASTA SAUCES AND KETCHUPS
INCLUDE ALL NATURAL
"VERMONT CUISINE" KETCHUP
ORIGINAL AND KICKIN', PLUS
SPICY PEANUT, TEX-MEX, SUN-
DRIED TOMATO BASIL PASTA
SAUCES. THE KETCHUP MUG IS
REUSEABLE AND ALL PRODUCT
JARS ARE RECYCLABLE. THE
ILLUSTRATION IS A CARICATURE
OF DAVE, THE OWNER.
**DESIGNER AND ILLUSTRATOR,
JIM CARSONS; DESIGNER,
DALE COYKENDALL FOR
UNCLE DAVE'S KITCHEN,
BONDVILLE, VERMONT.**

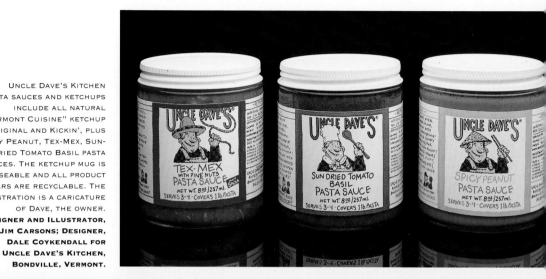

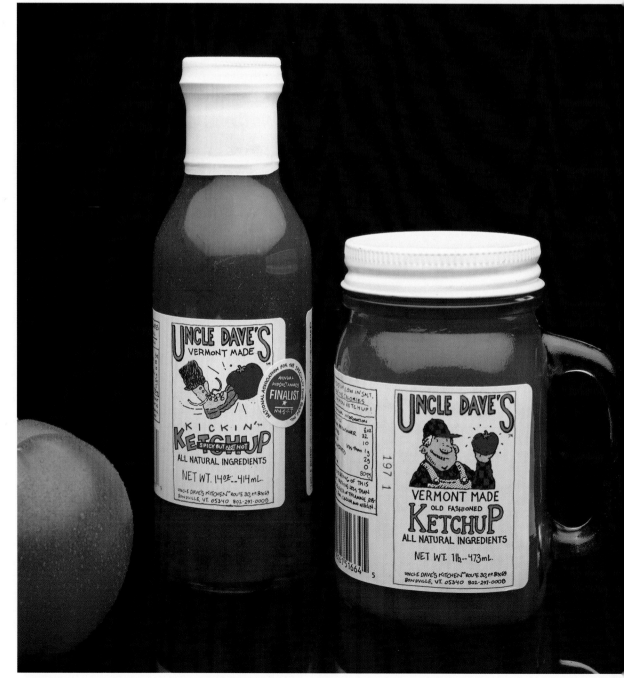

48

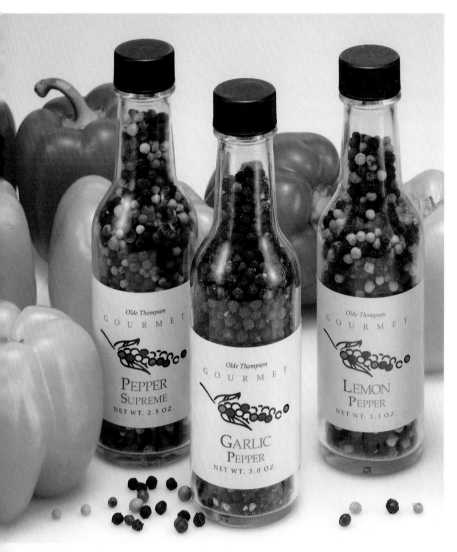

OLDE THOMPSON SALT AND
PEPPERCORN IS MARKETED AS
A GOURMET LINE OF FOOD
PRODUCTS.
DESIGN FIRM,
NICK LANE DESIGN,
MILL VALLEY, CALIFORNIA;
CREATIVE DIRECTOR,
NICK LANE; DESIGN
DIRECTOR, ANNE CHAMBERS;
PHOTOGRAPHER,
BRIAN LEATART.

PACKAGING FOR PECOS VALLEY
SPICE COMPANY'S DESIGNER
GOURMET CHILI KIT.
DESIGNED BY
JANE BUTEL, PECOS VALLEY
SPICE COMPANY, AND
MILTON GLASER,
MILTON GLASER, INC.,
NEW YORK, NEW YORK.

OPPOSITE PAGE
PACKAGING DESIGN FOR
CRANKS, LONDON
DESIGN FIRM
NEWELL AND SORRELL, LTD.
LONDON; CREATIVE
DIRECTORS, JOHN SORRELL
FRANCES NEWELL; DESIGNER
SARAH FRANKS; ILLUSTRATOR
EDWARD BAWDEN

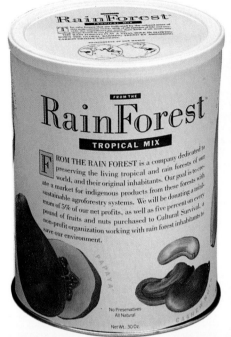
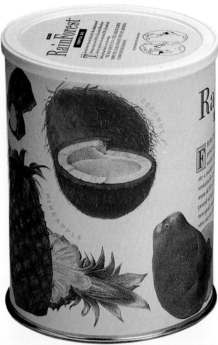

50

PACKAGING FOR FROM THE
RAIN FOREST, INC., NEW YORK,
NEW YORK. THE COMPANY IS
DEDICATED TO PRESERVING
TROPICAL AND RAIN FORESTS,
AND A PERCENT OF PROFITS
FROM FRUIT AND NUT SNACKS
GOES TO CULTURAL SURVIVAL,
A NON-PROFIT COMPANY
CREATING MARKETS FOR
PRODUCTS INDIGENOUS TO
THE RAIN FOREST.
DESIGN FIRM, PENTAGRAM,
NEW YORK, NEW YORK;
PARTNER AND DESIGNER,
PAULA SCHER.

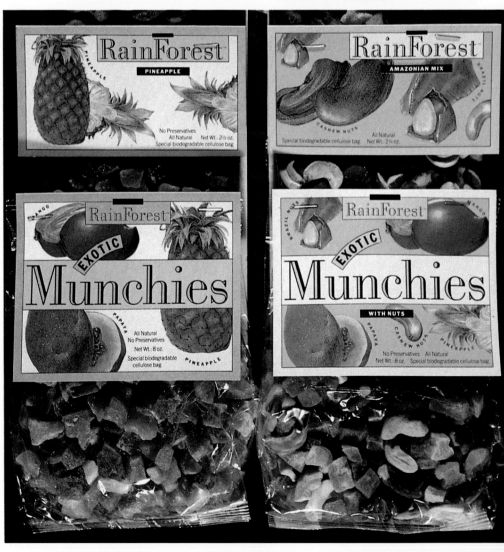

CRANKS
WHOLEFOODS
TRAIL MIX

CRANKS
WHOLEFOODS
RED LENTILS

CRANKS
WHOLEFOODS
ALMONDS

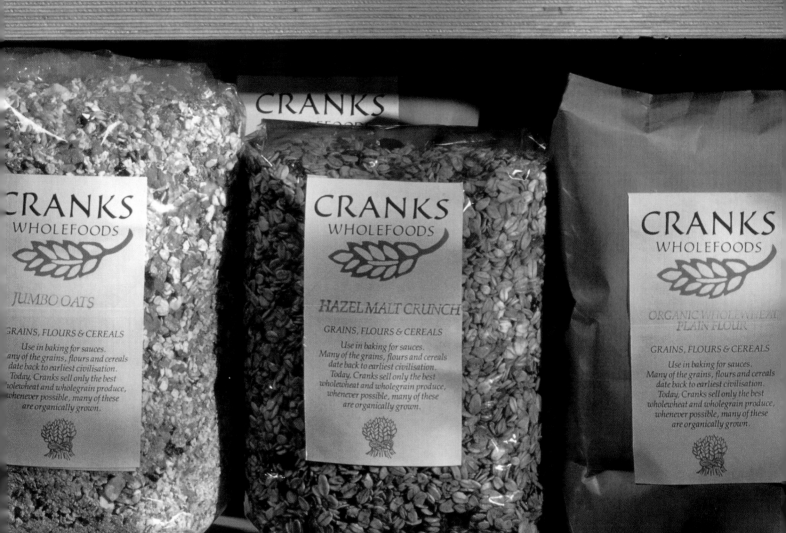

CRANKS
WHOLEFOODS
JUMBO OATS

GRAINS, FLOURS & CEREALS

Use in baking for sauces.
Many of the grains, flours and cereals
date back to earliest civilisation.
Today, Cranks sell only the best
wholewheat and wholegrain produce,
whenever possible, many of these
are organically grown.

CRANKS
WHOLEFOODS
HAZEL MALT CRUNCH

GRAINS, FLOURS & CEREALS

Use in baking for sauces.
Many of the grains, flours and cereals
date back to earliest civilisation.
Today, Cranks sell only the best
wholewheat and wholegrain produce,
whenever possible, many of these
are organically grown.

CRANKS
WHOLEFOODS
ORGANIC WHOLEWHEAT
PLAIN FLOUR

GRAINS, FLOURS & CEREALS

Use in baking for sauces.
Many of the grains, flours and cereals
date back to earliest civilisation.
Today, Cranks sell only the best
wholewheat and wholegrain produce,
whenever possible, many of these
are organically grown.

CRANKS

CRANKS
WHOLEFOODS
SAFARI MIX

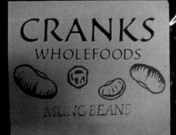

CRANKS
WHOLEFOODS
MUNG BEANS

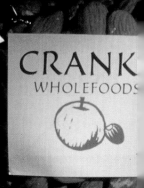

CRANK
WHOLEFOODS

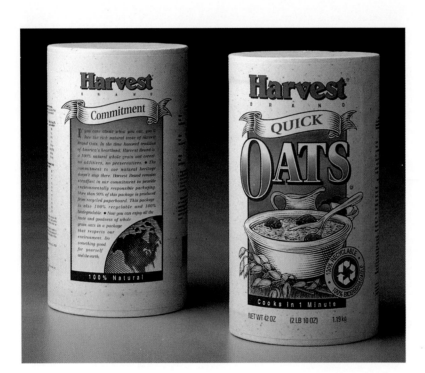

PACKAGING DESIGN FOR
HARVEST BRAND OATS.
RECYCLABLE, BIODEGRADABLE,
FIBER BOARD, RECYCLED PAPER
AND VEGETABLE SOY-BASED
INKS WERE USED. FRENCH
HAND-MADE TEXTURED PAPER
WAS 4 COLOR SCANNED, TINTED.
**DESIGN FIRM,
SWEITER DESIGN, DALLAS,
TEXAS; DESIGNERS,
JOHN SWEITER, JIM VOGEL,
PAUL MUNSTERMAN;
ILLUSTRATOR, CLINT HANSON.**

AUTUMN BOCK BEER LABEL
DESIGN FOR SCHIRF BREWING
COMPANY. THE SPECIAL BOCK
BEER IS BREWED IN THE FALL
AND DISTRIBUTED LOCALLY.
THE LABEL IS ECONOMICAL
AND SIMPLY GLUED ONTO A
STANDARD BOTTLE.
**DESIGN FIRM,
THE WELLER INSTITUTE FOR
THE CURE OF DESIGN, INC.,
PARK CITY, UTAH; ART
DIRECTOR, DESIGNER AND
ILLUSTRATOR, DON WELLER.**

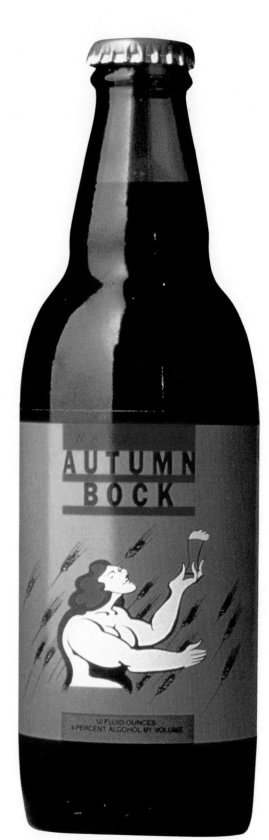

PACKAGING DESIGN OF
BLOOMINGDALE'S ULTIMATE
PRETZEL TIN, A PRIVATE LABEL
CHRISTMAS '89 ITEM FOR THE
FOOD DEPARTMENT.
**DESIGN FIRM,
ROBERT VALENTINE INC.,
NEW YORK, NEW YORK;
ART DIRECTOR AND DESIGNER,
ROBERT VALENTINE; DESIGNER
AND ILLUSTRATOR,
YOUNG KIM.**

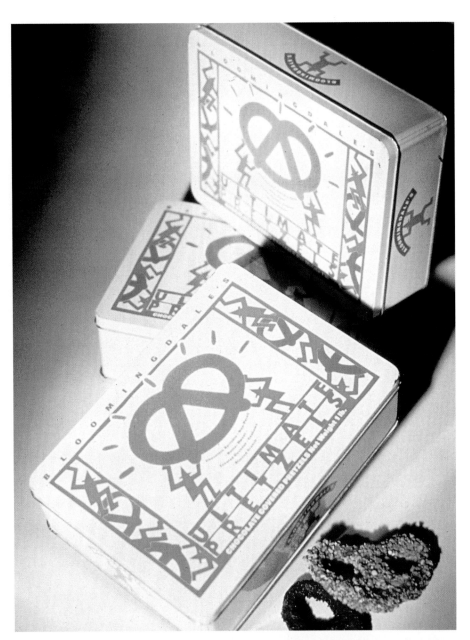

PACKAGE AND LABEL DESIGN
FOR BETTE'S DINER PANCAKE
AND SCONE MIXES. BETTE'S
DINER USES ONLY ALL
NATURAL, FRESH-MILLED
FLOUR PRODUCTS.
**DESIGNED BY
BETH WHYBROW LEEDS
FOR BETTE'S DINER,
BERKELEY, CALIFORNIA.**

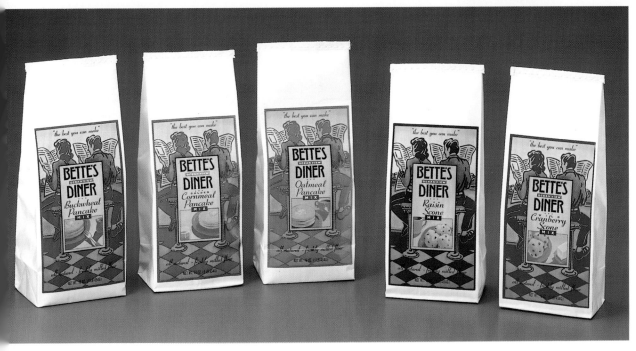

GRAPHIC PACKAGING AND
REDESIGN OF GALLO BRAND
PASTA, FOR COMERCIAL GALLO,
S.A.,BARCELONA, SPAIN.
**DESIGN FIRM,
LANDOR ASSOCIATES,
SAN FRANCISCO, CALIFORNIA;
DESIGNERS, ALISON SLOGA,
HEDLEY WESTERHOUT.**

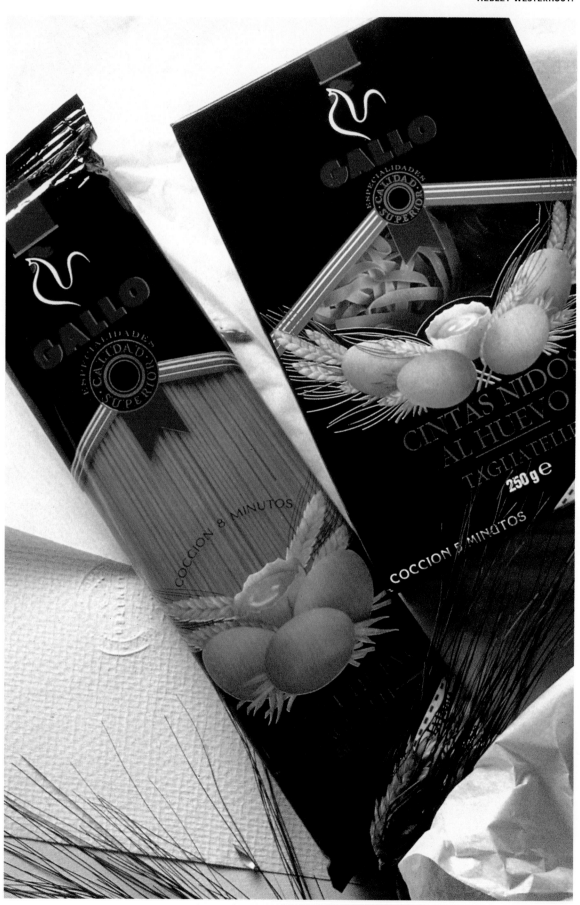

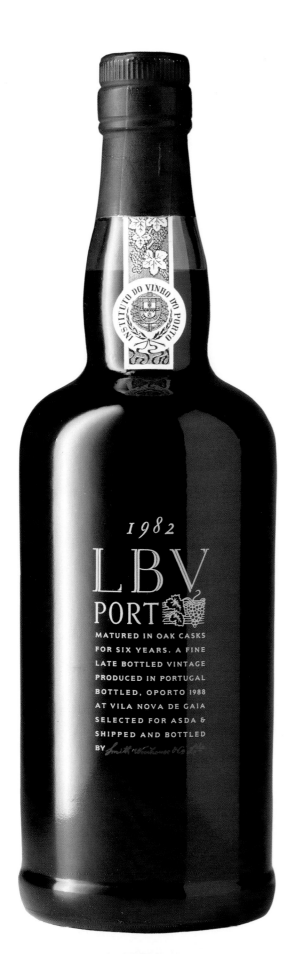

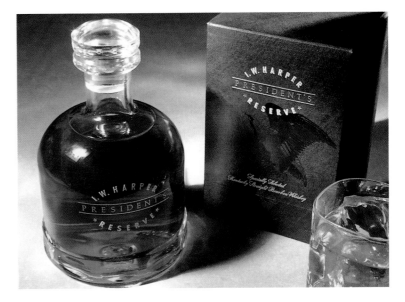

I.W. HARPER SPECIAL
DECANTER FOR SCHENLEY
INDUSTRIES, DALLAS, TEXAS.
THE BOTTLE DESIGN WAS
TARGETED TO THE JAPANESE
MARKET. STRONG GRAPHICS
COMMUNICATE AN AMERICAN
ORIGIN.
**DESIGN FIRM,
LANDOR ASSOCIATES,
SAN FRANCISCO, CALIFORNIA;
DESIGNERS, JOHN KIIL,
NICOLAS APARICIO.**

ASDA LBV PORT IS AN IN-
STORE LATE-BOTTLED VINTAGE.
THE USE OF BLACK, WHITE AND
RED TYPOGRAPHY BUILDS ON
CONVENTIONAL PORT VALUES.
THE GRAPHICS ARE SCREENED
DIRECTLY ONTO THE BOTTLE.
**DESIGN FIRM,
LEWIS MOBERLY, LONDON;
DESIGNER, ILLUSTRATOR AND
TYPOGRAPHER, MARY LEWIS;
ASDA DESIGN CONTROLLER,
JOHN SUGDEN.**

PRETIJS SNACK FOOD.
**DESIGN FIRM,
MILFORD-VAN DEN BERG
DESIGN, B.V., HOLLAND;
DESIGNER,
ROB VAN DEN BERG.**

ENGELSE DROP, ENGLISH
LICORICE CANDY IS A HIGH-
QUALITY PRODUCT MARKETED
TO THE DUTCH CONSUMER.
**DESIGN FIRM,
MILFORD-VAN DEN BERG
DESIGN B.V., HOLLAND;
CREATIVE DIRECTOR AND
DESIGNER, DANNY KLEIN.**

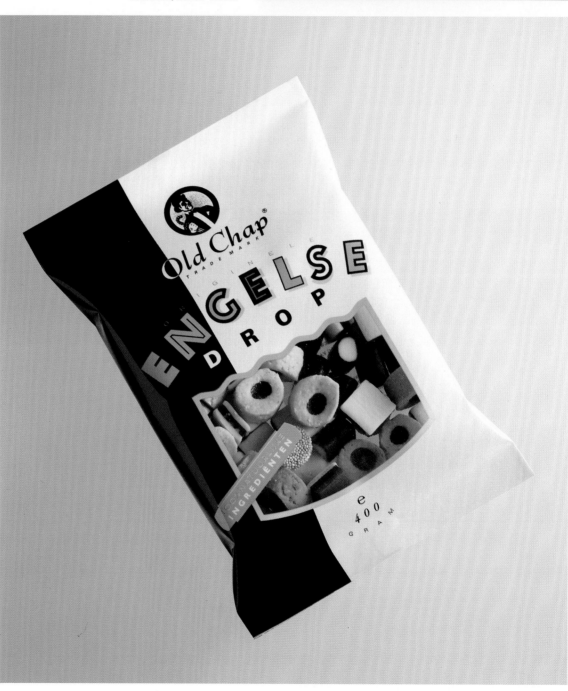

DESIGN OF PACKAGE AND
GO, FOR La CROIX SPARKLING
TER, La CROISE,
SCONSIN. THE NEW BOTTLE
D CAN ARE EXAMPLES OF
ST USE OF TRANSPARENT INK
ENDING SCREEN TINTS SOLID
CLEAR.
SIGN FIRM,
NY LANE/DESIGN COMPANY,
KLAND, CALIFORNIA;
SIGNER, TONY LANE.

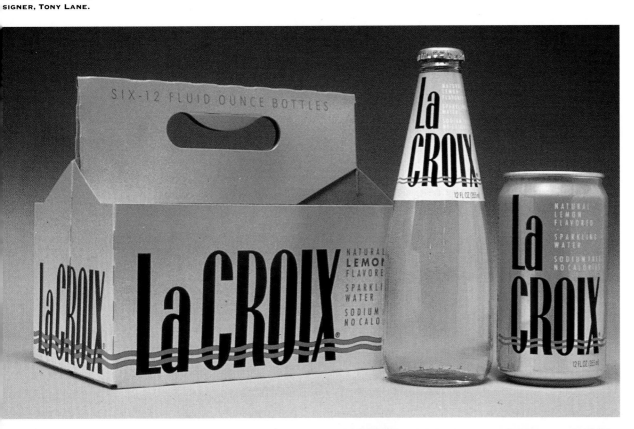

57

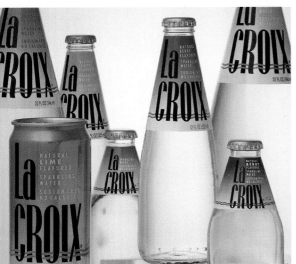

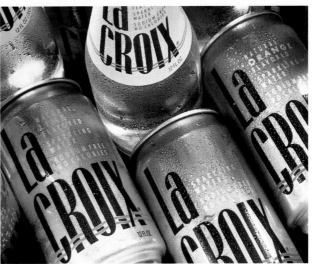

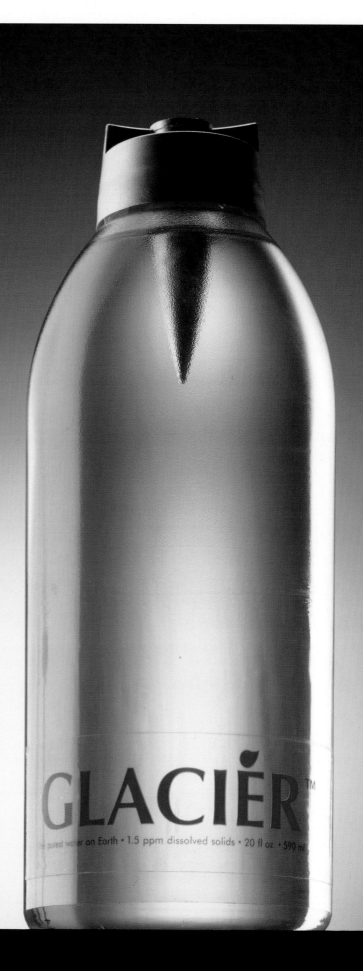

OPPOSITE PAGE:
BOTTLE AND LABEL DESIGN FOR
GLACIÉR BOTTLED WATER. THE
WATER HAS 1.5 PPM TOTAL
DISSOLVED SOLIDS AND IS
THE PUREST WATER ON EARTH.
DESIGNED BY
PHILIPPE STARCK.

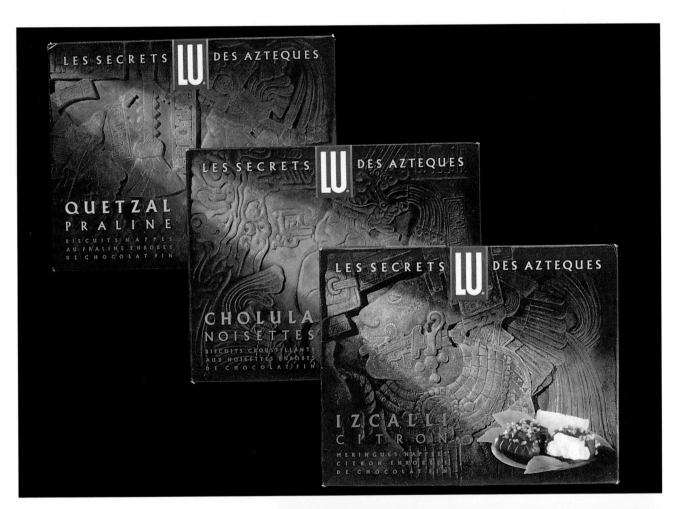

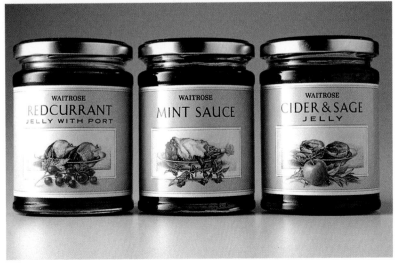

PACKAGING FOR LU BISCUITS
"SECRETS DES AZTEQUES."
DESIGN FIRM,
MICHAEL PETERS LIMITED,
LONDON; ART DIRECTOR AND
DESIGNER, SHERINE RAOUF.

WAITROSE RELISHES PACKAGE
DESIGN REFLECTS THE QUALITY
OF THE PRODUCT AND DEPICT
THE INGREDIENTS TOGETHER
WITH THE DISH THEY ARE
TRADITIONALLY SERVED WITH.
DESIGN FIRM,
LEWIS MOBERLY, LONDON;
ART DIRECTOR AND DESIGNER,
MARY LEWIS; ILLUSTRATOR,
WENDY BRETT; DESIGN
COORDINATOR,
DOUGLAS COOPER,
WAITROSE LTD.

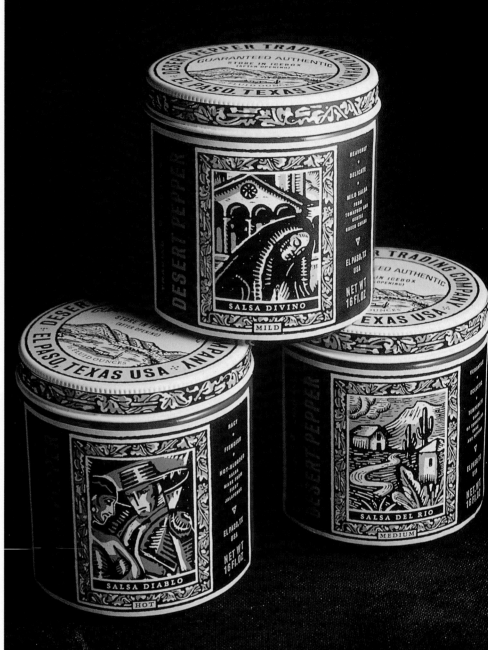

DESERT PEPPER LABEL
DESIGNS FOR EL PASO
CHILE COMPANY'S NEW LINE
OF SALSAS FEATURE MEXICAN
WOODCUTS.
**DESIGN FIRM,
CHARLES S. ANDERSON,
MINNEAPOLIS, MINNESOTA;
ART DIRECTORS
AND DESIGNERS,
CHARLES S. ANDERSON,
DANIEL OLSON;
ILLUSTRATORS,
RANDALL DAHLK,
CHARLES S. ANDERSON,
DANIEL OLSON.**

LABEL DESIGNS FOR THREE
EL PASO CHILE GOURMET
SALSA SAUCES: SNAKEBITE
(HOT), **DESIGN FIRM,
EMERY ADVERTISING,
EL PASO, TEXAS;
CREATIVE DIRECTOR
PARK KERR; DESIGNER,
HENRY MARTINEZ.**
SALSA PRIMERA (MILD), AND
CACTUS SALSA (MEDIUM),
**DESIGN FIRM,
OLD EL PASO IN HOUSE
DESIGN DEPARTMENT,
EL PASO TEXAS;
CREATIVE DIRECTOR
PARK KERR; DESIGNERS,
BECKY BUSHING, WESLEY KING.**

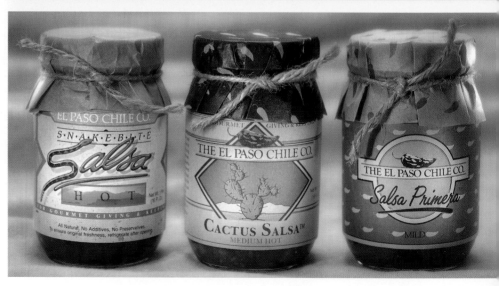

ACKAGE DESIGN FOR XEN
OSMIC CREAMS, A LICORICE-
LAVORED CORDIAL MARKETED
O BLACK WOMEN. BOTTLE IS
PECIALLY DESIGNED AND
OATED AND INCLUDES A DIE-
UT LABEL WITH ILLUSTRATION
ND HOLOGRAPHIC FOIL. FOR
N 'EXTRA-TERRESTRIAL
XPERIENCE.'
**ESIGN FIRM,
HE JANICE ASHBY DESIGN
ARTNERSHIP, WYNBERG,
OUTH AFRICA;
ESIGNER, JANICE ASHBY.**

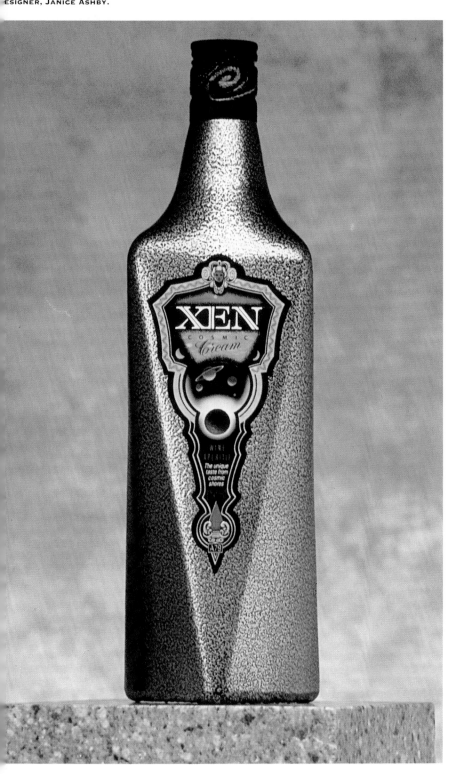

61

GRAND UNION BRAND JELLY,
PART OF A COMPREHENSIVE
PRIVATE LABEL PACKAGING
PROGRAM. RATHER THAN
CREATING AN OVERALL DESIGN
SYSTEM FOR ALL GRAND UNION
PRODUCTS, EACH FOOD
CATEGORY IS TREATED
INDIVIDUALLY.
**DESIGN FIRM,
MILTON GLASER, INC.,
NEW YORK, NEW YORK;
ART DIRECTORS,
MILTON GLASER,
DAVID FREEDMAN;
DESIGNER, MARC ROSENTHAL;
PHOTOGRAPHER,
MATTHEW KLEIN.**

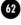

62

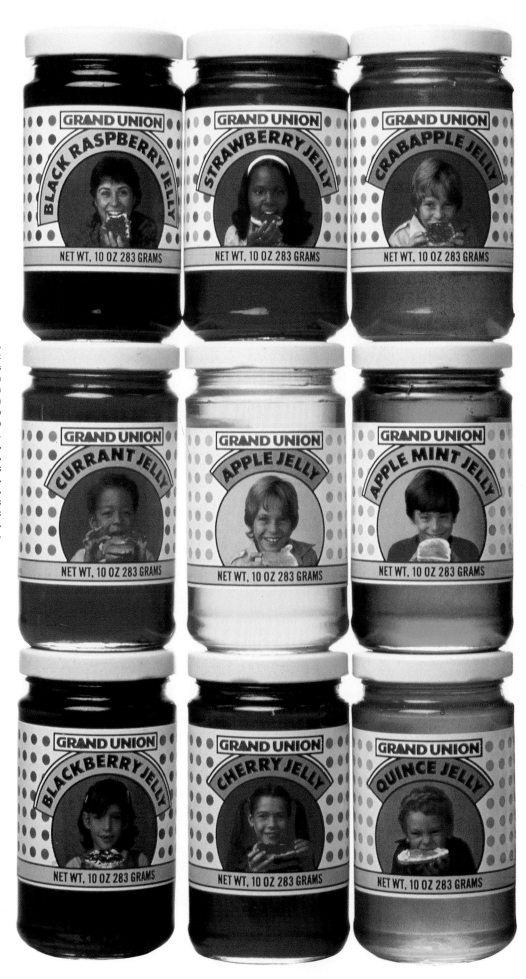

LIMMITS ARE COMPLETE MEALS
IN BISCUIT FORM FOR DIET-
CONSCIOUS CONSUMERS.
**DESIGN FIRM,
LEWIS MOBERLY, LONDON;
ART DIRECTOR, MARY LEWIS;
DESIGNERS, JIMMY YANG,
MARY LEWIS; PHOTOGRAPHER,
ROBIN BROADBENT.**

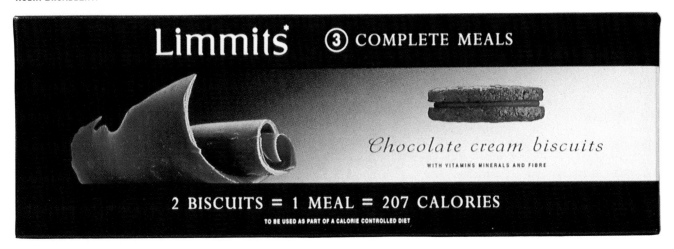

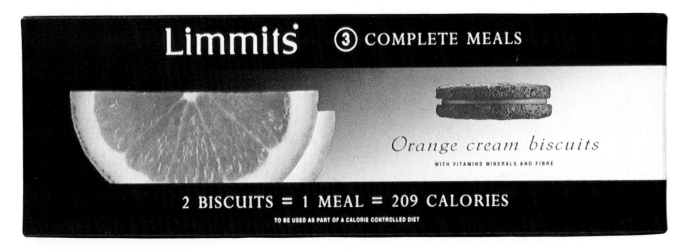

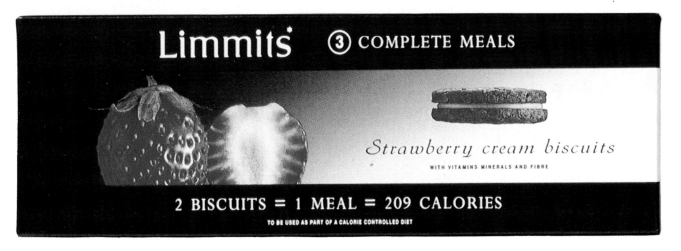

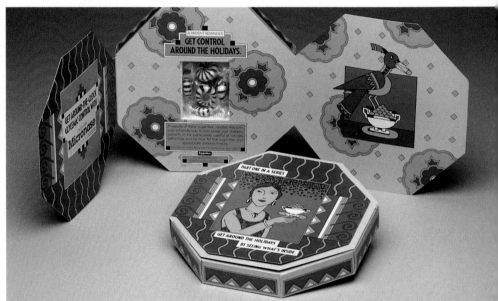

ABOVE:
SAMMONTANA GELATI
ALL'ITALIANA, ITALY'S
SECOND LARGEST ICE
CREAM MANUFACTURER.
**DESIGN FIRM,
MILTON GLASER, INC.,
NEW YORK, NEW YORK;
DESIGNERS, MILTON GLASER,
MARC ROSENTHAL;
ILLUSTRATOR,
MARC ROSENTHAL.**

PROMOTIONAL PACKAGING
FOR MICRONASE, AN ANTI-
DIABETIC CANDY MARKETED
TO PHYSICIANS, INCLUDED A BOX
OF THE CANDY.
**DESIGN FIRM,
THE PUSHPIN GROUP,
NEW YORK, NEW YORK;
ART DIRECTOR, JIM BURTON;
DESIGNER AND ILLUSTRATOR,
SEYMOUR CHWAST.**

CONTAINER DESIGN FOR LINE
OF CYRCK ICE CREAMS AND
SORBETS. THE PACKAGE IS
REUSEABLE PLASTIC, PRINTED
IN SIX COLORS.
**DESIGN FIRM,
THE PUSHPIN GROUP,
NEW YORK, NEW YORK;
DESIGNER AND ILLUSTRATOR,
SEYMOUR CHWAST.**

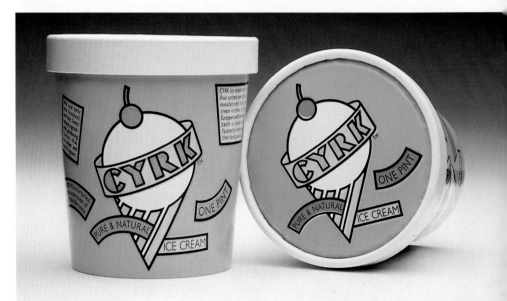

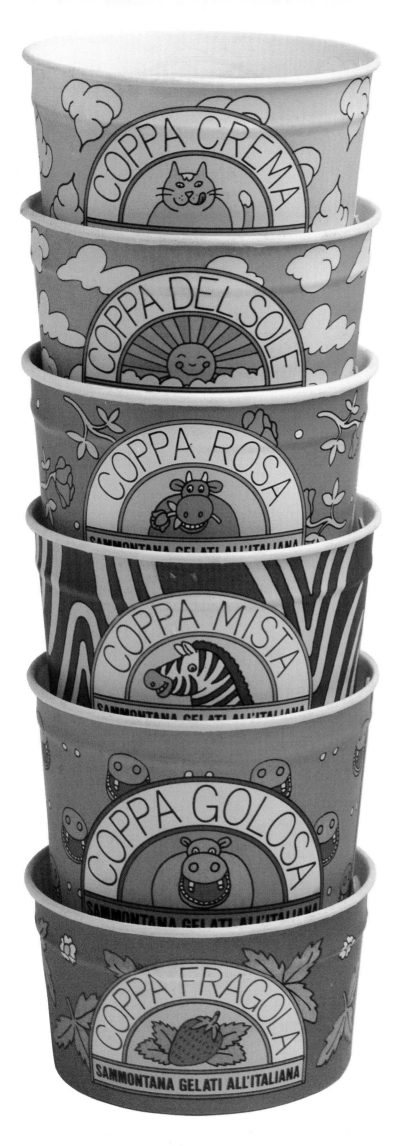

COPPA CREMA

COPPA DEL SOLE

COPPA ROSA
SAMMONTANA GELATI ALL'ITALIANA

COPPA MISTA
SAMMONTANA GELATI ALL'ITALIANA

COPPA GOLOSA
SAMMONTANA GELATI ALL'ITALIANA

COPPA FRAGOLA
SAMMONTANA GELATI ALL'ITALIANA

CUP PACKAGING FOR
SAMMONTANA
GELATI ALL'ITALIANA.
DESIGN FIRM,
MILTON GLASER, INC.
NEW YORK, NEW YORK;
DESIGNERS, MILTON GLASER,
MARC ROSENTHAL;
ILLUSTRATOR,
MARC ROSENTHAL.

BEN & JERRY'S LIGHT IS A
NEW LINE BASED ON THE
ORIGINAL PACKAGE.
**DESIGNED BY
LYN SEVERANCE OF
BEN & JERRY'S,
NORTH MORETOWN, VERMONT.**

JIVE IS A NEW KIND OF ICE
CREAM PRODUCT BASED ON
YOGURT. IT IS SOLD TO THE
DUTCH CONSUMER MARKET.
**DESIGN FIRM,
MILFORD-VAN DEN BERG
DESIGN B.V., HOLLAND;
CREATIVE DIRECTOR AND
DESIGNER, DANNY KLEIN;
DESIGNER, HANS REISINGER;
ILLUSTRATOR,
RAYMOND LOBATO.**

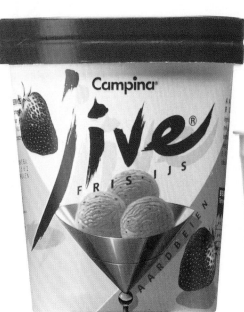
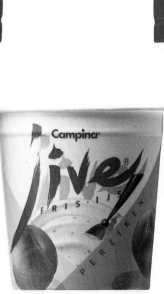
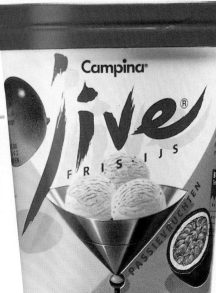

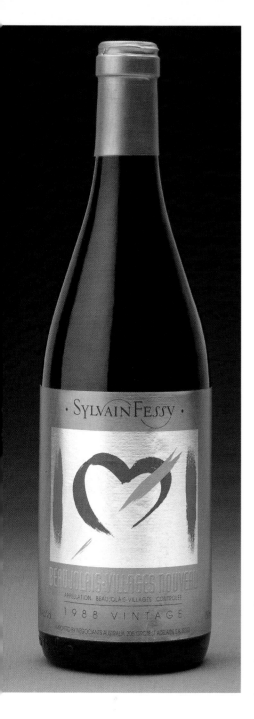

Package design for Sylvain Fessy Beaujolais Nouveau, an French wine for international distribution. **Design Firm, Barrie Tucker Design Pty, Ltd., Eastwood, Australia; Art Director, Designer, Illustrator, Typographer, Barrie Tucker; Finished Art, Elizabeth Schlooz.**

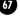

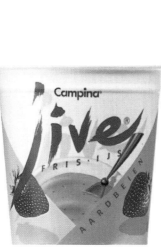

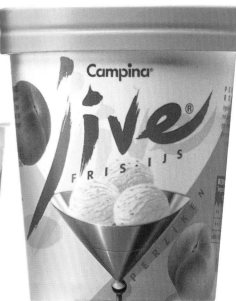

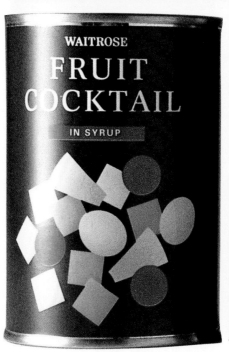

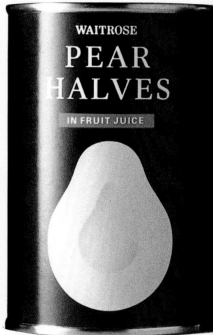

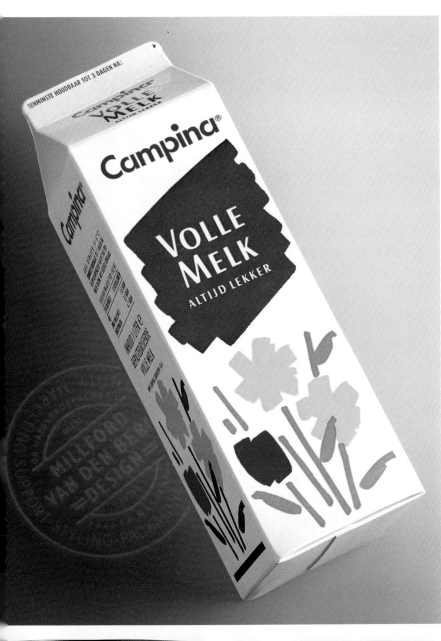

THE DESIGN OF DAILY FRESH
DAIRY PRODUCTS WAS
RESEARCHED USING GESTALT
PSYCHOLOGY. NON-PVC
MATERIALS WERE USED.
DESIGN FIRM,
MILFORD-VAN DEN BERG
DESIGN, B.V.,HOLLAND;
DESIGNER,
ROB VAN DEN BERG.

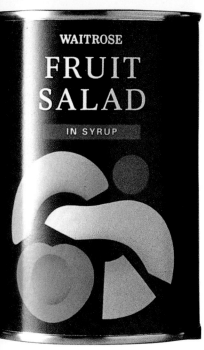

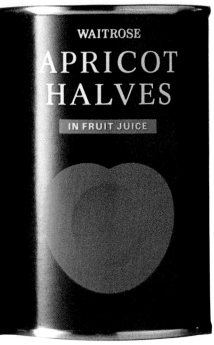

THE DESIGN SOLUTION FOR
WAITROSE CANNED FRUITS
HELPS SIMPLIFY CONSUMER
SELECTION BY CREATING
SYMBOLIC IMAGES AND
USING CLEAR CODING OF
FRUIT AND SYRUP JUICES.
DESIGN FIRM,
LEWIS MOBERLY, LONDON;
ART DIRECTOR, MARY LEWIS;
DESIGNERS, KARIN DUNBAR,
MARY LEWIS, ANN MARSHALL,
JOANNE SMITH;
ILLUSTRATORS,
JOANNE SMITH,
KARIN DUNBAR; WAITROSE
LTD. DESIGN COORDINATOR,
DOUGLAS COOPER.

ZOLO IS A SET OF SCULPTURE TOYS. ZOLO 1 AND 2 ARE PACKAGED DIFFERENTLY. ZOLO1 IS IN ITS OWN NATURAL UNFINISHED WOOD, REUSABLE BOX. ZOLO 2 WAS PACKAGED TO SELL FOR A LOWER PRICE TO A BROADER AUDIENCE. IT HAS A SELECTED NUMBER OF PIECES THAT ARE INCLUDED IN ITS CARDBOARD CONTAINER (SEE PAGES 72, 73).

THE CHILD WITHIN

Sandra Higashi and Byron Glaser are two young graphic designers who shifted their focus from the client-focused world of graphic design to design their own toys.

How did you approach the packaging of Zolo™?

When we worked with clients we always approached packaging before to be marketing driven. So packaging has been an evolution for us. Zolo was our very first product. Our own. And we wanted it to be more esoteric, we wanted people to be curious about it. So we put no selling copy on the package. We also wanted to have people display the toy itself. Our lawyer put together a focus group and the results showed that the packaging didn't have enough selling copy on it. But we stood by our guns. And for the sophisticated gift and museum shop market Zolo ended up in, we were right.

There were a few buyers with smaller shops and no display area who criticized that you couldn't "get it" from the pack-aging. So in Zolo 2™, you can see we used photographs instead of flat, abstract illustrations of the pieces and we included pieces from Zolo on the outside of the box. In Cubizm™, we actually made the game become the packag-ing. With Kooky Cutters™, it was natural to use a tin. We also included a lot of information on the top.

What has been your source of inspiration?

In Zolo, nature provided many of the shapes; natural forms, natural materials like wood. In Cubizm there is no right solution to the puzzle. In Kooky Cutters, we used art as the inspiration for the shapes. To become artists. The basis of both is that the abstractions allow it to be many things to many people.

Why did you start to design toys?

We were disappointed by toy stores and what's available for kids today to play with. There was definitely room for other things. We were trying to figure out what would really inspire children to be creative. Of course, once we created Zolo, we realized we were part of the audience as well.

If you talk to toy manufacturers, you'll find that they all have toys very pidgeon-holed. We were told that no one would be interested in Zolo because it didn't fit in any category. Girls, 3-5 years of age; boys, 10-13, etc. We were told that it's the

law according to Hasbro and other manufacturers. We'd gone outside the structure. We are going for the biggest audience. We don't have an age group. They wouldn't know where to put us in the store. Of course, they were wrong and Zolo has sold millions of dollars in retail sales. We carved a lucrative niche in the upscale market. And, as we expected, Zolo was received enthusiastically by all ages, in all walks of life.

We put reply cards into every Zolo and people return them to us. They come from all over. Toddlers to elderly people. Parents say that their baby's attention span is greater with Zolo than other toys. But our favorite reply card came from a woman who has arthritis who plays with Zolo every day because it makes her feel creative and is good for her arthritis.

On our reply cards, we ask people to fill in their three wishes. I'd say they're mostly the same—to stop world hunger, for world peace. That's the kind of person who's attracted to Zolo. The cards prove to us that we're right. We grant all their wishes, of course. No problem.

What restrictions do you have because you're creating toys for kids?

A large part of the problem with a lot of manufacturers is that they won't take risks. They're all worried about stick-ing their necks out. So they won't introduce truly innovative products. There's not enough room for an alternative. In manufacturing toys in general, a lot of it is about image and packaging. Take Ninja Turtles®. The dolls, the film, the costumes. It's character licensing. Little Pretty Pony®, Garfield®, Where's Waldo?®—it's all formula marketing. The wrong people are making the decisions.

Sandra Higashi + Byron Gl
Higashi Glaser De

THE GESTALT OF DESIGN

...ailey, is co-owner with Laurie Eichengreen of ...Mythology, a store on the upper west side of New ...k City. Mythology sells toys for children from ages ...e to ninety, is frequented by many designers.

...ur store is a paradise for designers. How do you ...cide what to sell in your shop?
...e design of the product is not the primary reason we ...ose to add it to our collection. And we do see the store ...a collection. We offer a very graphic and filtered presen-...ion of what's going on in the world through the collective ...conscious imagery in Mythology. It's all image. We don't ...lly care if the product is manmade, machine made, a ...ique item or if there are millions of them in the world ...eady. We don't care if it's functional or has a purpose ...f it even works, for that matter. Does the product have ...phic strength which makes the image speak to us? Does ...nake you vibrate? Does design create the mystery, the ...gic, the sensibility, the impact?

...hen does a package design help? When does it ...der?
...en the package is a plus, an extra, an add on, it helps. ...ique toys for instance, look better when you put both ...and package together. Each gives the other a boost. The ...ue is greater. Often the toy inside looks nothing like the ...ckage, but it's an interpretation of what's inside—which ...ven better. Together, it makes a double whammy.

...import laws have changed, however. We've noticed that ...Japanese and Chinese require their packaging to show ...l photography instead of illustration. But the photogra-...y is really ugly so we can't display the boxes anymore. ...awful.

...en Katsu Kimura, the wonderful Japanese package ...igner, had a show in New York a few years ago, we ...ually bought many of the packages from the show and ...d them. They went for anywhere between $10-70 per ...x. With nothing in it. People, especially designers, love to ...ect them because they're so unusual. Of course, there ...s the book out on Katsu Kimura and that helped build ...dibility.

...netimes we actually snip the header off the packaging if ...offensively designed.

We don't influence the package design. Sometimes some-one comes in with a package and when we don't really like it they ask what they should do to change it. We don't do that. It has to be a reflection of their personal expression; a reflection of what's happening in the world.

Often the packaging is so much a part of the product that you can't separate the two, which of course is pretty ideal if both packaging and product are wonderfully designed.

We can display anything in the store next to anything else. Each has its own dynamic. We have the work of fine artists, folk artists, graphic designers. The design is usually anony-mous. So it blurs all the edges. It's not such an ego state-ment of its creator that way. People are shocked some-times. A piece that costs $3,000 is sitting right next to one for $2.98. This shocks people. I think that's good.

We think of the store as being a three-dimensional collage. Everything has to function on its own terms. If the packag-ing doesn't work, and the product can't be displayed with-out its packaging, we would reject the product.

What about the Collective Unconscious?
Usually in package design we're talking of an anonymous artist working to make a graphic statement of communication. How can he communicate to his fellow man the essence and wonder of this product? Look at the orange crate label art created around the turn of the century in California. For the most part, they are wonderful graphic statements of things we care about and know—a cat, a cow girl, an orange. We get a strong jolt of what that thing is about through that artist's interpretation.

Certain package designs lose some of their spir-it if they're too sophisticated. Do you agree?
That's true. We forgive a lot when a package has soul but lacks sophistication. And sometimes we don't care because the lack of sophistication actually makes it a better package anyhow.

Baily & Laurie Eichengreen, co-owners Mythology

EACH VOO DOO KIT IS HANDMADE (A MARKER TAKES THE PLACE OF USING PRINTING INKS) BY A MAN IN NEW ORLEANS. MYTHOLOGY CUSTOMERS CLAIM IT HAS REAL POWERS AND SO THIS PRODUCT HAS BECOME VERY POPULAR IN NEW YORK.

It's Later Than You Think
VOODOO Kit
From Ole New Orleans
Why Can't I Sleep?
By Ora Baer

BELOW:
ZOLO™ PLAY SCULPTURE TOYS
ARE COMPRISED OF **55** HAND-
CARVED AND HANDPAINTED
WOODEN PIECES THAT CAN
BE COMBINED IN AN
INFINITE VARIETY OF WAYS.
OPPOSITE PAGE:
ZOLO 2™ TOY DESIGNS
CAN BE ADDED TO THE
ORIGINAL ZOLO. PACKAGING
DESIGN INCORPORATES
RECYCLABLE AND REUSABLE
MATERIALS.
**DESIGN FIRM,
HIGASHI GLASER DESIGN,
FREDERICKSBERG, VIRGINIA;
DESIGNERS, BYRON GLASER,
SANDRA HIGASHI;
PHOTOGRAPHER,
DON CHIAPPINELLI.**

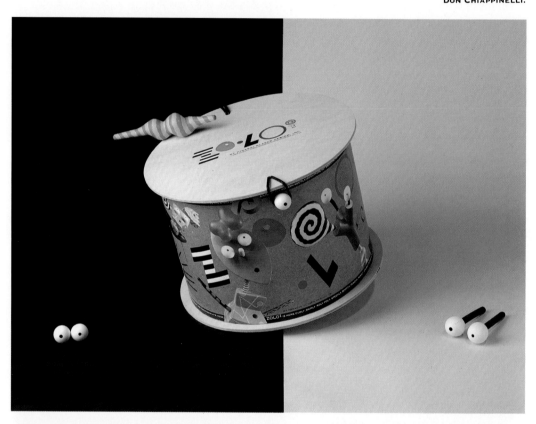

KOOKY CUTTERS™ IS A SET OF
EIGHT ABSTRACT-SHAPED METAL
SCULPTING FORMS THAT ARE
PACKAGED IN A REUSABLE TIN.
INCLUDED ARE RECIPES AND
DECORATING TIPS PRINTED ON
TRANSPARENT DOILIES.
**DESIGN FIRM,
HIGASHI GLASER DESIGN,
FREDERICKSBERG, VIRGINIA;
DESIGNERS, BYRON GLASER,
SANDRA HIGASHI.**

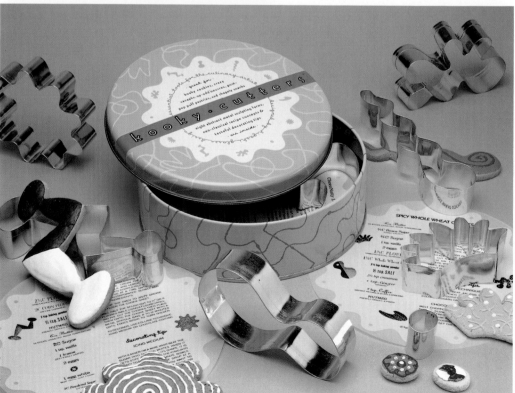

ZO·LO©
BY HIGASHI GLASER DESIGN

© 1997 ZOLO, INC. ALL RIGHTS RESERVED. ZOLO™ IS A TRADEMARK OF ZOLO, INC. NEW YORK, NY

ZOLO™ LURKING WITHIN THIS
BOX ARE MORE THAN 50 TWISTY,
TWIRLY, SQUIGGLY, WIGGLY,
KNOBBY, BLOBBY AND POLKA-
DOTTY HANDMADE WOODEN
PIECES WAITING TO BE PUT
TOGETHER. JUST RELEASE YOUR
IMAGINATION, AND ZOLO™ WILL
GO WILD.
 ZOLO™ CAN BE A WIGGLY
TREE, A WOBBLY SCULPTURE, A
KOOKY DOG, A SPOOKY MONSTER,
A FRIENDLY PLACE OR A SHARLY
FACE. ZOLO™ CAN BE WEIRD OR
FUNNY OR SCARY. ZOLO™ CAN BE
ANYTHING YOU WANT IT TO BE.
 JUST OPEN YOUR MIND,
FEEL FROM YOUR HEART AND
DISCOVER THE SECRET OF ZOLO™

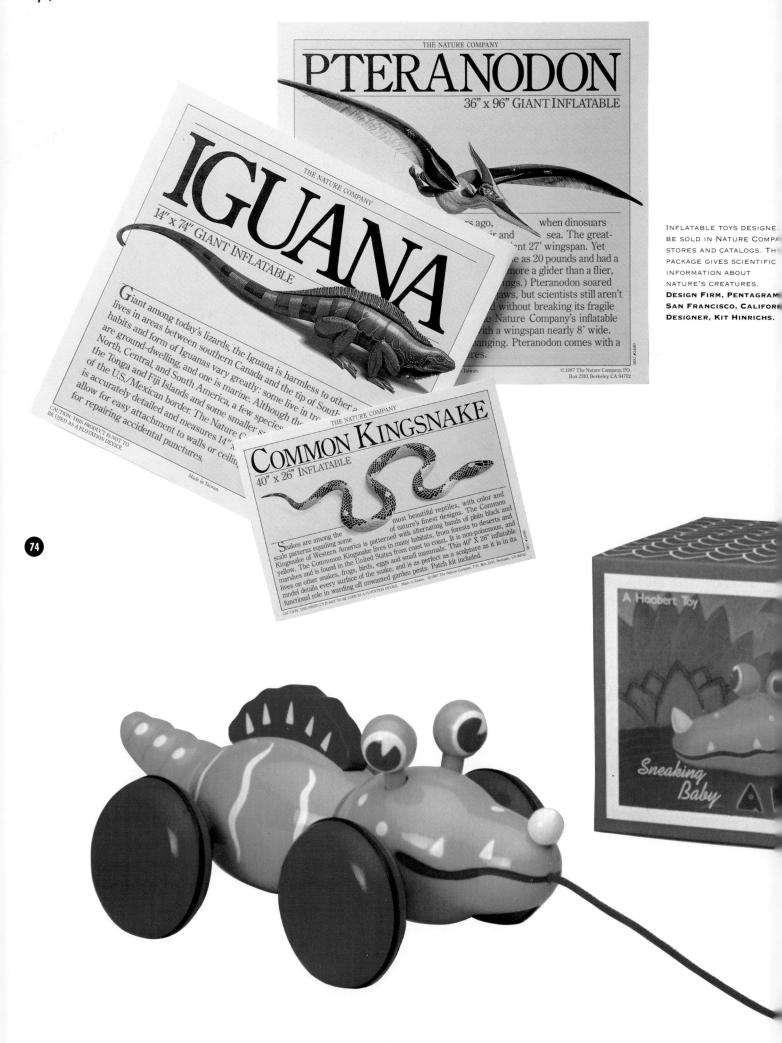

PTERANODON
36" x 96" GIANT INFLATABLE
THE NATURE COMPANY

...rs ago, ... when dinosuars ...ir and ... sea. The great-...nt 27' wingspan. Yet ...e as 20 pounds and had a ...more a glider than a flier, ...ngs.) Pteranodon soared ...aws, but scientists still aren't ...d without breaking its fragile ...e Nature Company's inflatable ...ith a wingspan nearly 8' wide. ...nanging. Pteranodon comes with a ...res.

...Taiwan. ©1987 The Nature Company, P.O. Box 2310, Berkeley, CA 94702

IGUANA
14" x 74" GIANT INFLATABLE
THE NATURE COMPANY

Giant among today's lizards, the Iguana is harmless to other a... lives in areas between southern Canada and the tip of South... habits and form of Iguanas vary greatly: some live in tre... are ground-dwelling, and one is marine. Although th... North, Central, and South America, a few species... the Tonga and Fiji Islands and some smaller s... of the U.S./Mexican border. The Nature C... is accurately detailed and measures 14" x... allow for easy attachment to walls or ceilin... for repairing accidental punctures.

CAUTION: THIS PRODUCT IS NOT TO BE USED AS A FLOTATION DEVICE.

Made in Taiwan.

COMMON KINGSNAKE
40" x 26" INFLATABLE
THE NATURE COMPANY

Snakes are among the most beautiful reptiles, with color and scale patterns equaling some of nature's finest designs. The Common Kingsnake of Western America is patterned with alternating bands of plain black and yellow. The Commmon Kingsnake lives in many habitats, from forests to deserts and marshes and is found in the United States from coast to coast. It is non-poisonous, and lives on other snakes, frogs, birds, eggs and small mammals. This 40" X 26" inflatable model details every surface of the snake, and is as perfect as a sculpture as it is in its functional role in warding off unwanted garden pests. Patch kit included.

CAUTION: THIS PRODUCT IS NOT TO BE USED AS A FLOTATION DEVICE. Made in Taiwan. ©1987 The Nature Company, P.O. Box 2310, Berkeley, CA 94702

INFLATABLE TOYS DESIGNE... BE SOLD IN NATURE COMPA... STORES AND CATALOGS. TH... PACKAGE GIVES SCIENTIFIC INFORMATION ABOUT NATURE'S CREATURES.
DESIGN FIRM, PENTAGRAM... SAN FRANCISCO, CALIFOR... DESIGNER, KIT HINRICHS.

A Hopbert Toy

Sneaking Baby

A SERIES OF THREE
EDUCATIONAL SOFTWARE
PACKAGES FOR THE MACINTOSH
PRODUCED BY SENSEI TO TEACH
MATHEMATICS.
**DESIGN FIRM, WOODS + WOODS,
SAN FRANCISCO, CALIFORNIA;
ART DIRECTOR, ALISON WOODS;
DESIGNERS, ALISON WOODS,
PAUL WOODS.**

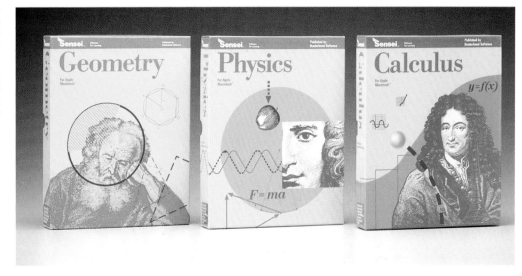

PACKAGING SYSTEM FOR
HOOBERT TOYS. THIS LINE OF
BOXES WITH AFFIXED LABELS IS
SOLD IN SOPHISTICATED GIFT
AND TOY SHOPS.
**DESIGNED AND ILLUSTRATED BY
DAVID KIRK AND SUSAN KIRK
OF HOOBERT TOYS,
KING FERRY, NEW YORK.**

76

PACKAGE DESIGN OF HOOBERT
WOODEN PULL TOYS AND PLAY
SETS. PRINTED FOUR-COLOR
LABELS ARE GLUED TO PRINTED
ONE-COLOR BOXES.
**DESIGNED BY, DAVID KIRK AND
SUSAN KIRK OF HOOBERT
TOYS, KING FERRY, NEW YORK;
ILLUSTRATION, DAVID KIRK.**

OPPOSITE PAGE:
PACKAGING SYSTEM FOR THE
JACK RUBIES' NEW WORK, "SEE
THE MONEY IN MY SMILE,"
INCLUDES CD, ALBUM, POSTER,
ADS, T-SHIRTS, AND POSTCARDS.
**DESIGN FIRM,
MOLLY LEACH DESIGN,
NEW YORK, NEW YORK;
DESIGNER, MOLLY LEACH;
PHOTOGRAPHER,
PHIL NICHOLLS;
ILLUSTRATOR, MOLLY LEACH;
STILL PHOTOGRAPHER,
BRADFORD WALKER EVANS
HITZ; ANTIQUE TOY,
COLLECTION OF MILLIE SMITH.**

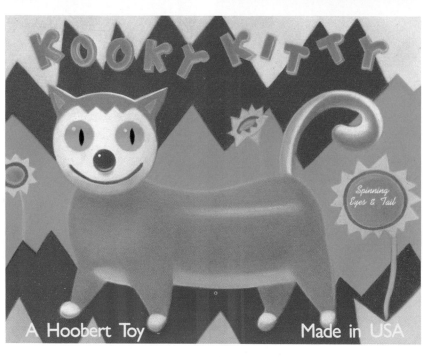

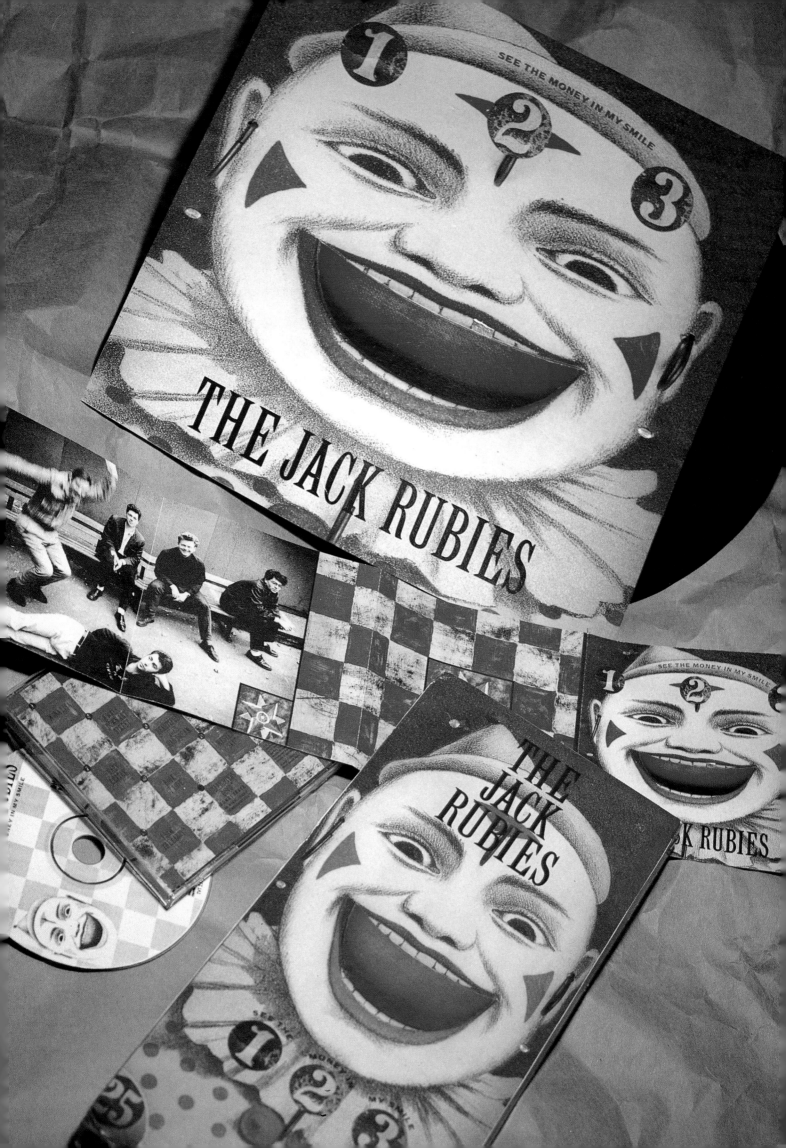

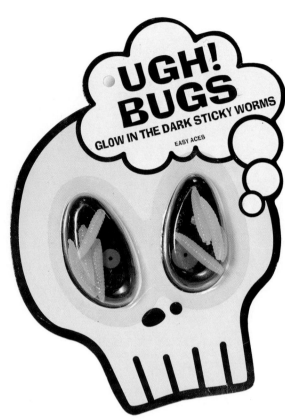

UGH! BUGS
GLOW IN THE DARK STICKY WORMS
EASY ACES

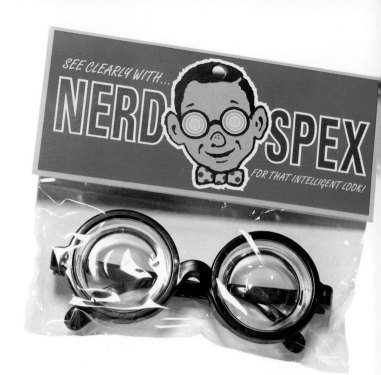

SEE CLEARLY WITH...
NERD SPEX
FOR THAT INTELLIGENT LOOK!

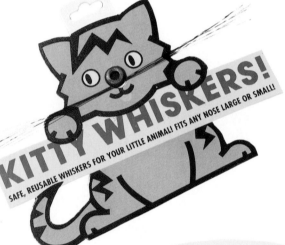

KITTY WHISKERS!
SAFE, REUSABLE WHISKERS FOR YOUR LITTLE ANIMAL! FITS ANY NOSE LARGE OR SMALL!

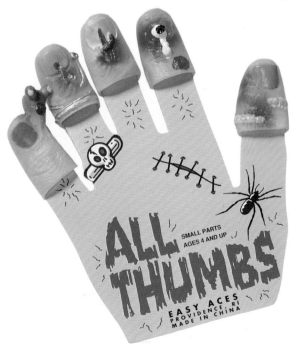

ALL THUMBS
SMALL PARTS
AGES 4 AND UP
EASY ACES
PROVIDENCE, RI
MADE IN CHINA

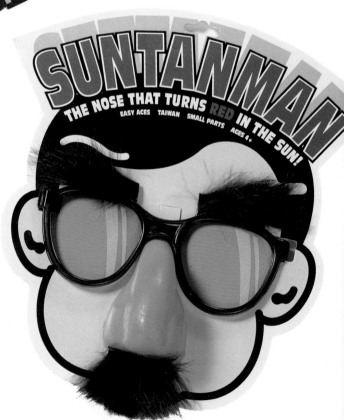

SUNTANMAN
THE NOSE THAT TURNS RED IN THE SUN!
EASY ACES TAIWAN SMALL PARTS AGES 4+

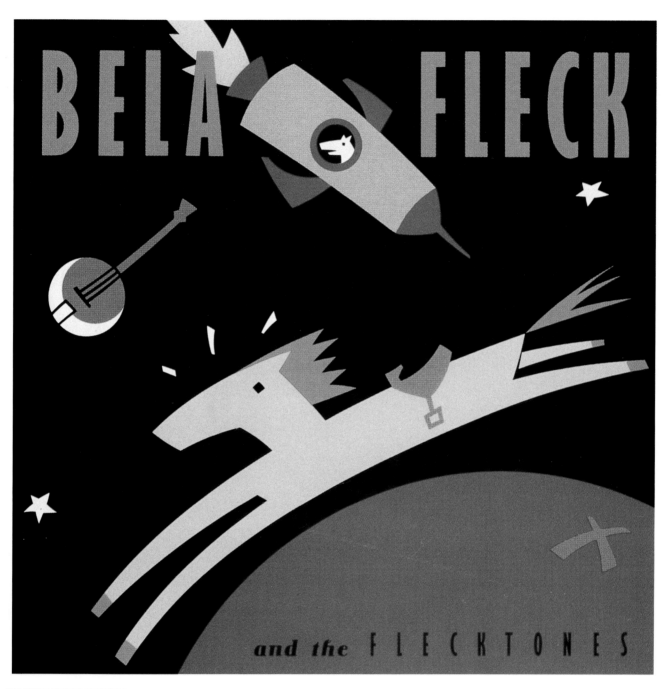

CD COVER DESIGN FOR BELA
FLECK AND THE FLECKTONES
"FLIGHT OF THE COSMIC
HIPPO".
**DESIGN BY
WARNER BROS./REPRISE
RECORDS, NASHVILLE,
TENNESSEE; ART DIRECTOR,
LAURA LIPUMA-NASH;
DESIGNER AND ILLUSTRATOR,
MARK FOX/BLACKDOG.**

OPPOSITE PAGE:
PACKAGE DESIGNS FOR NERD
SPEX, ALL THUMBS, KITTY
WHISKERS, UGH! BUGS, AND
SUNTAN MAN NOVELTIES.
**DESIGNED BY
MARY E. HERMANSEN,
MARY E. ROSES, BILL LANE OF
EASY ACES, INC., PROVIDENCE,
RHODE ISLAND.**

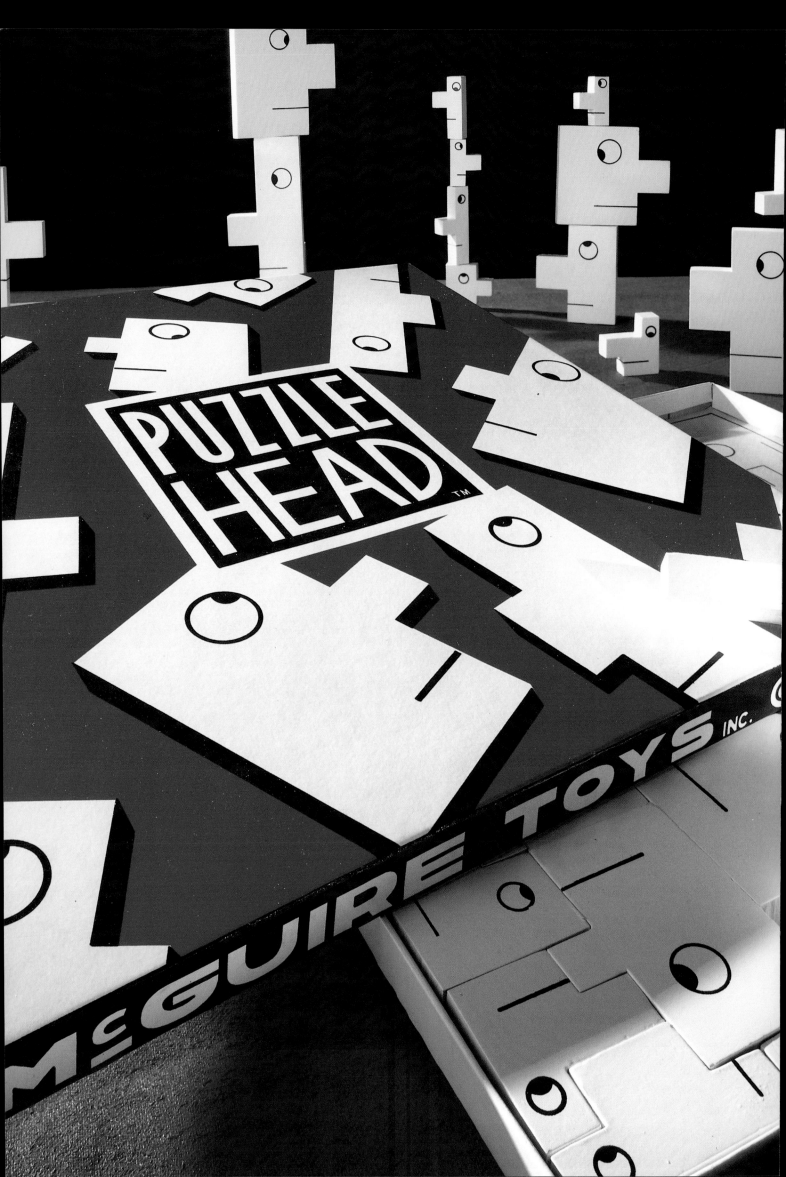

OPPOSITE PAGE:
PUZZLE HEAD WOOD PUZZLE
COMES WITH 36 SIMILAR,
YET DIFFERENT SHAPED
BLOCKHEADS.
DESIGNED BY
RICHARD MCGUIRE,
MCGUIRE TOYS,
NEW YORK, NEW YORK.

GO FISH CARD GAME IS BASED
ON THE ORIGINAL "GO FISH";
THE GAME BOX IS DESIGNED TO
RESEMBLE A SARDINE CAN.
DESIGNED BY RICHARD MCGUIRE,
MCGUIRE TOYS,
NEW YORK, NEW YORK.

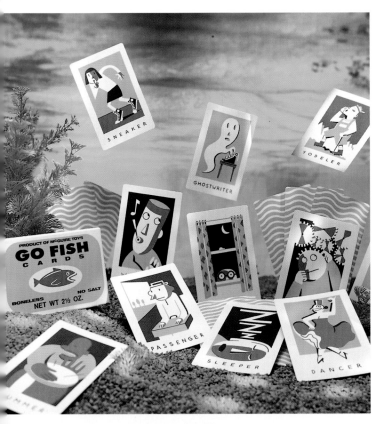

CUBIZM PORTRAITS™ IS A
MULTI-PERSONALITY SET OF
WOOD-BLOCKS. PURCHASERS
ARE ENCOURAGED TO CREATE
THEIR OWN SELF-PORTRAIT ON
AN ENCLOSED REPLY CARD.
SHOWN BELOW IS ONE SENT
IN BY MICHAEL BOROSKY FROM
SAN FRANCISCO.
DESIGN FIRM,
HIGASHI GLASER DESIGN,
FREDERICKSBERG, VIRGINIA;
DESIGNERS, BYRON GLASER,
SANDRA HIGASHI;
PHOTOGRAPHER,
DON CHIAPPINELLI; SELF-
PORTRAIT, MICHAEL BOROSKY.

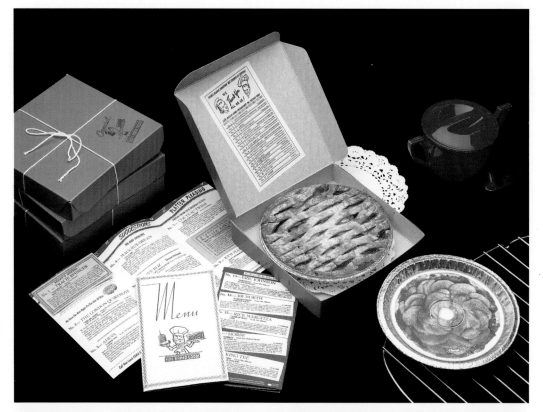

DESIGN FOR CAPITOL APPLE PIE SAMPLER COMPACT DISC. THE CD WAS SCENTED WITH THE AROMA OF APPLES. DESIGNED BY CAPITOL RECORDS, HOLLYWOOD, CALIFORNIA; ART DIRECTOR, TOMMY STEELE; DESIGNER, JIM HEIMAN; PHOTOGRAPHER, LARRY DUPONT; DESIGN COORDINATOR, JIM LADWIG/AGI, INC.

82

PIZZA SAMPLER COMPACT DISC DESIGN FOR CAPITOL RECORDS. USED AS A PROMOTIONAL ITEM, THE CD IS SILKSCREENED OVER PAPER COATED CORRUGATED CARDBOARD, WITH WAXED VARNISH "STAIN". DESIGNED BY CAPITOL RECORDS, HOLLYWOOD, CALIFORNIA; ART DIRECTOR, TOMMY STEELE; DESIGNER AND ILLUSTRATOR, ANDY ENGEL; DESIGN COORDINATOR, JIM LADWIG/AGI, INC.

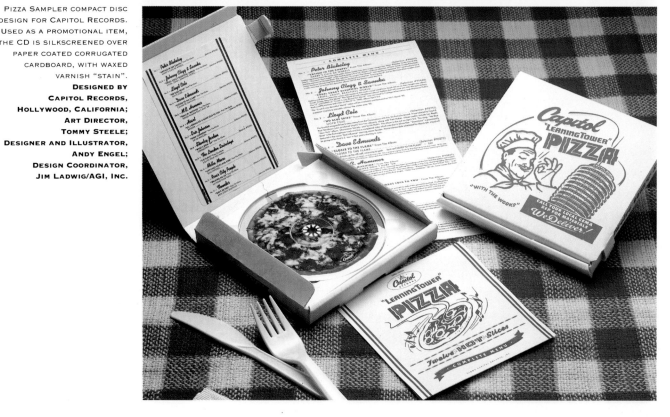

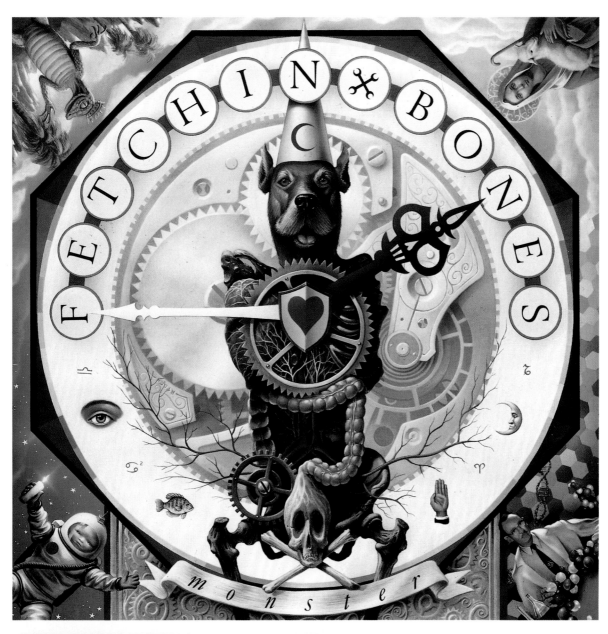

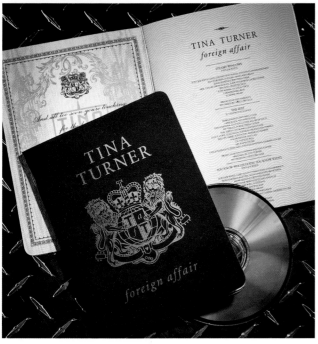

COVER DESIGN FOR FETCHIN
BONES "MONSTER" ALBUM.
**DESIGNED BY
CAPITOL RECORDS,
HOLLYWOOD, CALIFORNIA;
ART DIRECTOR,
TOMMY STEELE; DESIGNER
AND ILLUSTRATOR,
MARK RYDEN; PRODUCTION
DESIGNER, PETER WAHLBERG.**

COMPACT DISC DESIGN FOR
TINA TURNER'S "FOREIGN
AFFAIR" RELEASE IS A SPECIAL
EDITION CD PASSPORT. GOLD
FOIL STAMPING WAS USED OVER
LEXON, THE SAME MATERIAL
USED FOR AUTHENTIC U.S.
PASSPORTS.
**DESIGNED BY
CAPITOL RECORDS,
HOLLYWOOD, CALIFORNIA;
ART DIRECTORS, BILL BURKS,
TOMMY STEELE; DESIGNER,
GLENN SAKAMOTO;
PHOTOGRAPHERS, HERB RITTS,
PETER LINDBERGH;
DESIGN COORDINATOR,
WESTLAND GRAPHICS; LOGO
ILLUSTRATOR, ANDY ENGEL.**

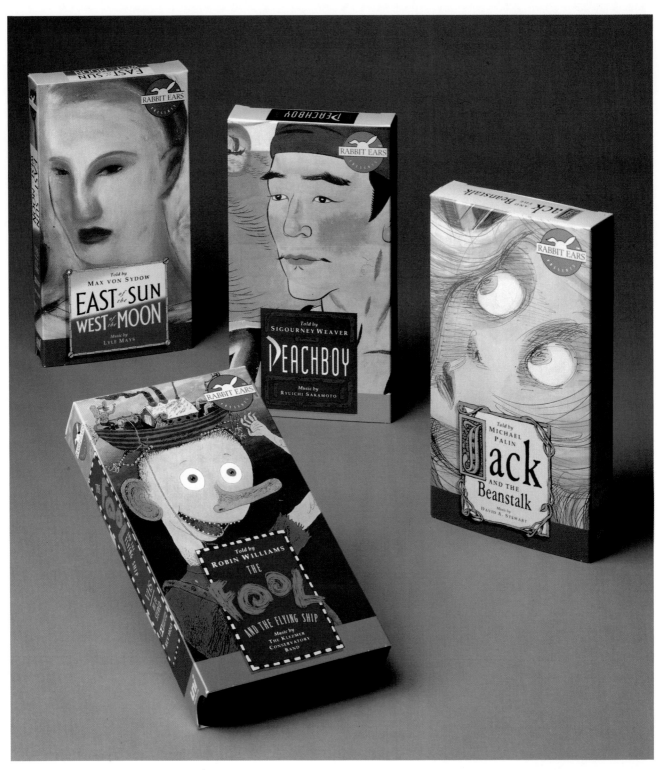

RABBIT EARS, FROM THE "WE
ALL HAVE TALES" SERIES OF
13 INTERNATIONAL FOLK
STORIES NARRATED BY WORLD-
RENOWNED ACTORS.
**DESIGN FIRM,
COREY EDMONDS MILLEN,
LOS ANGELES, CALIFORNIA;
ART DIRECTORS,
PETER MILLEN, PAUL ELLIOTT.**

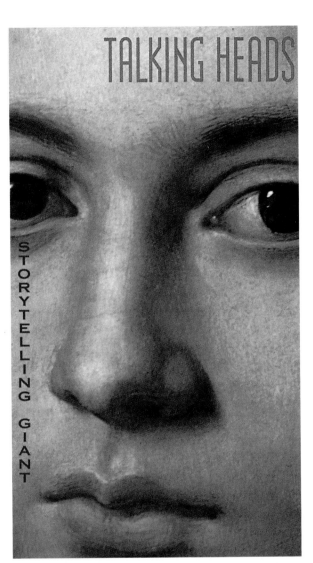

PACKAGE DESIGN FOR STORY
TELLING GIANT, A HOME VIDEO
FOR CHILDREN.
DESIGN FIRM, M&CO.,
NEW YORK, NEW YORK;
DESIGNERS, TIBOR KALMAN,
EMILY OBERMAN;
PAINTING, PERUGINO,
SCALA/ART RESOURCES;
BACK COVER PHOTOGRAPHY,
AP/WORLD WIDE.

ALBUM COVER DESIGN FOR
BALI: GAMELAN AND KECAK.
DESIGN FIRM,
ALEXANDER ISLEY DESIGN,
NEW YORK, NEW YORK; ART
DIRECTOR, ALEXANDER ISLEY;
DESIGNER, CARRIE LEEB.

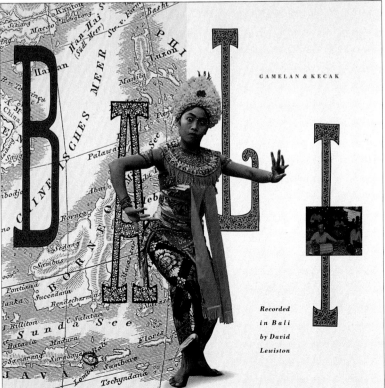

ALBUM, CASSETTE AND CD
COVER FOR MASSIVE HITS
THE BEST OF TOM ZÉ
DESIGN FIRM
ALEXANDER ISLEY DESIGN
NEW YORK, NEW YORK; ART
DIRECTOR, ALEXANDER ISLEY
DESIGNER
ALEXANDER KNOWLTON

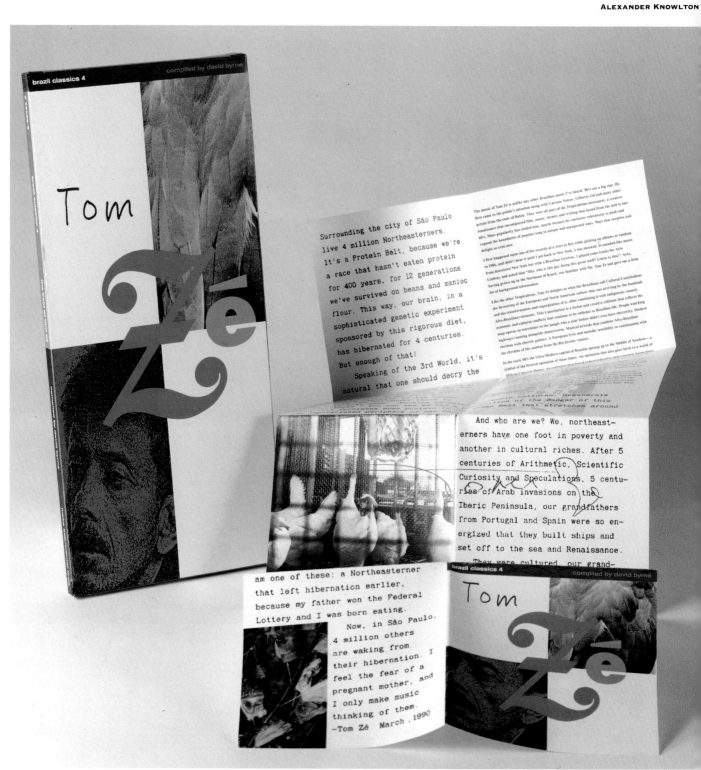

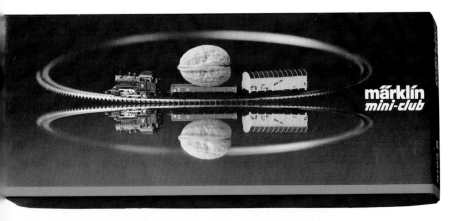

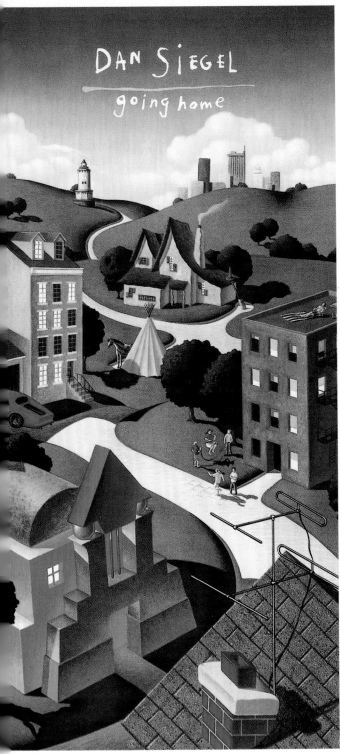

MÄRKLIN Z GAUGE STARTER
SET PACKAGING INTRODUCES
THE SMALLEST MASS-PRODUCED
ELECTRIC MODEL TRAINS IN THE
WORLD. .
**DESIGNED BY
GEBR. MÄRKLIN & CIE. GMBH,
GERMANY.**

"GOING HOME/DAN SIEGEL,"
CD PACKAGING FOR CONTEMP-
ORARY JAZZ SINGER. THE
ARTIST WANTED TO CONVEY
WHAT "HOME" MEANS TO A
VARIETY OF PEOPLE.
**DESIGNED BY
SONY MUSIC, NEW YORK,
NEW YORK; ART DIRECTORS,
NANCY DONALD,
DAVID COLEMAN;
ILLUSTRATOR, STEVE CARVER.**

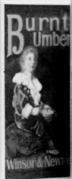
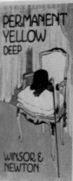
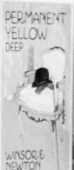
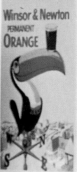

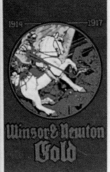
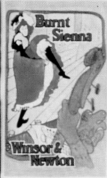
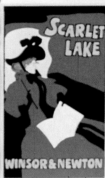
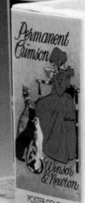
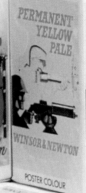
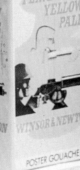
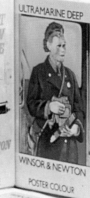
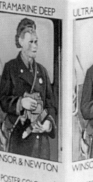
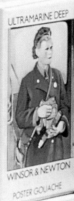
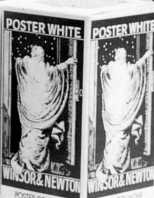

PACKAGE DESIGNS FOR
WINDSOR AND NEWTON RANGE
OF ARTISTS MATERIALS.
**DESIGN FIRM,
MICHAEL PETERS LIMITED,
LONDON; DESIGNER,
MICHAEL PETERS.**

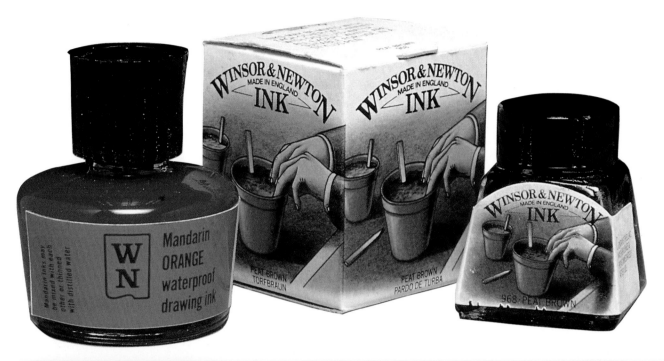

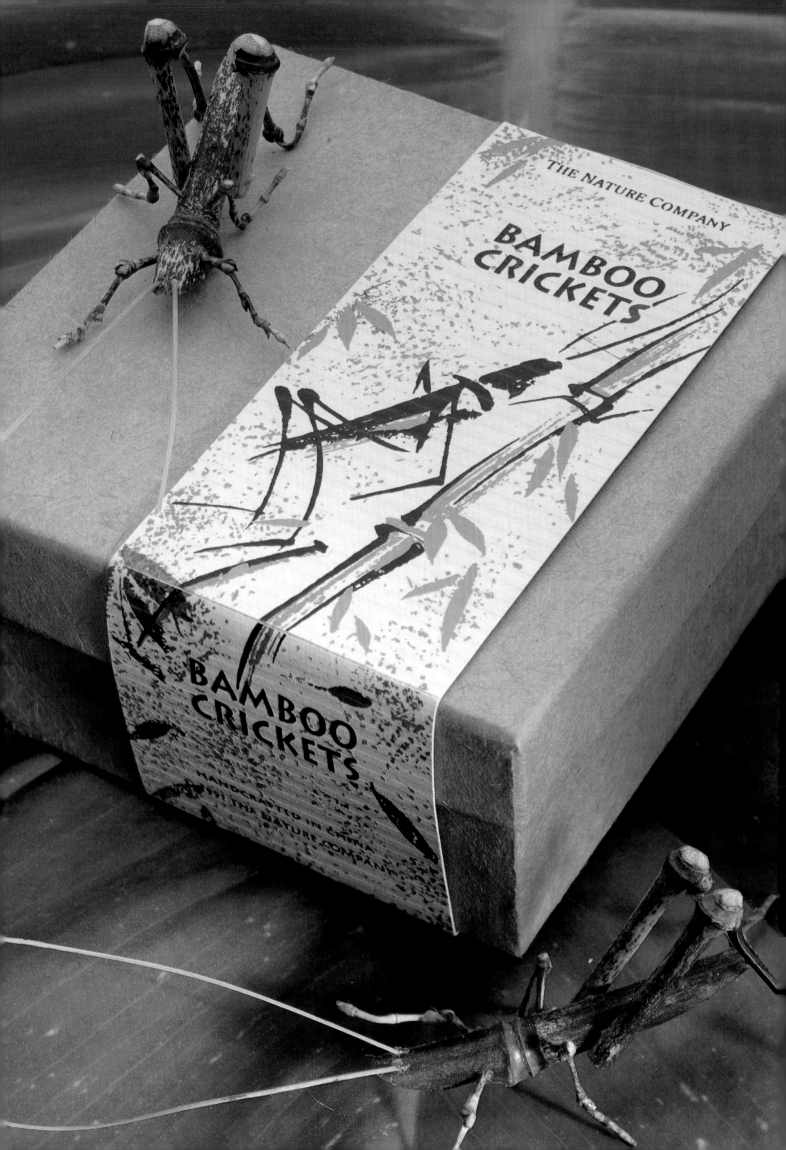

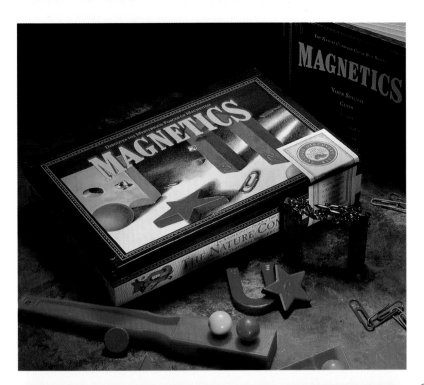

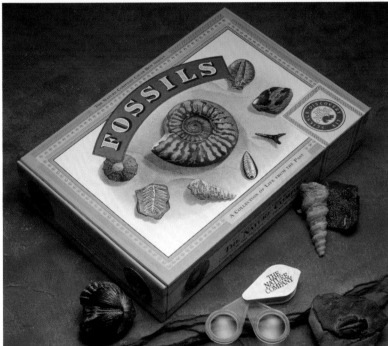

CIGAR BOX SERIES: MAGNETICS
CONTAINS AN ASSEMBLAGE OF
TRICKS AND PROJECTS DEMON-
STRATING THE STRANGE
EFFECTS OF MAGNETISM.
INCLUDES A 12-PAGE ACTIVITY
BOOKLET.
**DESIGNED BY
THE NATURE COMPANY,
BERKELEY, CALIFORNIA;
DESIGNER AND ILLUSTRATOR,
JEAN SANCHIRICO.**

NATURE COMPANY CIGAR BOX
SERIES: FOSSILS. AN EDUCA-
TIONAL KIT FOR CHILDREN, THE
BOX CONTAINS EIGHT EXCEP-
TIONALLY WELL-PRESERVED
SPECIMENS, A HAND LENS AND
BOOKLET.
**DESIGNED BY
THE NATURE COMPANY,
BERKELEY, CALIFORNIA;
DESIGNER, KATHY WARINNER;
ILLUSTRATOR,
BARBARA BANTHIEN.**

CIGAR BOX SERIES: OPTICAL
ILLUSIONS. THE KIT CONTAINS
A FUN COLLECTION OF TRICKS
AND EXPERIMENTS ON THE
PROPERTIES OF LIGHT AND
SIGHT.
**DESIGNED BY
THE NATURE COMPANY,
BERKELEY, CALIFORNIA;
DESIGNER, KATHY WARINNER;
ILLUSTRATOR,
BARBARA BANTHIEN.**

OPPOSITE PAGE:
BOX DESIGN OF BAMBOO
CRICKETS, FOR THE NATURE
COMPANY.
**DESIGNED BY
THE NATURE COMPANY,
BERKELEY, CALIFORNIA;
DESIGNER,
ASSUMPTA NISHWAKI;
CALLIGRAPHY,
GEORGIA DEAVER.**

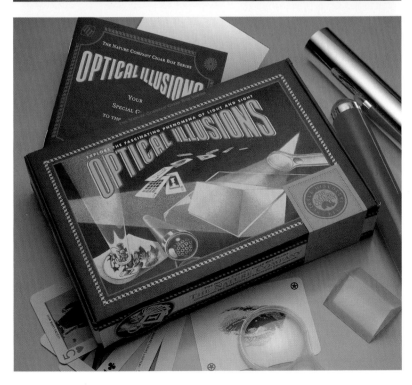

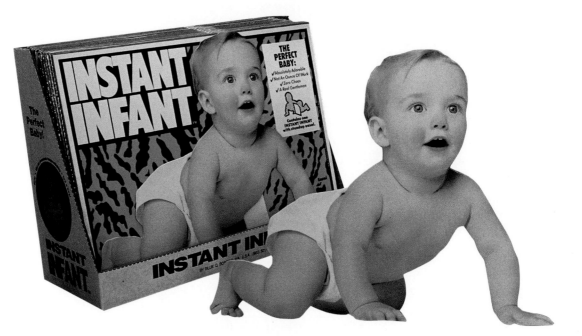

FABULOUS FLATS IS A SERIES
OF STAND UP PIECES THAT WAS
EXPANDED AFTER THE EXTREM-
ELY SUCCESSFUL LAUNCH OF
FLAT CAT. EACH PIECE IS A
LIFE-SIZE CARDBOARD DIE-CUT
WITH EASEL.
**DESIGNED BY BLUE Q,
BOSTON, MASSACHUSETTS;
DESIGNERS, MITCH NASH,
SETH NASH.**

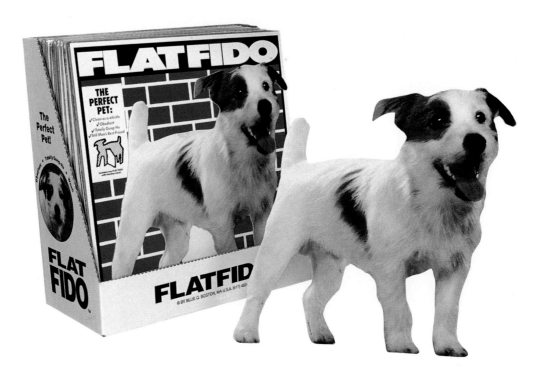

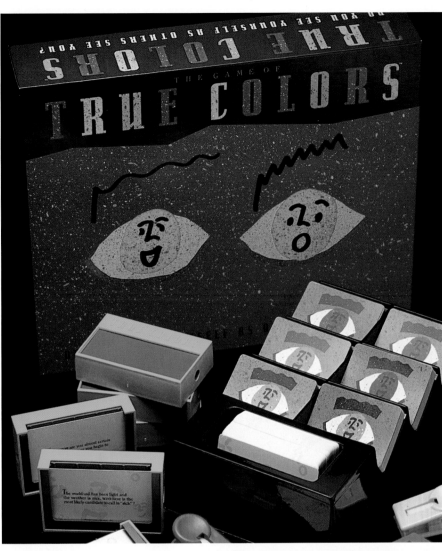

MILTON BRADLEY'S TRUE
COLORS IS AN ADULT GAME
WHERE PLAYERS ARE ASKED
QUESTIONS AND THEN SCORE
POINTS BY CORRECTLY
GUESSING HOW MANY PLAYERS
VOTED FOR YOUR ANSWERS.
DESIGN FIRM,
SIBLEY/PETEET DESIGNS,
DALLAS, TEXAS;
ART DIRECTORS, DON SIBLEY,
JIM BREMER;
DESIGNER AND ILLUSTRATOR,
DIANA MCKNIGHT.

TABOO IS A MILTON BRADLEY
GAME TARGETED TO THE ADULT
MARKET, AND REQUIRES
PLAYERS TO GUESS SECRET
WORDS BY AVOIDING CERTAIN
TABOO CLUE WORDS.
DESIGN FIRM,
SIBLEY/PETEET DESIGN,
DALLAS, TEXAS; DESIGNER
AND ILLUSTRATOR,
DON SIBLEY; ART DIRECTORS,
DON SIBLEY, JIM BREMER.

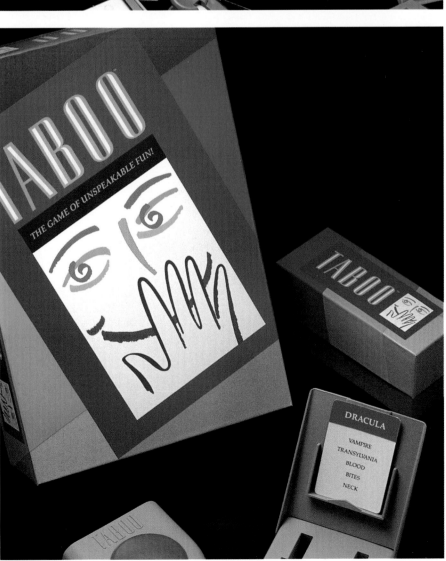

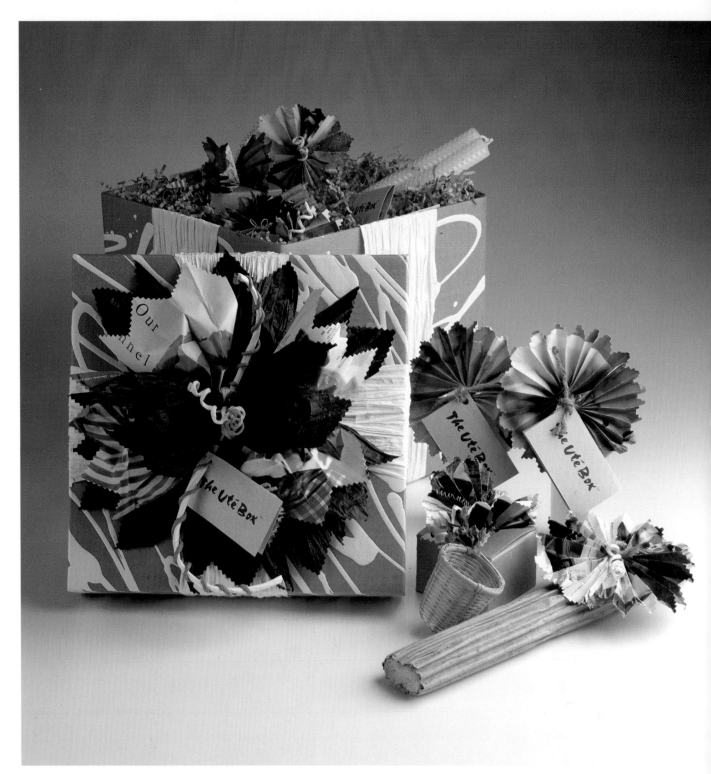

PACKAGE DESIGN FOR Th
UTE BOX™, A HANDCRAFTE
COSMETICS ENSEMBLE TH
IS MADE OF RECYCLED AN
RECYCLABLE MATERIALS, A
WELL AS LOW AND NON-TOX
PAINTS. THE PRODUCTS INSI
ALL RELATE TO A RITUA
OF BATHING—CANDLE
INCENSE, HERBAL TEA
DESIGNED ▶
BONNIE CORSANO ◀
EARTHLY TREASURE
JERSEY CITY, NEW JERSE

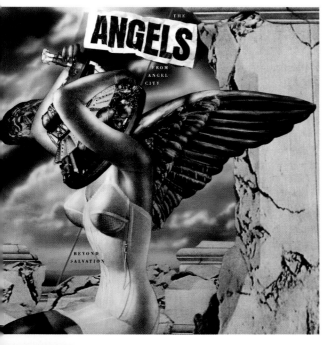

COVER ALBUM PACKAGE DESIGN
OF THE ANGELS "BEYOND
SALVATION," FOR CHRYSALIS
RECORDS, NEW YORK.
**ART DIRECTOR,
PETER CORRISTON;
DESIGNER, MARC COZZA;
ILLUSTRATOR,
HUBERT KRETZSCHMAR.**

PACKAGING FOR
BLOOMINGDALE'S PRIVATE
LABEL AM/FM RADIO,
CHRISTMAS '88.
**DESIGN FIRM,
ROBERT VALENTINE INC.,
NEW YORK, NEW YORK;
ART DIRECTOR AND DESIGNER,
ROBERT VALENTINE.**

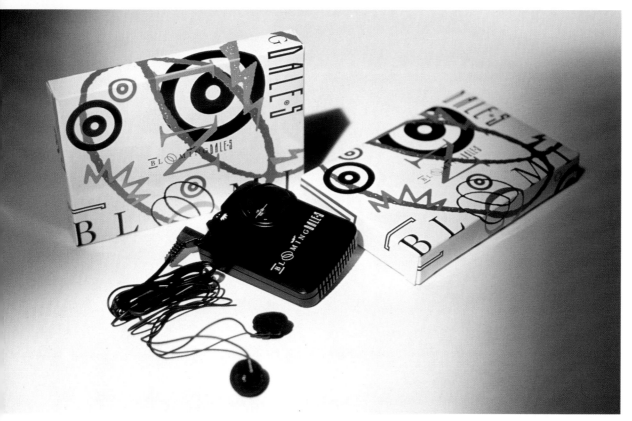

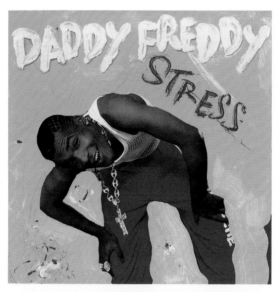

Album package design for Daddy Freddy's "Stress" portrays the Jamaican musician using local colors.
Design and Artwork, Marc Cozza; Photographer, Normski.

Design for CD and cassette of Ray Obiedo "Iguana" for Windham Hill Records.
Design Firm, Visual Strategies, San Francisco, California; Designers, Dennis Gallagher, John Sullivan; Illustrator, Bud Peen; Photographer, Patricia Leeds.

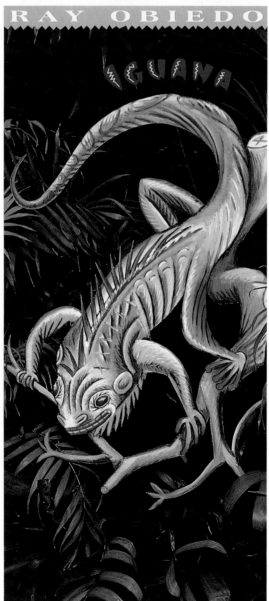

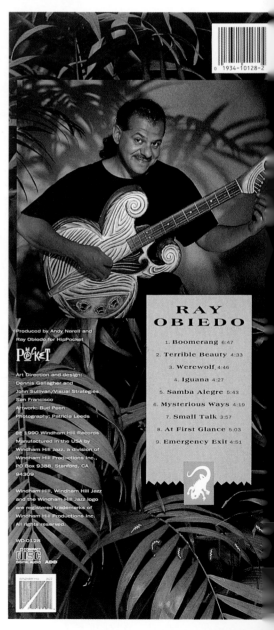

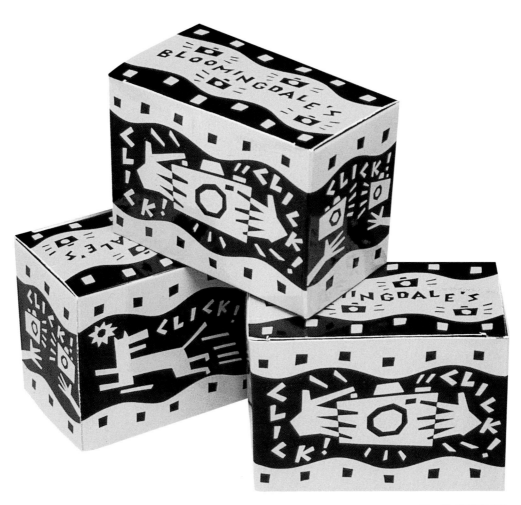

PACKAGING DESIGN FOR
BLOOMINGDALE'S CAMERA,
AN EXCLUSIVE GIFT-WITH-
PURCHASE FOR BACK-TO-
SCHOOL '89 SEASON.
**DESIGN FIRM,
ROBERT VALENTINE INC.,
NEW YORK, NEW YORK;
ART DIRECTOR AND DESIGNER,
ROBERT VALENTINE;
ILLUSTRATOR,
MICHAEL BARTALOS.**

POLYGRAM VIDEO MUSIC SINGLE
FOR CRYSTAL WATERS "GYPSY
WOMAN," KNOWN
THE WORLD OVER BY ITS
"LA DA DEE LA DA DA."
**DESIGN BY
POLYGRAM VIDEO,
NEW YORK, NEW YORK;
ART DIRECTOR,
ELENA PETRONE; DESIGNER,
BEN ARGUETA.**

CRYSTAL WATERS
GYPSY WOMAN VIDEO SINGLE

LA DA DEE

LA DA DA

LA DA DEE

LA DA DA

LA DA DEE

LA DA DA

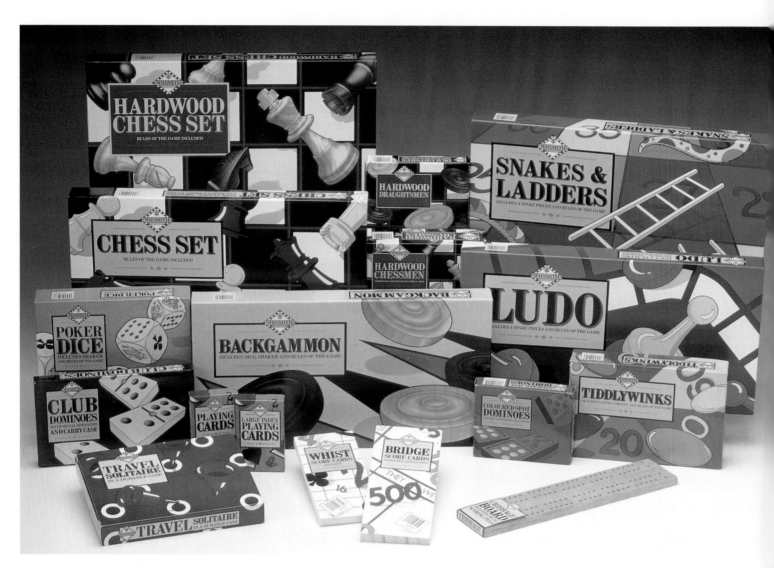

PACKAGE DESIGN FOR SERI
OF W.H. SMITH GAME
DESIGN FIR
MICHAEL PETERS LIMITE
LONDON; ART DIRECTO
GLENN TUTSSEL; DESIGNE
CAROLINE WARIN
ILLUSTRATION, W.I. AR

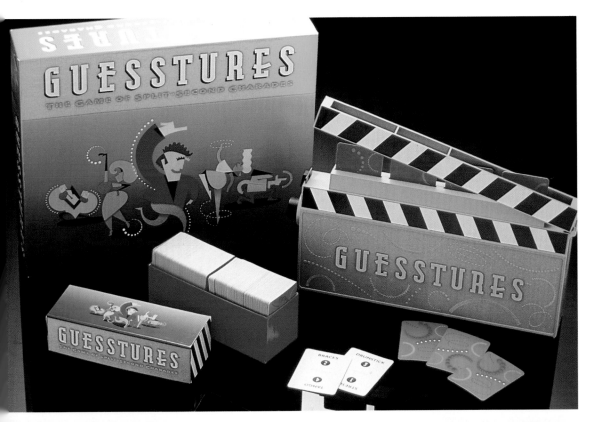

MILTON BRADLEY'S
GUESSTURES GAME IS
BASED ON CHARADES.
DESIGN FIRM,
SIBLEY/PETEET DESIGN,
DALLAS, TEXAS; DESIGNER
AND ILLUSTRATOR,
DAVID BECK; ART DIRECTORS,
DON SIBLEY, JIM BREMER.

PACKAGE DESIGNS FOR MILTON
BRADLEY'S SCATTERGORIES JR.
GAME.
DESIGN FIRM,
SIBLEY/PETEET DESIGN,
DALLAS, TEXAS; DESIGNER
AND ILLUSTRATOR,
JOHN EVANS; ART DIRECTORS,
DON SIBLEY, JIM BREMER.

Peter Allen, Creative Director
Apple Computers

THE GREENING OF APPLE

Peter Allen is creative director, worldwide packaging of Apple Computers in San Francisco. Recently, Apple decided to systematically reassess its packaging system.

What led Apple to a redesign?
After five years, we wanted to revitalize the product through the packaging, use environmentally appropriate materials and cut costs.

This is such a huge, and expensive, undertaking. How did you approach your decisions?
We employed a four-phase Japanese-style quality management plan: *1. Make a Plan; 2. Do Work Towards the Plan; 3. Check What You Did; and 4. Act On It.*

We started with sourcing inks and materials worldwide and understanding all the concerns of manufacturing and marketing. We knew that the white cardboard packaging for which Apple had become famous was often delivered scuffed and marred. We found that soy-based inks are not available worldwide. We examined the return on investment and estimated we could save $3,000,000 a year by changing the design specifications of the box.

At the end of *Phase one,* we produced a clear document which listed all of our needs and concerns.

In *Phase two* we invited several outside designers to come and brainstorm the new design with us. They included Courtney Reeser, Ian McLean, Earl Gee, Mitchell Mauk, Tamotsu Yagi and Brian Collentine, all individual designers, no firms. We wanted fresh ideas, not bureaucracy. Their input was interesting, they had some great ideas, it was a useful exercise. We also worked with the Michael Peters Group in New York to assess our brand's equities, to determine Apple's positive attributes. And we brought in Cheskin and Masten from Palo Alto for our quantitative research needs. The results of their findings were essential to our plan.

One thing we learned: the public is very skeptical of big business. They don't believe what we say we're doing. So we decided not to make major pronouncements about our environmental concerns on our packaging. We just added the official recycling logo on the box, along with all the other little icons. And we hired an independent consumer group to audit our activities. Later, there will be press coverage, which will let the world know objectively that we've done the right thing. It's better to have things like this said "of you, not by you."

We chose brown as a color for the cardboard. Our inks are black and white. We also wanted to reinforce our "business machines image" so we now have a black Apple logo, not red or green. The typography and photography of the product are very strong. We found that we didn't need to enhance the packaging further. Our equity is in our product and image. There's no need for additional decoration.

We conducted site audits. Since we manufacture in Ireland and Singapore, we had to make sure that the raw materials would be available worldwide in the quantities we require and that the printing would be consistent.

Phase three was our reality check. We presented our designs and findings to the executive level to get them to buy into what we're doing. We're currently in *Phase four;* creating guidelines for print production standards and design guidelines worldwide. We're aiming for 30-100 percent post-consumer waste in our cardboard. There must be a standard acceptable level of ink opacity. The inks are all water-based and contain no heavy metals that can be bad for the environment.

Financially speaking, we were pleasantly surprised to find that we're saving even more than we originally projected.

What's next?
After the roll out, we're starting to look at what goes in the package, the manuals, the styrofoam. We need to reduce the amount of material in the box. Corporately, we've decided to share what we found. We want to encourage more manufacturers to rethink their packaging as we have.

THE REDESIGN OF THE APPLE COMPUTER PACKAGING SYSTEM IS ON PAGE 111.

A STORE WITH A MISSION

Katherine Tiddens is the proprietor of Terra Verde Trading Co., an ecological department store in the Soho District of New York City, which was created to sell environmentally beneficial products and to promote ecological practices.

What is the optimal package design?

No packaging.

Everybody's very concerned about shoplifting so products are often over-packaged. Merchants and package designers must be willing to be more creative in their merchandising. If a product is likely to be stolen, we keep one on display and the rest in back. The customer walks out with the packaging only if it's essential to the product. No shrinkwrapping. It just ends up in the waste basket. Unbelievably, we keep getting samples of earth-friendly products that manufacturers want us to consider selling wrapped in plastic or packed in styrofoam. The Japanese wrap gifts with scarfs, called furoshiki, instead of wrapping paper. We sell beautiful, simple reusable boxes and baskets in which people can package their gifts.

We've made it a policy to sell only recyclable packaging and environmentally sound products. We test each product that's sent to us, and consider it a challenge to research the ingredients or manufacturing processes. Plywood, for instance, is not acceptable, since it is put together with glues containing formaldehyde. Certain kinds of varnishes and many kinds of paints can rule out a product. Glues on the back of labels can make the labels unrecyclable. Often we can go back to the manufacturer and work together to make the product appropriate for Terra Verde. Sometimes, we ask them to deliver the goods but not the package, or if the package is essential to the product, they sometimes adjust it to fit our store policy. Occasionally, we'll spend several hours discussing some problem concerning a new product before calling the manufacturer with feedback. They are often very appreciative of our efforts, especially if the product is in the development stage.

What is your message to package designers?

Think back in time 20 or 30 years to a time before current packaging practices. Ask your mother or grandmother about old merchandising or packaging methods.

Why New York?

A lot of people write off New York as a disaster. I find life very livable here. Opening Terra Verde was an expression of my faith in the city. A very large number of people seek us out to thank us for opening the store. We keep in touch with a lot of environmentalists and entrepreneurs, including some from other countries who are thinking the same way we are. Just last week we received faxes from Japan, Brazil, Italy.

How are other countries dealing with similar problems?

Denmark is experimenting with a universal container system for beverages and other bottled goods. In Germany, I've heard that stores must keep a container next to the door where customers can place the packaging they don't wish to take home with them. Then it's the storekeeper's responsibility to get rid of the packaging. At Terra Verde we don't give shopping bags to customers, we encourage shoppers to bring their own bags. We sell recycled kraft shopping bags for a quarter (our cost), and at the end of each month we give the money to a different environmental organization.

Would you say you're a store with a message?

I'd say we're a store with a mission! My vision is that one day all stores will take ecological considerations as a matter of course. I'd like to help change the way that products are manufactured, packaged, and marketed. But we try to operate with a sense of humor and a sense of style. I do not want anyone on the staff to appear self righteous. We have a limited time to make fundamental changes in the way business is conducted in this country, the earth is really much smaller than we used to think, and our resources are limited.

THE PACKAGING FOR BEROL PENCILS WAS DESIGNED BY NEWELL AND SORRELL, LONDON AND ARE SOLD INTERNATIONALLY (SEE PAGE 131).

Katherine Tiddens, Proprietor Terra Verde Trading Co.

WHSMITH

GOLD COLOUR MARKER

Extra fine point
Caution: contains toxic substances

WHSMITH

WATERCOLOUR MARKER

Chisel tip
Ink colour as barrel

WHSMITH

PERMANENT MARKER

Bullet tip
Ink colour as cap plug

WHSMITH

HIGHLIGHTER

Ink colour as barrel

102

PACKAGING FOR W.H. SMITH BRAND WRITING INSTRUMENTS. DESIGN FIRM, NEWELL AND SORRELL, LTD., LONDON; CREATIVE DIRECTOR, JOHN SORRELL; ART DIRECTOR, JEREMY SCHOLFIELD; DESIGNER, GILLIAN THOMAS; ILLUSTRATORS, JONATHAN WRIGHT, RICHARD OSLEY.

BEROL "KARISMA" DOUBLE-ENDED MARKERS. DESIGN FIRM, NEWELL AND SORRELL, LTD., LONDON; CREATIVE DIRECTORS, JOHN SORRELL, FRANCES NEWELL; DESIGNER, DERICK HUDSPITH.

OPPOSITE PAGE: BEROL "KARISMA" COLOUR PENCILS HAVE CHAMFERED ENDS. THE OUTER PACKAGING IS RECYCLED PAPER EMBOSSED WITH HALLMARKS. DESIGN FIRM, NEWELL AND SORRELL, LTD., LONDON; CREATIVE DIRECTORS, JOHN SORRELL, FRANCES NEWELL; DESIGNER, DERICK HUDSPITH; PHOTOGRAPHER, PETER MANSFIELD.

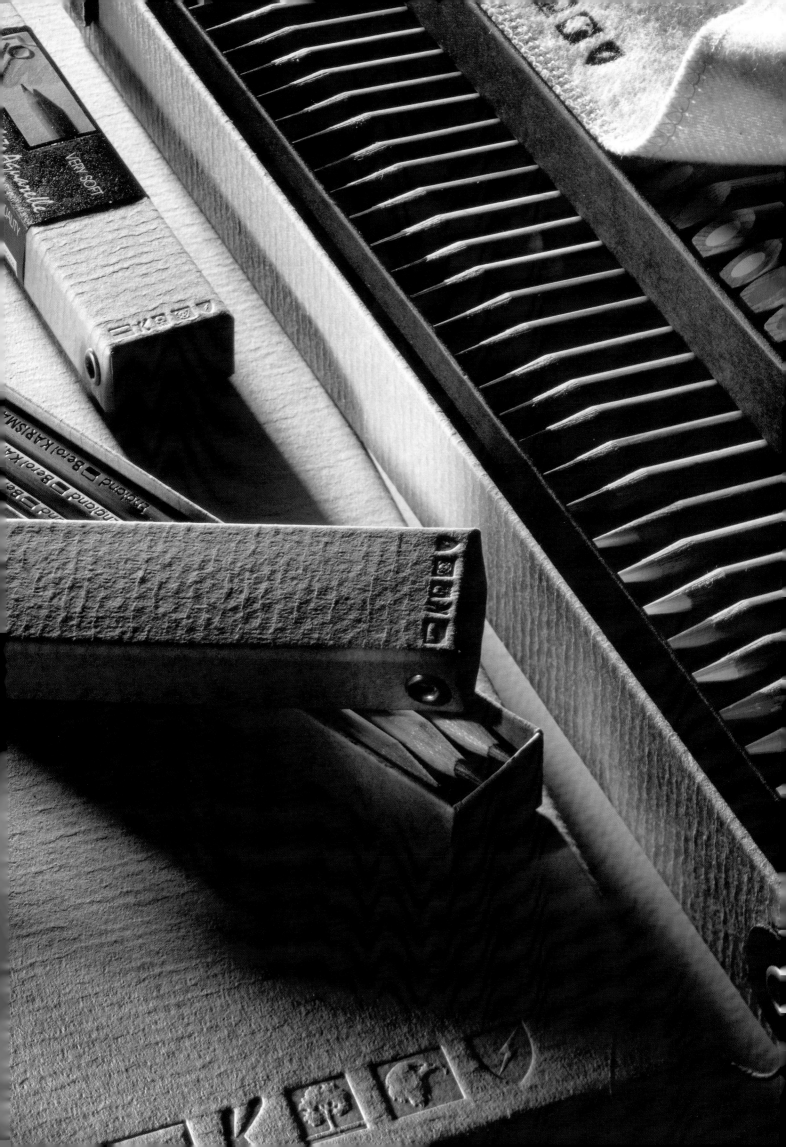

W.H. Smith Stores Premium Range stationery is given an up-market appearance with a gold seal on all the labels. The points showing what is contained in the package are illustrated on the labels. Design Firm, The Partners Design Consultants Ltd., London; Art Director, Aziz Cami; Designers, Marita Lashko, Phillip Pennington, Greg Quinton; Illustrator, Malcolm English.

The package design for these pencils display their unique properties, as well as providing protection. The pencil is textured like a thread bolt. Designed by Designproducts, Sandisfield, Massachusetts; Product and Package Designer, David Wiechnicki.

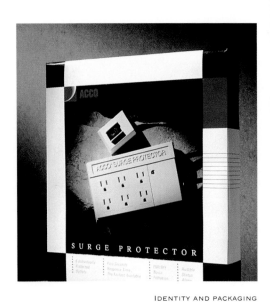

IDENTITY AND PACKAGING
SYSTEM OF ACCO OFFICE AND
HOME PRODUCTS, FOR ACCO
WORLD CORPORATION,
DEERFIELD, ILLINOIS.
**DESIGN FIRM,
LANDOR ASSOCIATES,
SAN FRANCISCO, CALIFORNIA;
DESIGN DIRECTOR,
ELLEN SPIVAK; CREATIVE
DIRECTOR, KAY STOUT.**

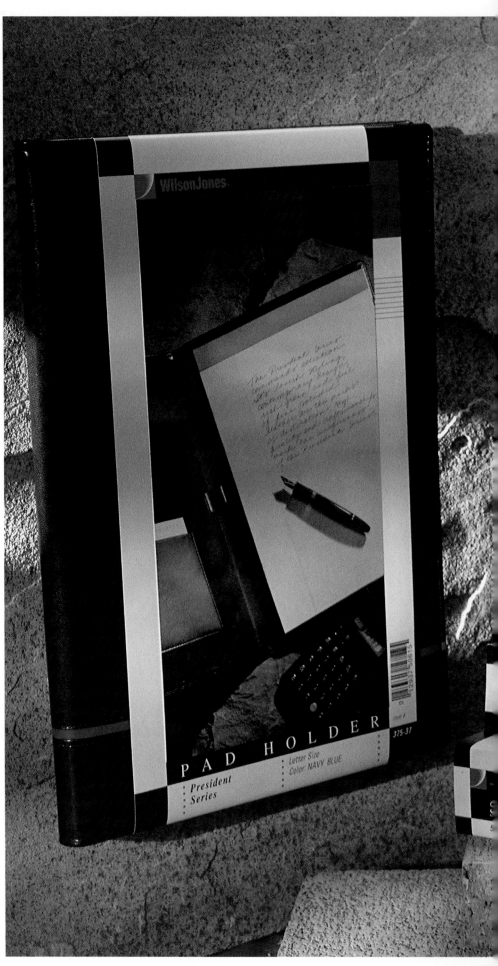

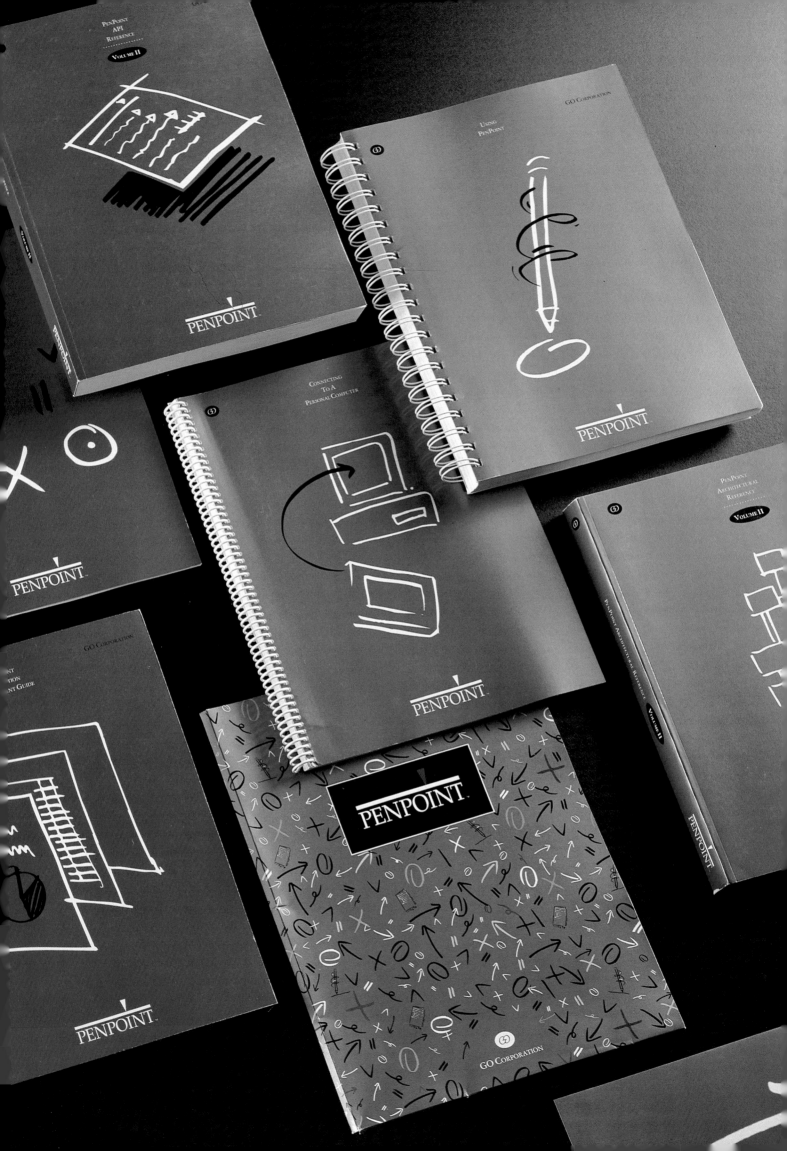

OPPOSITE PAGE AND BELOW:
PACKAGING DESIGN FOR
PENPOINT, A NEW PEN-BASED
COMPUTER OPERATING SYSTEM
FOR THE MAC.
DESIGN FIRM,
CLEMENT MOK DESIGNS,
SAN FRANCISCO, CALIFORNIA;
DESIGNER AND ILLUSTRATOR,
CLEMENT MOK.

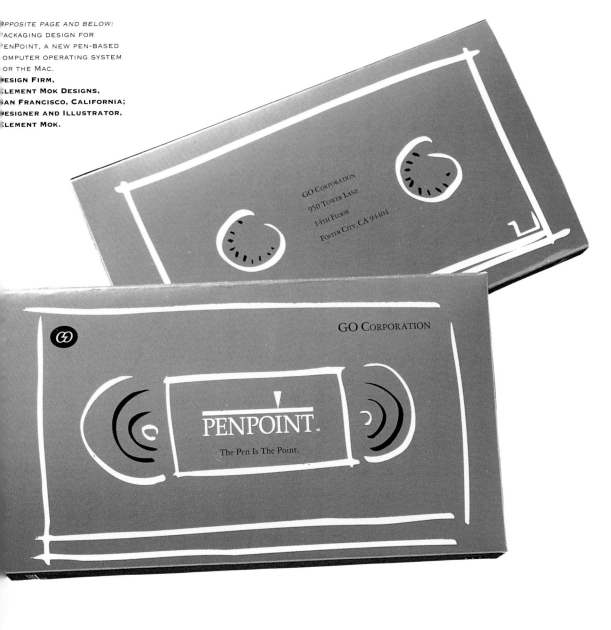

PACKAGE DESIGN FOR LETRA
STUDIO, TYPE DESIGN AND
MANIPULATION SOFTWARE,
CREATED WITH LETRASET
SOFTWARE.
DESIGN FIRM,
CLEMENT MOK DESIGNS,
SAN FRANCISCO, CALIFORNIA;
ART DIRECTOR, CLEMENT MOK;
DESIGNER, CHUCK ROUTHIER;
ILLUSTRATOR,
NEVILLE BRODY.

PACKAGE DESIGN FOR COLOR
STUDIO, COLOR ILLUSTRATION
AND IMAGE ASSEMBLY SOFT-
WARE SYSTEM. A STIPULATION
OF THE ASSIGNMENT WAS TO
USE LETRASET SOFTWARE TO
CREATE THE PACKAGING.
DESIGN FIRM,
CLEMENT MOK DESIGNS,
SAN FRANCISCO, CALIFORNIA;
ART DIRECTOR, CLEMENT MOK;
DESIGNER, CHUCK ROUTHIER;
ILLUSTRATOR,
NEVILLE BRODY.

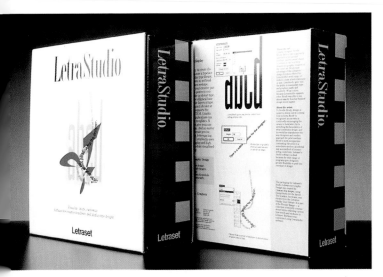

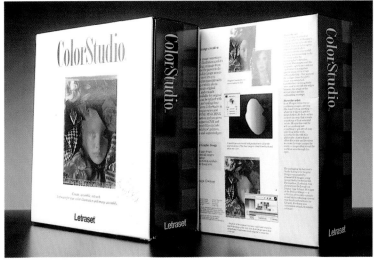

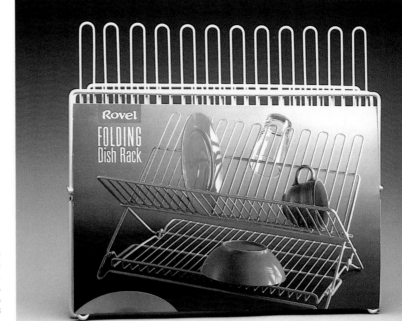

DISH RACK PACKAGING
DESIGNED FOR BETTER
HOUSEWARES CORP.
**DESIGN FIRM,
LEWIN/HOLLAND, INC.,
NEW YORK, NEW YORK;
DESIGNER, CHERYL LEWIN.**

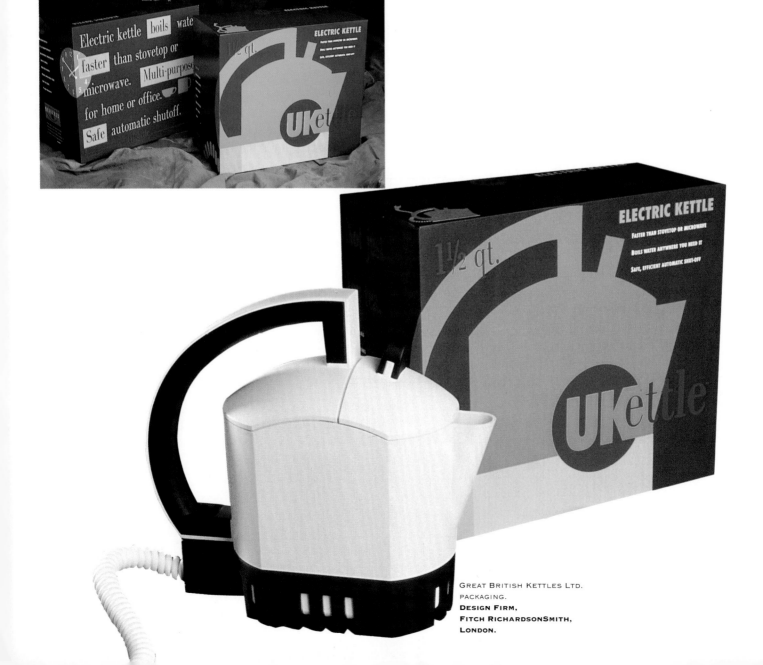

GREAT BRITISH KETTLES LTD.
PACKAGING.
**DESIGN FIRM,
FITCH RICHARDSONSMITH,
LONDON.**

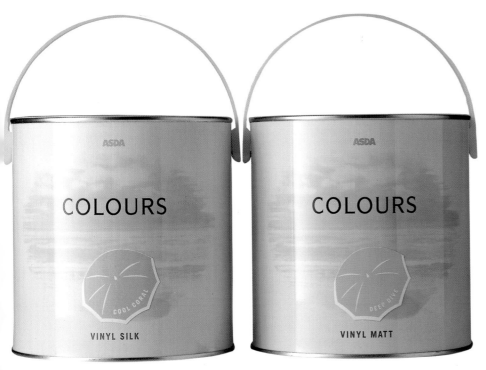

COLOURS

VINYL SILK

COLOURS

VINYL MATT

PRIVATE LABEL PAINT CAN
PACKAGING. TARGETED TOWARD
WOMEN. SOLD IN SUPER-
MARKETS IN THE UNITED
KINGDOM. THE RECYCLABLE
CAN IS MADE OF TIN PLATING
INSTEAD OF PLASTIC.
DESIGN FIRM,
LEWIS MOBERLY, LONDON;
DESIGNER, MARY LEWIS.

WORLDWIDE PACKAGING SYSTEM
FOR APPLE COMPUTERS IN
CALIFORNIA. SOLD IN 23
COUNTRIES WITH A TOTAL
OF 24 TRANSLATIONS. THE
CARDBOARD USED HAS A HIGH
POST-CONSUMER WASTE
CONTENT AND THE PRINTING
USES WATER-BASED INKS.
**DESIGNED BY
APPLE COMPUTER,
CUPERTINO, CALIFORNIA;
CREATIVE DIRECTOR,
PETER ALLEN; ART DIRECTOR,
JEAN STEVENS;
PRODUCTION MANAGER,
CHARLIE COSTANTINI;
PRODUCTION COORDINATORS,
GRETA MIKKELSEN,
PEGGY JENSEN, JANE BAILEY;
PRODUCTION ARTISTS,
KYOKO DOUGHERTY,
MEREDITH BAUMAN;
PHOTOGRAPHER,
BRUCE ASHLEY.**

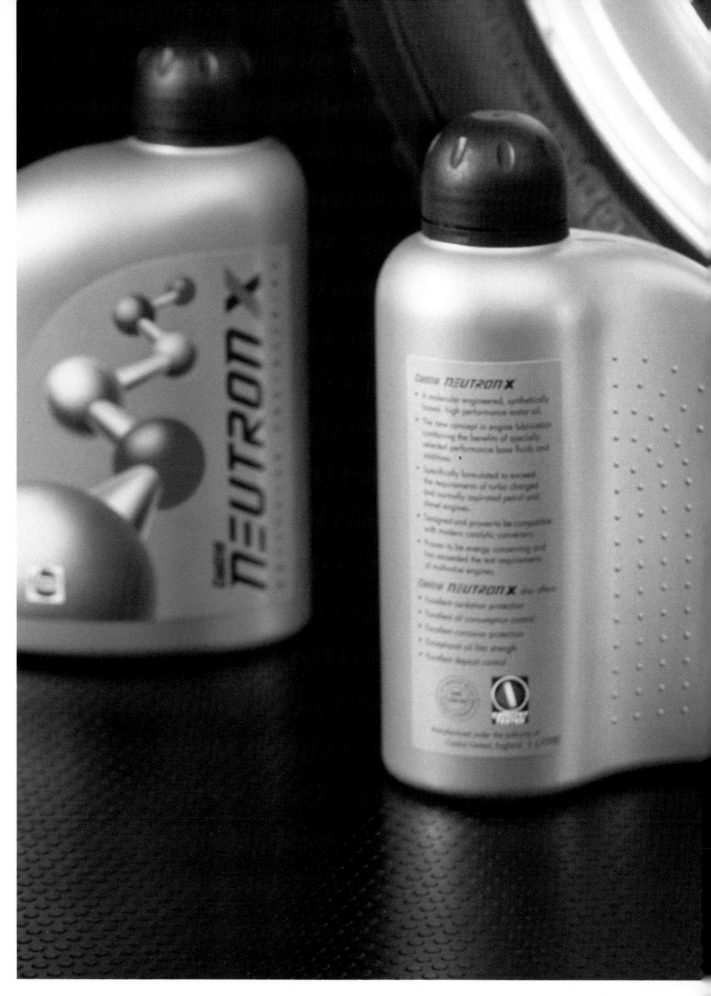

GRAPHIC AND STRUCTUR
PACKAGE DESIGN F
NEUTRON
DESIGN FIRM, ADDIS
DESIGN CONSULTAN
SAN FRANCISCO, CALIFORN
DESIGNER, MARTIN BUN

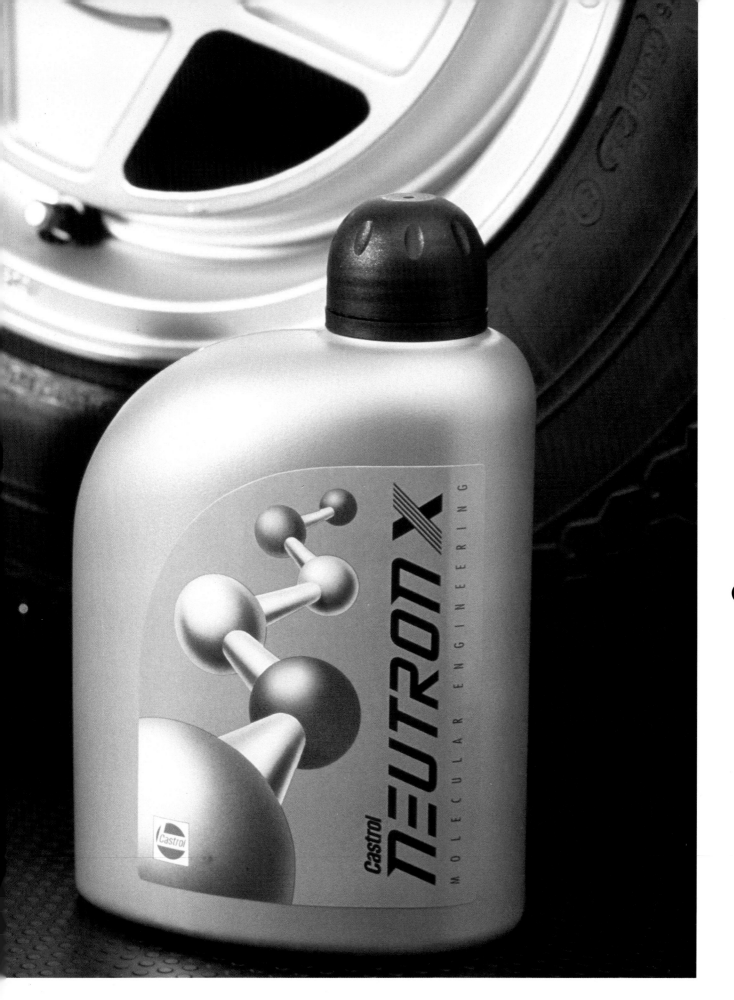

DESIGNASAURUS II SOFTWARE
PACKAGING SYSTEM IS AN EDUCA
TIONAL GAME FOR CHILDREN
DESIGN FIRM, WOODS + WOODS
SAN FRANCISCO, CALIFORNIA
ART DIRECTOR, PAUL WOODS
DESIGNERS, PAUL WOODS
ALISON WOODS; ILLUSTRATOR
DAVID BIEDRZYCK

Ages 7-14

DESIGNASAURUS II™

Discover and Experience the
Exciting World of Dinosaurs.

**BRITANNICA®
SOFTWARE**

IBM/TANDY
100%
COMPATIBLE

PACKAGE DESIGN FOR KID PIX, SOFTWARE PAINT PROGRAM FOR CHILDREN. ALL ARTWORK AND ILLUSTRATIONS WERE CREATED ON THE MAC. **DESIGN FIRM, WOODS + WOODS, SAN FRANCISCO, CALIFORNIA; ART DIRECTORS, ALISON WOODS, PAUL WOODS; DESIGNER, ALISON WOODS; DESIGN ASSISTANT, JULIA BECKER.**

PACKAGE DESIGN FOR ALGEBRA MADE EASY, SOFTWARE PROGRAM FOR HOME USE. **DESIGN FIRM, WOODS + WOODS, SAN FRANCISCO, CALIFORNIA; ART DIRECTOR AND DESIGNER, ALISON WOODS; DESIGNER, JULIA BECKER; COMPUTER ILLUSTRATION, JULIA BECKER; PHOTOGRAPHER, REID MILES.**

YOUR PERSONAL TRAINER FOR THE SAT IS A HOME/SCHOOL EDUCATIONAL SOFTWARE PROGRAM. PACKAGE INSERTS PROVIDE STRENGTH AND SUPPORT TO THE OUTSIDE PACKAGE, AND ARE MADE OF RECYCLABLE MATERIALS. **DESIGN FIRMS, DAVIDSON & ASSOCIATES, INC., TORRANCE, CALIFORNIA; HAMAGAMI/CARROLL & ASSOCIATES, SANTA MONICA, CALIFORNIA.**

PACKAGE DESIGN FOR ALGEBRA I, SEMESTER II. THE PROGRAM IS USED IN SCHOOLS AND THE HOME. **DESIGN FIRM, WOODS + WOODS, SAN FRANCISCO, CALIFORNIA; ART DIRECTOR AND DESIGNER, PAUL WOODS; COMPUTER ILLUSTRATION, PAUL WOODS.**

PACKAGE DESIGNS F
FARALLON'S VARIETY I A
OPPOSITE PAGE, VARIETY
PRODUCT LINE, WHICH SPA
NETWORKING HARDWARE A
SOFTWARE, SOUND CAPTU
AND EDITING, AND MULTIMED
THE PREVIOUS PACKAGING H
BEEN LOADED WITH STYROFO
AND HAD PLASTIC SLEEV
THE NEW MATERIAL
ENVIRONMENTALLY FRIEND
DESIGN FIR
CLEMENT MOK DESIGN
SAN FRANCISCO, CALIFORN
ART DIRECTO
CLEMENT M
DESIGNER, CHUCK ROUTHIE
ILLUSTRATO
MARK PENBERTH

PACKAGE DESIGN FOR
PHONENET CONNECTOR
HARDWARE, A NETWORKING
DEVICE FOR THE MAC.
**DESIGN FIRM,
CLEMENT MOK DESIGNS,
SAN FRANCISCO, CALIFORNIA;
DESIGNER AND ILLUSTRATOR,
CLEMENT MOK.**

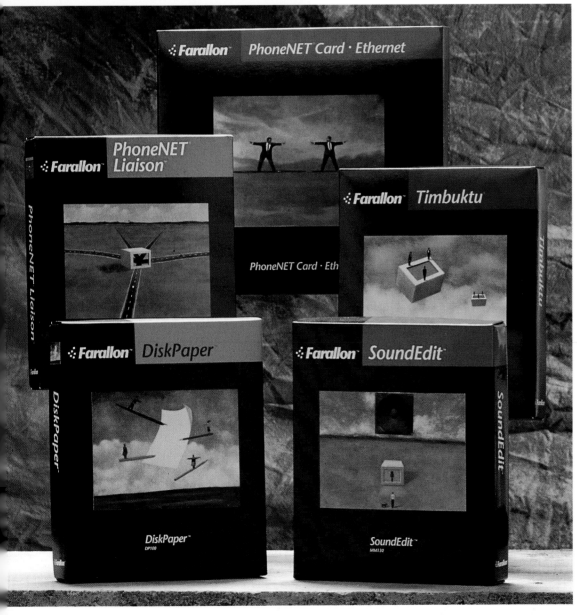

SOFTWARE PACKAGING FOR
COMPTON'S MULTIMEDIA
ENCYCLOPEDIA. ALL THE TEXT
IS INCLUDED ON A SINGLE CD
ROM DISK, INCLUDING THE
PICTURES. BOX WAS PRODUCED
BY A BOOK BINDER.
**DESIGN FIRM,
WOODS + WOODS,
SAN FRANCISCO, CALIFORNIA;
ART DIRECTOR AND DESIGNER,
ALISON WOODS; DESIGN
ASSISTANTS, JULIA BECKER,
ADELAIDA MEJIA,
THERESE RANDALL;
PHOTOGRAPHY AND IMAGES,
ENCYCLOPEDIA BRITTANICA.**

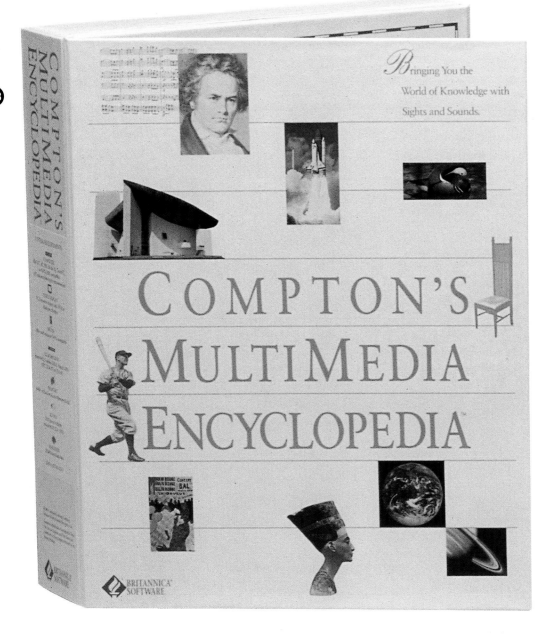

BUSH BUCK CHARMS AND GEO
JIGSAW SOFTWARE PROGRAMS
FOR PC GLOBE, INC. PC
GLOBE, INC., AND PC USA ARE
SOFTWARE PROGRAMS THAT
PROVIDE INSTANT GEOGRAPHIC
PROFILES.
DESIGN FIRM,
RICHARDSON OR RICHARDSON,
PHOENIX, ARIZONA;
CREATIVE DIRECTOR,
FORREST RICHARDSON;
DESIGNER AND COPYWRITER,
DIANE GILLELAND;
ILLUSTRATOR, BOB PETERS.

OPPOSITE PAGE:
PACKAGING SYSTEM FOR PC
GLOBE AND PC USA, EDUCA-
TIONAL, BUSINESS AND CON-
SUMER SOFTWARE PRODUCT.
THE PACKAGING IS MADE WITH
WATER-BASED COATINGS FOR
RECYCLING PURPOSES.
DESIGN FIRM,
RICHARDSON OR RICHARDSON,
PHOENIX, ARIZONA;
CREATIVE DIRECTOR,
FORREST RICHARDSON;
DESIGNER, DIANE GILLELAND.

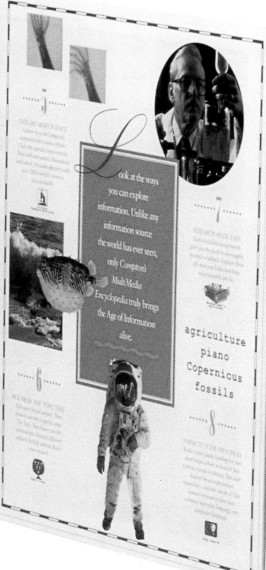

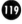
119

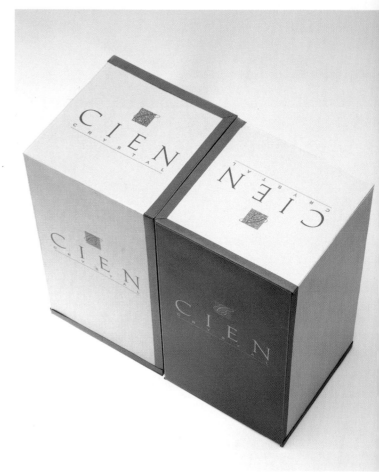

PACKAGING SYSTEM FOR
CRISA CORPORATION'S LINE
OF CEIN CRYSTAL. CRISA IS THE
ONLY MANUFACTURER OF CUT
CRYSTAL IN MEXICO.
**DESIGN FIRM,
CARSON PRITCHARD DESIGN,
ENCINO, CALIFORNIA;
DESIGNER,
CARSON PRITCHARD.**

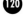
120

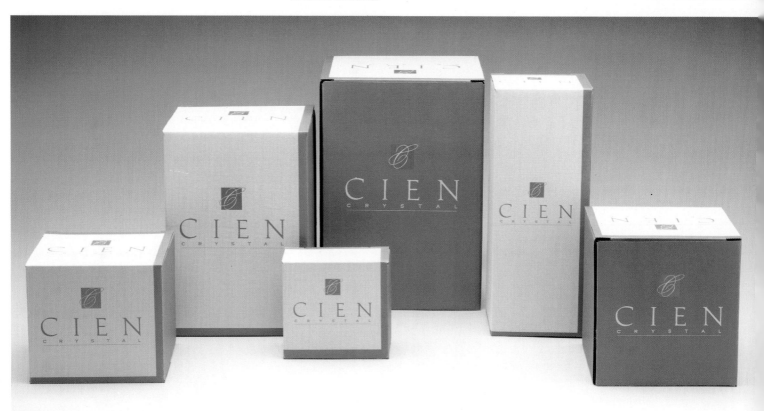

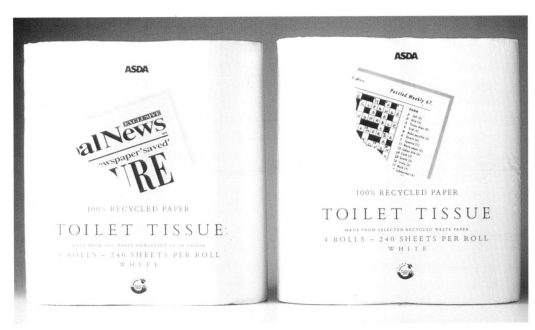

ASDA
100% RECYCLED PAPER
TOILET TISSUE
MADE FROM 100% WASTE NEWSPRINT OF UK ORIGIN
4 ROLLS — 240 SHEETS PER ROLL
WHITE

ASDA
100% RECYCLED PAPER
TOILET TISSUE
MADE FROM SELECTED RECYCLED WASTE PAPER
4 ROLLS — 240 SHEETS PER ROLL
WHITE

ASDA TOILET TISSUES ARE MADE FROM 100% RECYCLED PAPERS. DESIGN FIRM, MICHAEL PETERS LIMITED, LONDON; ART DIRECTOR, GLENN TUTSSEL; DESIGNER, DAVID PIKE.

DECO TILES ARE MADE OF VINYL AND STICK TO ANY SURFACE. THEY LEAVE NO RESIDUE WHEN REMOVED. DESIGN FIRM, LEWIN/HOLLAND, INC., NEW YORK, NEW YORK; DESIGNER AND ILLUSTRATOR, CHERYL LEWIN; PHOTOGRAPHER, BEN ROSENTHAL.

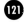

121

Wow! Now you can decorate yourself in minutes. DecoTiles are so easy to use. Move them around, change designs, and re-use them, with no residue. They are washable and heat resistant, so you can have fun redecorating your bathroom or kitchen...anywhere you want to jazz up your tiles. And they are non-toxic, so they're safe for kids. Just follow these simple steps:

1. Clean & dry surface
2. Peel off paper backing
3. Press firmly into position around edges

Mantee America, Inc.
Los Angeles, CA
New York, NY

Patent Pending

DecoTile
CHERYL LEWIN ACCENTS

12 Self Sticking Vinyl Tiles

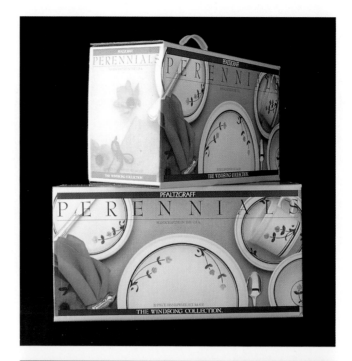

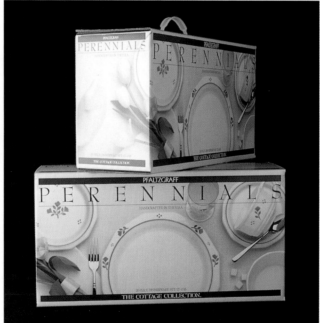

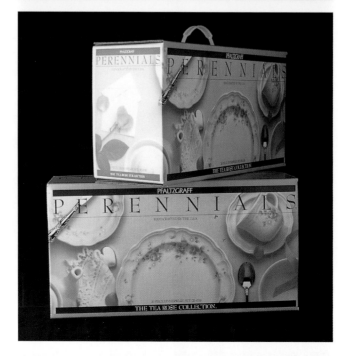

PERENNIALS CERAMIC DINNER
WARE, FOR PFALTZGRAFF
DESIGN FIRM
LANDOR ASSOCIATES
SAN FRANCISCO, CALIFORNIA
DESIGNERS, LANDOR
NEW YORK DESIGN STAFF

OPPOSITE PAGE
GUIGOZ REJUVINATED ITS LINE
OF FEEDING BOTTLES AND
MARKETED THE NEW DESIGN
TO THE YOUNG MOTHERS OF THE
NINETIES
DESIGN FIRM
B E P DESIGN GROUP
BRUSSELS, BELGIUM

PACKAGE DESIGN FOR
KLEENEX (KIMBERLY-CLARK OF
CANADA LTD.)
DESIGN FIRM,
BARRY ZAID DESIGN,
NEW YORK, NEW YORK;
PACKAGE CONCEPT, PAINTING,
BARRY ZAID.

PACKAGING DESIGNS FOR
KLABIN PAPER AND CELLULOSE
MANUFACTURERS.
DESIGN FIRM,
P & B COMUNICAÇÃO, BRAZIL;
ART DIRECTOR,
JOÃO DELPINO.

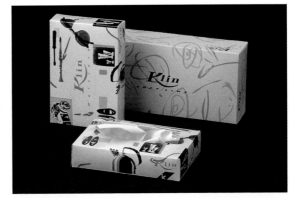

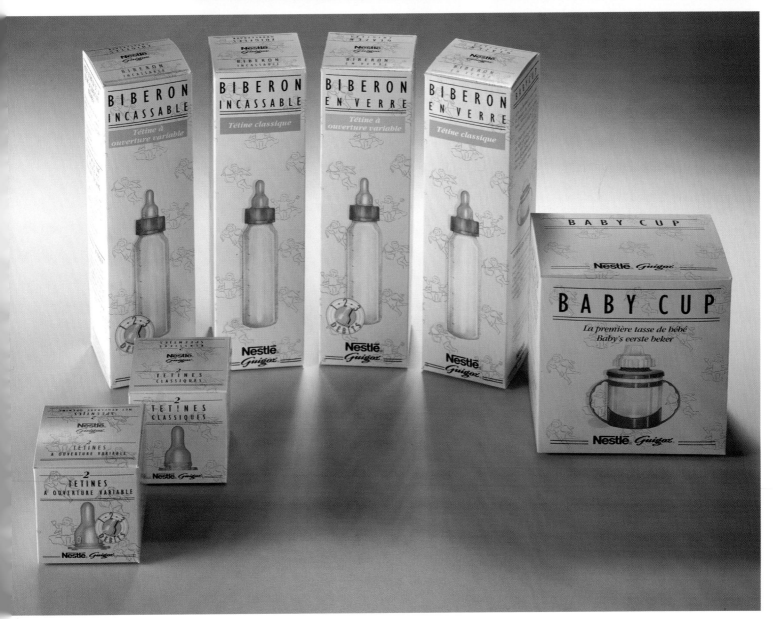

PACKAGE DESIGN FOR
CHARCOAL COMPANION LINE
OF BARBECUE ACCESSORIES
AND HARDWARE. THE PRODUCT
IS CREATED WITH A RADICALLY
DIFFERENT ARRAY OF SHAPES,
FORMATS AND SIZES.
DESIGN FIRM,
SHARON TILL ASSOCIATES,
OAKLAND, CALIFORNIA;
PHOTOGRAPHER,
PAUL MORRELL.

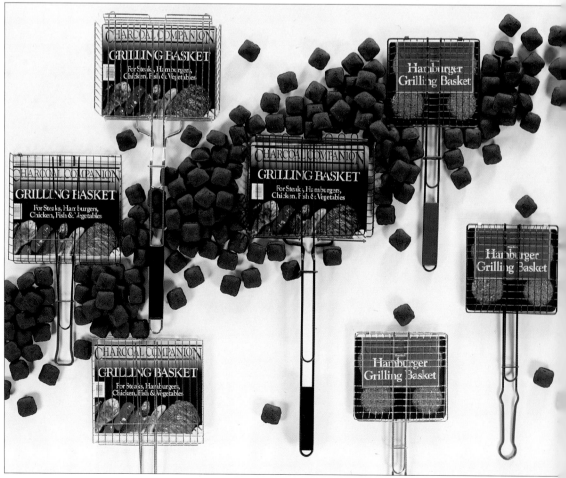

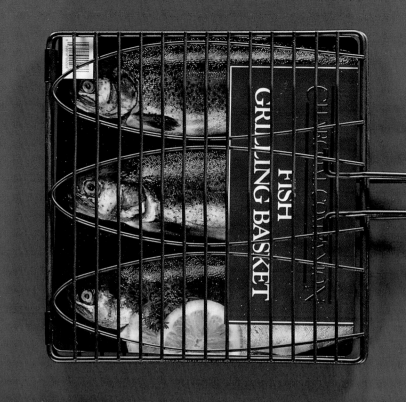

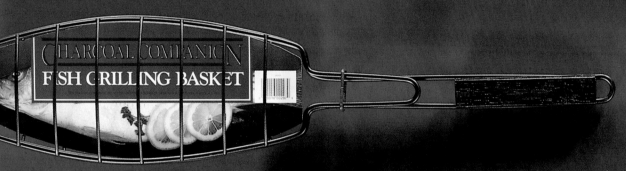

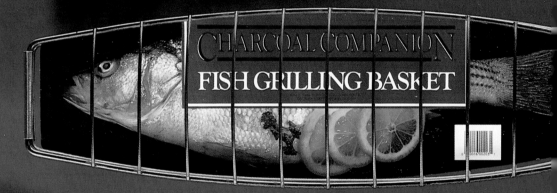

REDESIGN OF RAPID GRO
LINE OF NURSERY PRODUCTS
DESIGN FIRM, ADDISON DESIGN
CONSULTANTS
SAN FRANCISCO, CALIFORNIA
DESIGN DIRECTOR
KENICHI NISHIWAKI
DESIGNER
GARETH DEBENHAM

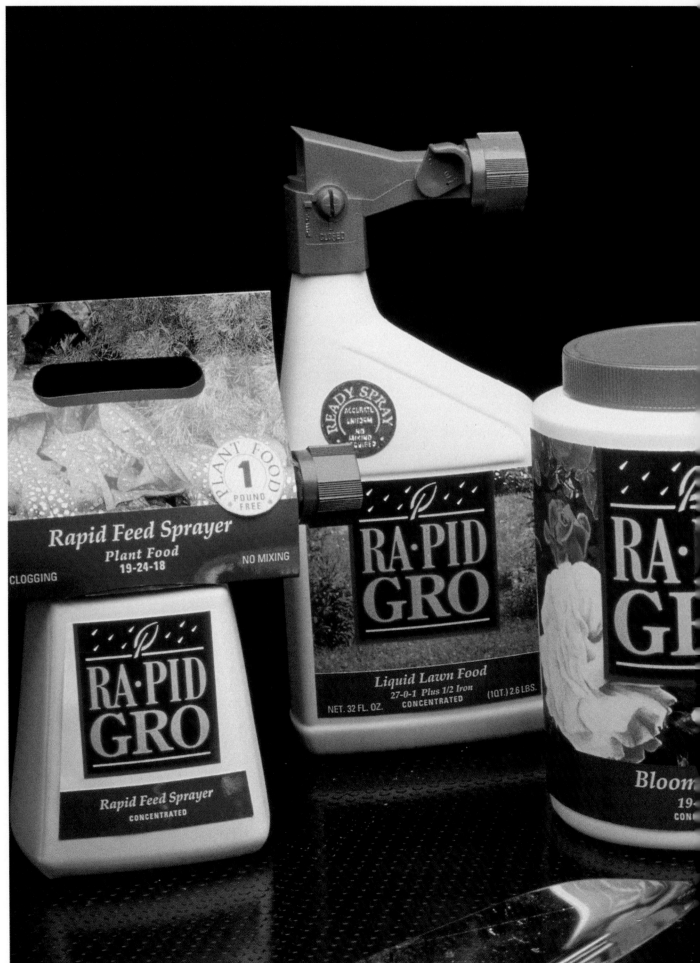

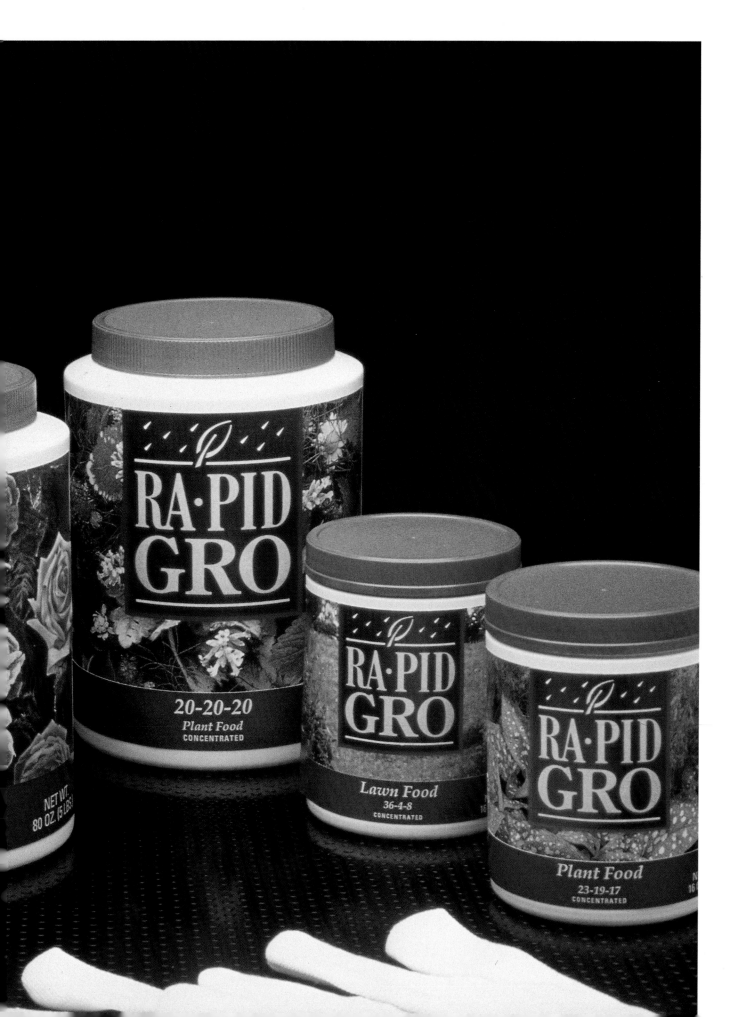

PFALTZGRAFF'S PACKAGING OF
GARDEN TOOLS.
**DESIGN FIRM,
LEWIN/HOLLAND, INC.,
NEW YORK, NEW YORK;
DESIGNER AND ILLUSTRATOR,
CHERYL LEWIN.**

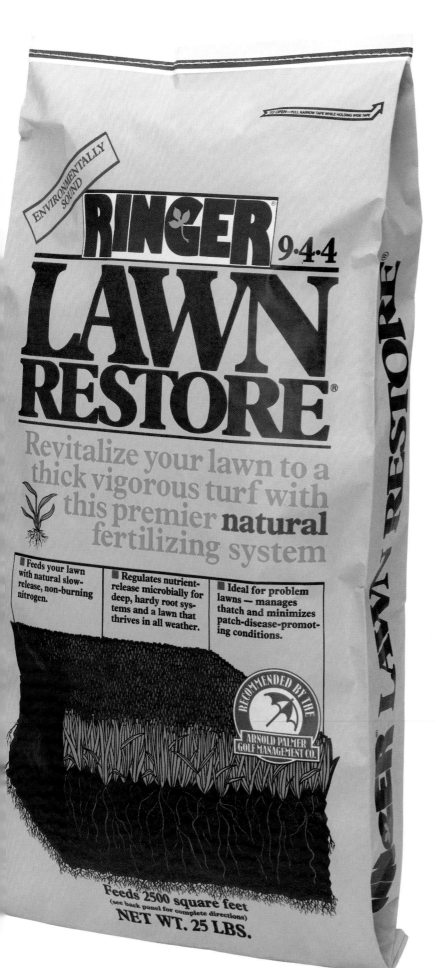

ENVIRONMENTALLY SOUND

RINGER 9·4·4
LAWN RESTORE®

Revitalize your lawn to a thick vigorous turf with this premier **natural** fertilizing system

■ Feeds your lawn with natural slow-release, non-burning nitrogen.

■ Regulates nutrient-release microbially for deep, hardy root systems and a lawn that thrives in all weather.

■ Ideal for problem lawns — manages thatch and minimizes patch-disease-promoting conditions.

RECOMMENDED BY THE ARNOLD PALMER GOLF MANAGEMENT CO.

Feeds 2500 square feet
(see back panel for complete directions)
NET WT. 25 LBS.

NATURAL ORGANIC LAWN AND GARDEN PRODUCTS ARE THE FOCUS OF RINGER CORP'S COMPOST PLUS, COMPOST MAKER, AND LAWN RESTORE. THE PACKAGING IS MADE FROM RECYCLED PAPERBOARD BOXES. **DESIGN FIRM, DESIGNED MARKETING,INC., MINNEAPOLIS, MINNESOTA; DESIGNER, TIM MORAN.**

129

OPPOSITE PAGE:
SOLLY'S CHOICE PREMIUM
WILDFLOWER SEED MIXES.
THE REMOVABLE LABELS ON
THE TINS OFFER A LOVELY
AND UNIQUE CONTAINER
FOR PLANTING.
**DESIGN FIRM, MODERN DOG,
SEATTLE, WASHINGTON;
TIN ILLUSTRATIONS AND
LABEL DESIGNS,
LI DESIGN, INC.,
NEW YORK, NEW YORK;
PACKAGING CONCEPT,
WALLY SHARP.**

NATURE COMPANY
WILDFLOWER SEED MIX, PART
OF A SERIES OF SEED MIXTURES
FOR NINE MAJOR GEOGRAPHIC/
CLIMATE ZONES IN THE U.S.
**DESIGNED BY
THE NATURE COMPANY,
BERKELEY, CALIFORNIA;
DESIGNER, MICHAEL MABRY.**

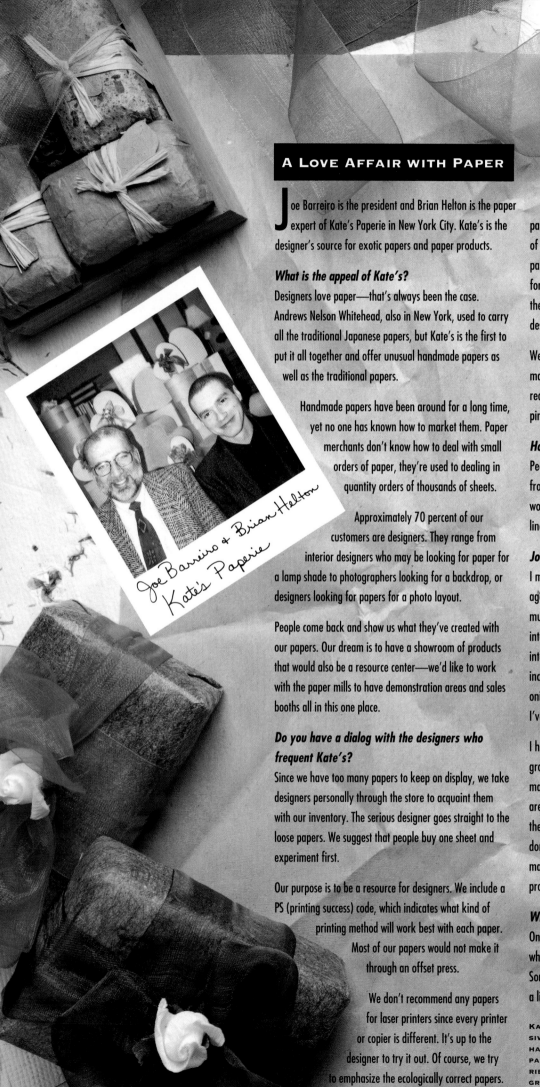

A LOVE AFFAIR WITH PAPER

Joe Barreiro is the president and Brian Helton is the paper expert of Kate's Paperie in New York City. Kate's is the designer's source for exotic papers and paper products.

What is the appeal of Kate's?

Designers love paper—that's always been the case. Andrews Nelson Whitehead, also in New York, used to carry all the traditional Japanese papers, but Kate's is the first to put it all together and offer unusual handmade papers as well as the traditional papers.

Handmade papers have been around for a long time, yet no one has known how to market them. Paper merchants don't know how to deal with small orders of paper, they're used to dealing in quantity orders of thousands of sheets.

Approximately 70 percent of our customers are designers. They range from interior designers who may be looking for paper for a lamp shade to photographers looking for a backdrop, or designers looking for papers for a photo layout.

People come back and show us what they've created with our papers. Our dream is to have a showroom of products that would also be a resource center—we'd like to work with the paper mills to have demonstration areas and sales booths all in this one place.

Do you have a dialog with the designers who frequent Kate's?

Since we have too many papers to keep on display, we take designers personally through the store to acquaint them with our inventory. The serious designer goes straight to the loose papers. We suggest that people buy one sheet and experiment first.

Our purpose is to be a resource for designers. We include a PS (printing success) code, which indicates what kind of printing method will work best with each paper. Most of our papers would not make it through an offset press.

We don't recommend any papers for laser printers since every printer or copier is different. It's up to the designer to try it out. Of course, we try to emphasize the ecologically correct papers.

We also act as agent for the designer of handmade papers and can negotiate any quantity purchases or rights of reproduction. It should be noted that some handmade papers have copyright now, so designers who buy papers for use in photography must be aware that if the paper they're using is protected under copyright, the paper designer may require a user fee.

We sell paper samples to designers all over the world. We'l make up a special order of samples based on their specific request, for example, "Send me something in blues and pinks with lots of texture."

How much of your paper is made of wood fibers?

People have a misconception: they think all paper is made from wood. Newspapers and printing papers are made of wood, but about 95 percent of our papers are made of linens, cotton, rags.

Joe, how do you find all these papers?

I make at least one trip to Europe a year. We have trading agents in the Far East. But our reputation has grown so much that people are coming to us at this point. A lot of interesting stuff just walks through the door. We just ran into a Brazilian company recently, in fact, which makes incredible natural-fiber papers—made with flowers, onions, bananas—the most unusual textures and fibers I've ever seen.

I heard recently that the kudzu weed, which is a vine-like ground cover imported to the southern part of the U.S., makes great paper. Very tough, long fibers. The Japanese are coming over to "farm" it. Kudzu is not only covering the ground, it's covering all the trees. It's out of control. W don't need all that kudzu, but we do need more raw materials for paper. This may solve two serious ecological problems at once!

What about the future of paper?

One problem is that there are no clear definitions as to what constitutes a recycled paper. Designers must be war Some mills will call a paper recycled when it really just ha a little newspaper thrown in.

KATE'S PAPERIE SELLS PRODUCTS PACKAGED EXCLU-SIVELY FOR THEM, SUCH AS THESE SOAPS WRAPPED IN HANDMADE PAPERS, TRADITIONAL JAPANES PAPERS PAPERS AND RAFFIA (TOP) AND MOKUBA PAPER AND RIBBON (BOTTOM). ALL THE PAPERS IN THE PHOTO-GRAPHS ON THE COVER AND CHAPTER DIVIDER PAGES ARE FROM KATE'S PAPERIE (SEE PAGES 134, 135).

Paul Hawken, CEO
Smith + Hawken

THINKING INSIDE THE BOX

Paul Hawken is the CEO of Smith & Hawken, the catalog merchandisers. Winners of the 1991 American Center for Design business award, Smith & Hawken was the first company to sign the Valdez Principles, the environmental code developed for business after the Exxon oil spill disaster in 1989.

How did Smith & Hawken discover popcorn as a packing material?

The way I remember it, when I was a kid, things were packed that way. Popcorn was used until styrofoam was invented. Someone had the great idea to replace popcorn with plastic that will last a thousand years—and they named it "popcorn" too! It was part of an era—the Fifties, Sixties; it was an insane love affair with technology—poisons, plastics, formica—technology overtook people's sensibilities. We didn't even dream about the waste stream then.

I think we were the first company to reintroduce real popcorn as a packing material in 1987 when there was no environmentally sound alternative. Now there are cornstarch alternatives to popcorn that dissolve in water.

Your corporate policy is considered environmentally correct. Is there ever resistance to adhere to this standard within the company?

There is resistance; not to each other, but to profiteering. Back in 1990 there were companies out there taking advantage of the sudden surge of interest in recycled papers. Paper companies were artificially raising prices because the demand was high. I wrote about this. I said, "You're sending the wrong message." Short-term thinking is what got us in trouble in the first place.

What about other companies getting on the eco band wagon?

Some companies are being hypocritical. But, hypocrisy is a good place to start. You can tell how big a change is by how much hypocrisy precedes it. It's not business that will sustain a change. It's the customer. If customers aren't sincere in demanding change, there will be no change.

As more companies become environmentally correct, do you think your unique position will be diminished?

We don't do it to be unique. A lot of companies are knocking us off and I think it's fabulous! People started getting our packages and writing to other companies, saying, "Why don't you do this too?"

Do you have any words of wisdom for all those designers who are concerned about creating future garbage?

Good design comes from limitations. There is no such thing as good design and excess. Economy, ecology—that's good design. Designers should reconfigure packaging from what you have to what you need. The trick is to eliminate packaging. This is a total reversal of what was required before, which was how to make a product take up more space and use more materials in order to make it stand out more.

Then what do you predict the future retail sales environment in the United States will be like?

There's a hard goods store in Japan where absolutely nothing is packaged. It's a beautiful store. That's the way our stores are going to look in the future.

POPCORN, STRAW AND OTHER ORGANIC MATERIALS ARE USED IN SHIPPING AND PACKING BY SMITH & HAWKEN.

MOKUBA MAKES A COLLECTION
OF PAPERS AND RIBBONS FOR
WRAPPING, SOLD IN THE
UNITED STATES EXCLUSIVELY
AT KATE'S PAPERIE.
MOKUBA, JAPAN.

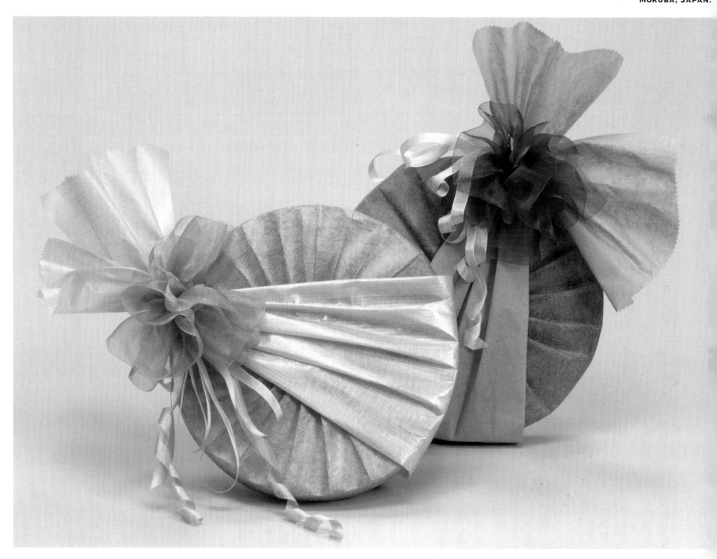

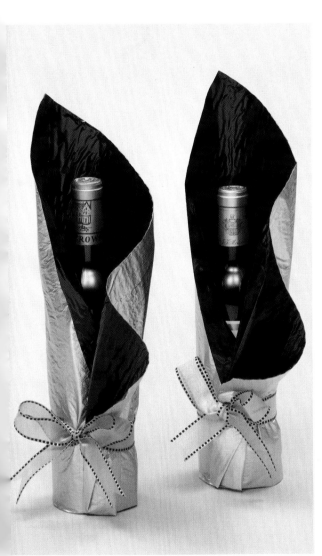

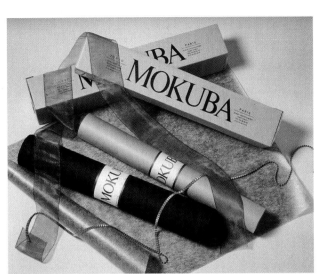

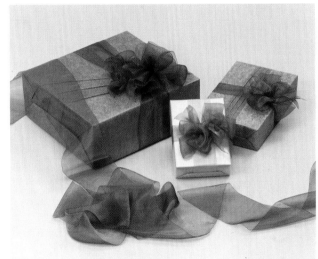

DARWIN DESK PACKAGES ARE PART
OF THE IN-STORE DISPLAY FOR
THE NATURE COMPANY. THEY
ELIMINATE THE NEED FOR SMALL
ITEMS TO BE LOCKED AWAY. THE
TRAYS, INSERTS AND STICKERS
ARE INTERCHANGEABLE.
**DESIGN FIRM,
GERALD REIS & COMPANY,
SAN FRANCISCO, CALIFORNIA;
DESIGNER, GERALD REIS.**

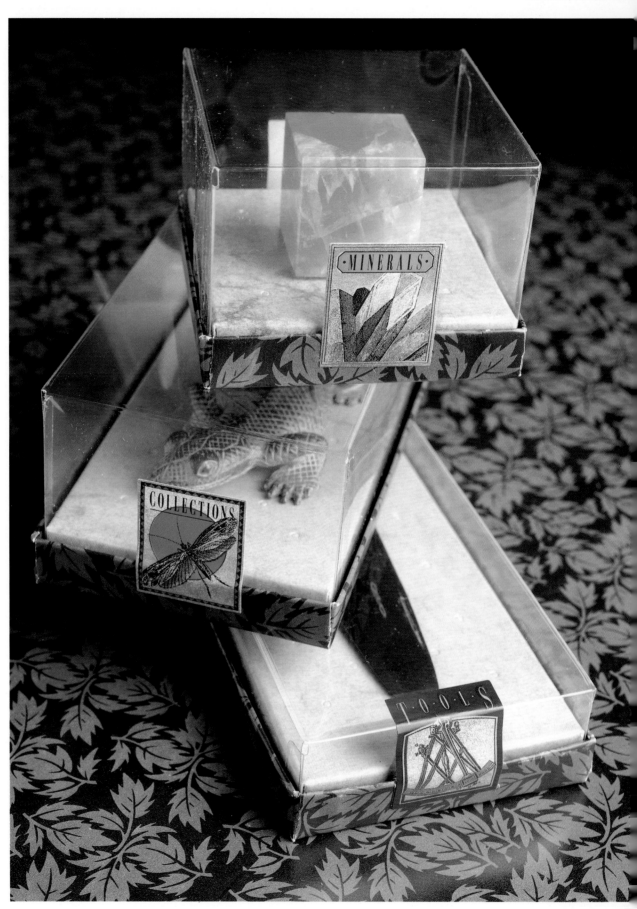

TURE COMPANY RECYCLED
AFT SHOPPING BAGS WERE
ED IN PLACE OF BLEACHED,
EATED MATERIALS.
SIGN FIRM,
RALD REIS & COMPANY,
N FRANCISCO, CALIFORNIA;
SIGNERS, GERALD REIS,
BERT TRESKIN.

NATURE COMPANY GIFT BOXES
WERE DESIGNED WITH A
COMMON THEME OF ETCHINGS
FROM NATURE, IN VARIOUS
SIZES. POST-CONSUMER
RECYCLED PAPER AND NON-
METALLIC INKS WERE USED.
DESIGN FIRM,
GERALD REIS & COMPANY,
SAN FRANCISCO, CALIFORNIA;
DESIGNER, GERALD REIS.

NATURE COMPANY WATER AND
ROCK WRAPPING PAPER IS 4
COLOR LITHO PRINTED ON
20 X 28 SHEETS.
DESIGNED BY
THE NATURE COMPANY,
BERKELEY, CALIFORNIA;
PHOTOGRAPHER,
JOHN FIELDER.

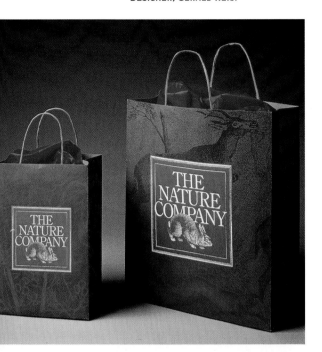

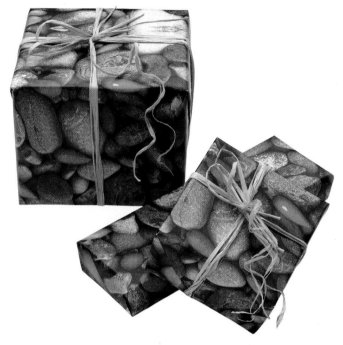

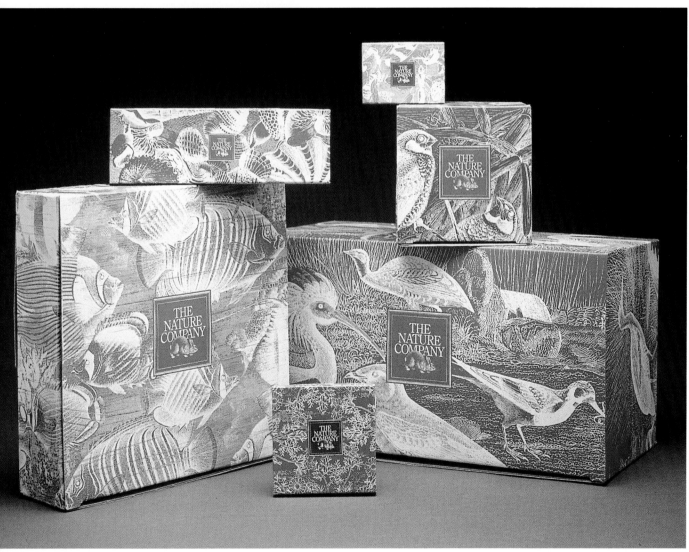

SELF PROMOTION CUSTOM MADE BOX CONTAINING AN EXPANDABLE SERIES OF 140 CARDS DOCUMENTING VARIOUS PROJECTS. **DESIGN FIRM, CHARLES S. ANDERSON, MINNEAPOLIS, MINNESOTA; ART DIRECTORS AND DESIGNERS, CHARLES S. ANDERSON, DANIEL OLSON.**

BARBER ELLIS GRADE REPORT BAG HOLDS PAPER SAMPLES AND IS HANDED OUT TO ATTENDEES OF THE COMPANY'S ANNUAL PAPER SHOW. **DESIGN FIRM, CHARLES S. ANDERSON, MINNEAPOLIS, MINNESOTA; ART DIRECTORS AND DESIGNERS, CHARLES S. ANDERSON, DANIEL OLSON.**

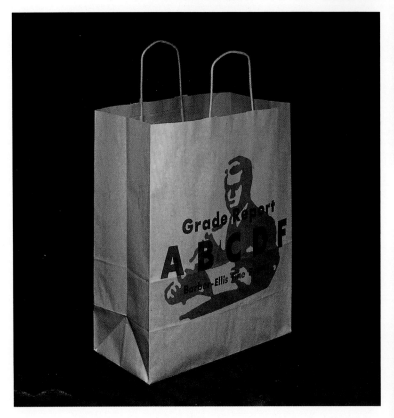

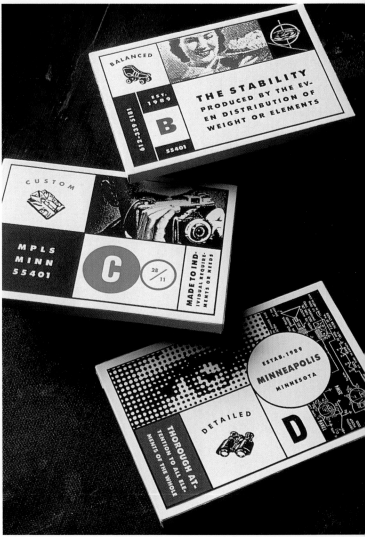

...M BOX PRESENTATION CASE
...SIGNED FOR PARAMOUNT
...ODUCTS, HOLLYWOOD. THE
...SE IS USED TO HOLD INFOR-
...TION ON THE COMPANY'S
...RITAGE OF MAKING MOVIES.
...SIGN FIRM,
...ARLES S. ANDERSON,
...NNEAPOLIS, MINNESOTA;
...T DIRECTORS,
...NIEL OLSON,
...ARLES S. ANDERSON.

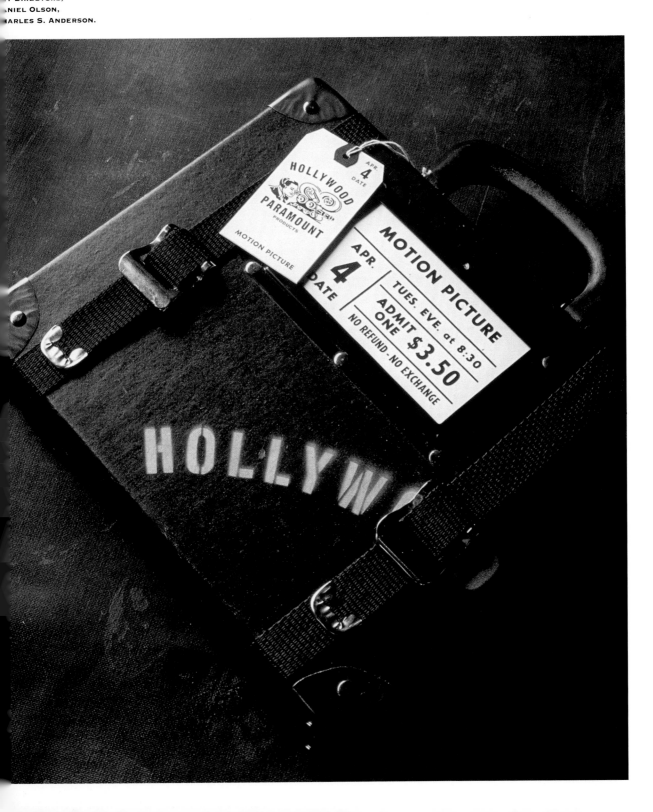

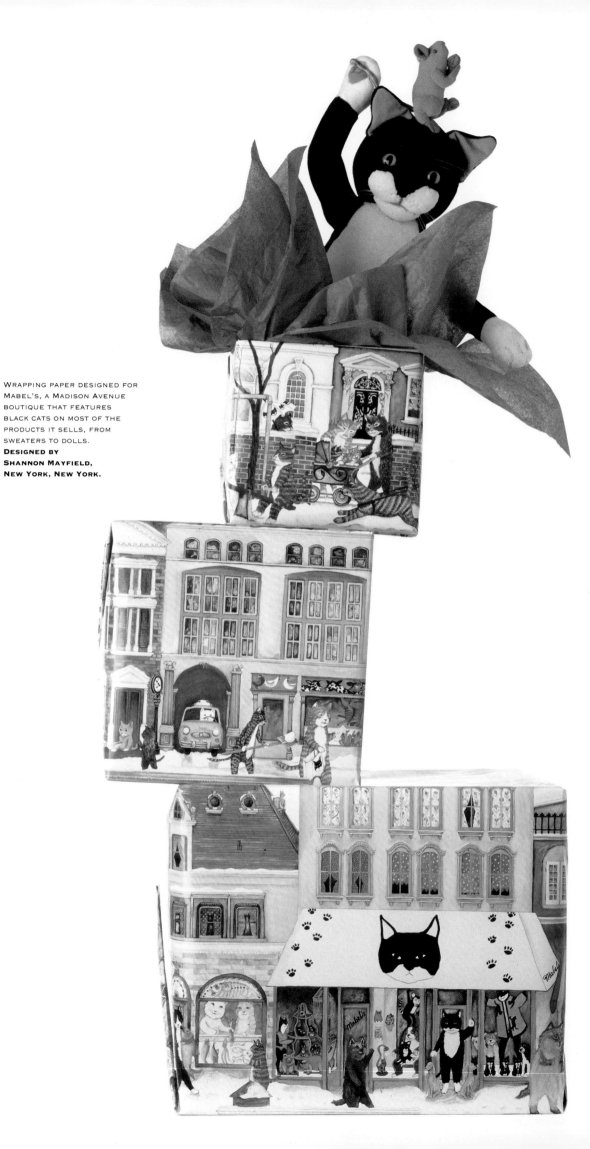

WRAPPING PAPER DESIGNED FOR MABEL'S, A MADISON AVENUE BOUTIQUE THAT FEATURES BLACK CATS ON MOST OF THE PRODUCTS IT SELLS, FROM SWEATERS TO DOLLS. **DESIGNED BY SHANNON MAYFIELD, NEW YORK, NEW YORK.**

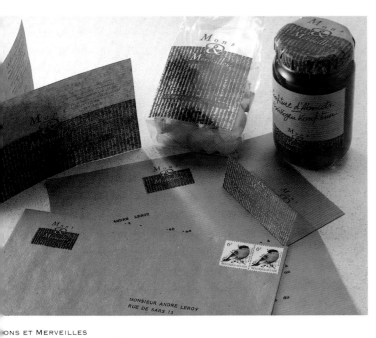

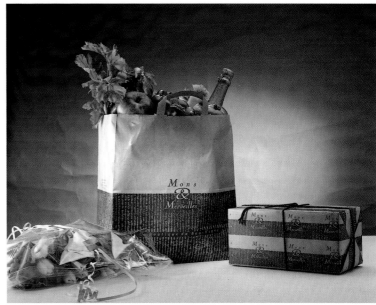

ONS ET MERVEILLES
AGS AND WRAPS FOR
AUL DESCAMPS.
ESIGN FIRM,
E P DESIGN GROUP,
ELGIUM; DESIGNER,
HRISTINE EVRARD-LAUWEREINS.

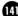

BAGS, BOXES, MENU AND
MATCHBOOKS DESIGNED FOR
TOULOUSE RESTAURANT,
MINNEAPOLIS. THE ESSENTIAL
MATERIALS USED ARE BROWN
CORRUGATED CARDBOARD AND
CRAFT PAPER.
DESIGN FIRM,
THE DUFFY DESIGN GROUP,
MINNEAPOLIS, MINNESOTA;
DESIGNER, TODD WATERBURY.

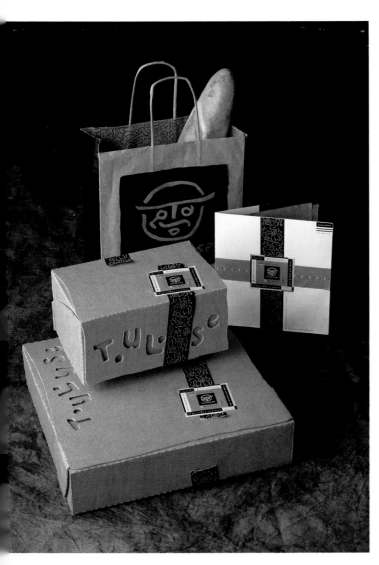

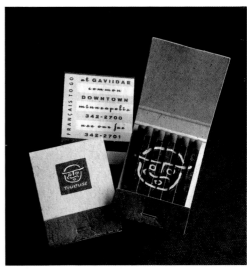

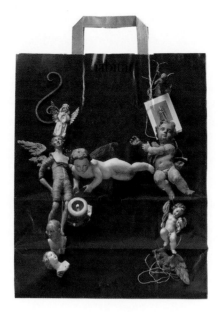
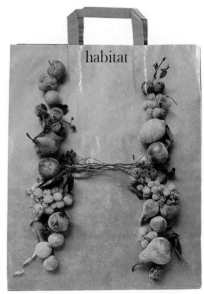

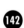

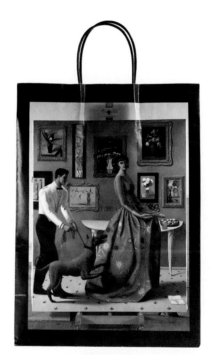
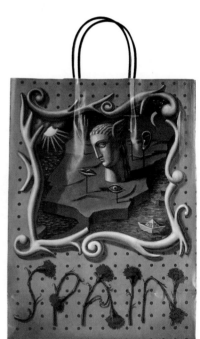

CHRISTMAS SHOPPING BAG
DESIGNS FOR HABITAT DESIGNS
LTD. INCORPORATED NEW
IDENTITY OF EXCLUSIVE "H"
CREATED OUT OF VARIOUS
MATERIALS.
DESIGN FIRM,
ROBERT VALENTINE INC.,
NEW YORK, NEW YORK;
ART DIRECTOR AND DESIGNER,
ROBERT VALENTINE;
PHOTOGRAPHER,
MARIA ROBLEDO;
STYLIST, ANITA CALARO.

BLOOMINGDALE'S "SPAIN"
SHOPPING BAG FOR FALL '90.
SPAIN HAD JUST BEEN CHOSEN
TO HOST THE '92 OLYMPICS IN
BARCELONA.
DESIGN FIRM,
ROBERT VALENTINE INC.,
NEW YORK, NEW YORK;
ART DIRECTOR AND DESIGNER,
ROBERT VALENTINE;
ILLUSTRATOR,
SIGFRIDO MARTÍN BEGUÉ

"VIVE LA FRANCE" SHOPPING
BAG WAS DESIGNED AS PART
OF BLOOMINGDALE'S FALL '89
STORE-WIDE PROMOTION.
DESIGN FIRM,
ROBERT VALENTINE INC.,
NEW YORK, NEW YORK;
ART DIRECTOR AND DESIGNER,
ROBERT VALENTINE;
PHOTOGRAPHER, GEOF KERN.

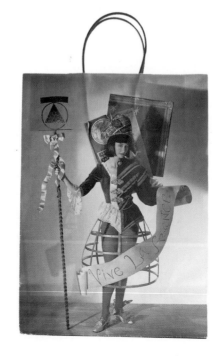
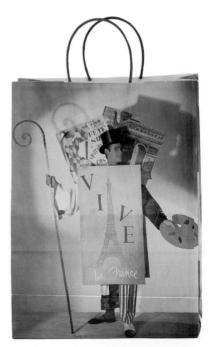

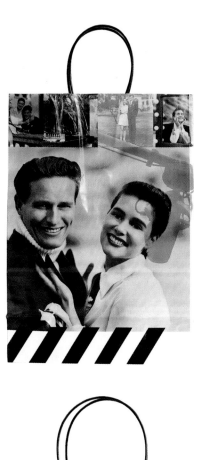

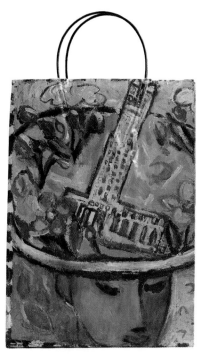
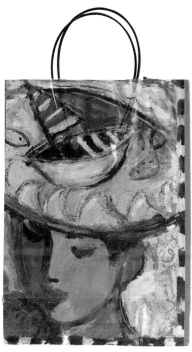
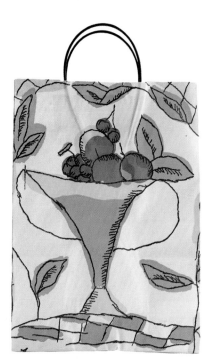
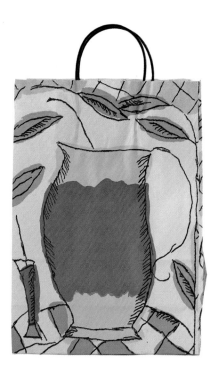

143

"HOLLYWOOD" SHOPPING BAG
DESIGN FOR BLOOMINGDALE'S
SPRING '88 SEASON.
DESIGN FIRM,
ROBERT VALENTINE INC.,
NEW YORK, NEW YORK;
ART DIRECTOR AND DESIGNER,
ROBERT VALENTINE;
PHOTOGRAPHER,
MATTHEW RALSTON.

"CHICAGO" SHOPPING BAG
SALUTED OPENING OF NEW
STORE IN CHICAGO.
DESIGN FIRM,
ROBERT VALENTINE INC.,
NEW YORK, NEW YORK;
ART DIRECTOR AND DESIGNER,
ROBERT VALENTINE;
ILLUSTRATOR,
KELLY STRIBLING.

BLOOMINGDALE'S "SUMMER"
SHOPPING BAG USES FRESH
IMAGES FOR THE '89 SEASON.
DESIGN FIRM,
ROBERT VALENTINE INC.,
NEW YORK, NEW YORK;
ILLUSTRATOR,
PHILIPPE WEISBECKER.

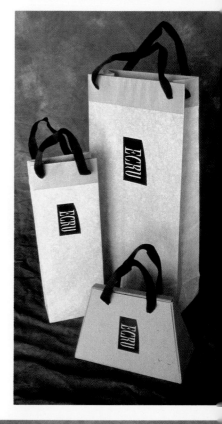

PACKAGE DESIGN FOR ECRU
DESIGNER CLOTHING. THE
BOXES ARE FABRICATED FROM
RECYCLED, BIODEGRADABLE
INDUSTRIAL CHIPBOARD THAT
CAN BE STORED FLAT AND THEN
FOLDED INTO CUSTOM SHAPES.
DESIGN FIRM,
MARGO CHASE DESIGN,
LOS ANGELES, CALIFORNIA.

OPPOSITE PAGE:
IDENTITY SYSTEM FOR
SPRINGERS CLOTHING STORES
IN THE HAMPTONS. RECYCLED
KRAFT PAPER BAGS, COTTON
RIBBONS AND HANDLES ARE
USED IN THE PACKAGING.
DESIGN FIRM,
CARBONE SMOLAN,
NEW YORK, NEW YORK;
PRINCIPAL, KEN CARBONE,
DESIGN DIRECTOR,
ALLISON MUENCH.

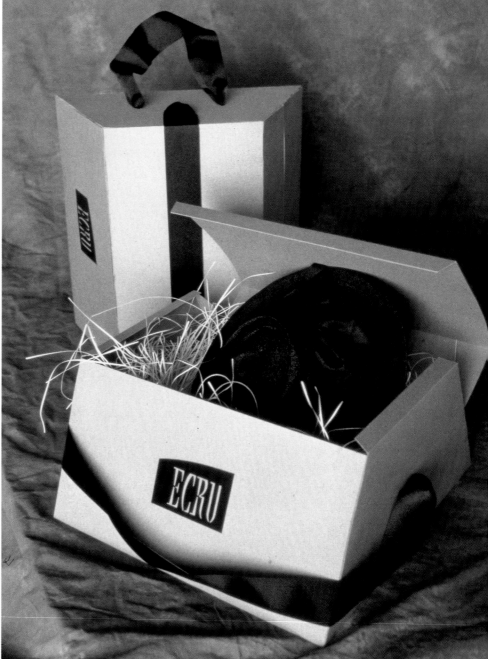

146

GUEST AMENITIES PACKAGE
DESIGN FOR THE EMPIRE
HOTEL, NEW YORK.
**DESIGN FIRM, PENTAGRAM,
NEW YORK, NEW YORK;
ASSOCIATE,
MICHAEL GERICKE;
DESIGNERS, JIM ANDERSON,
MICHAEL GERICKE,
ELAINE PETSCHEK.**

OPPOSITE PAGE:
GRAPHIC IDENTITY FOR HILTON
INTERNATIONAL HOTELS,
LONDON, ENGLAND.
**DESIGN FIRM,
LANDOR ASSOCIATES,
SAN FRANCISCO, CALIFORNIA;
DESIGN DIRECTOR,
MICHAEL CARABETTA;
CREATIVE DIRECTOR,
TOM SUITER.**

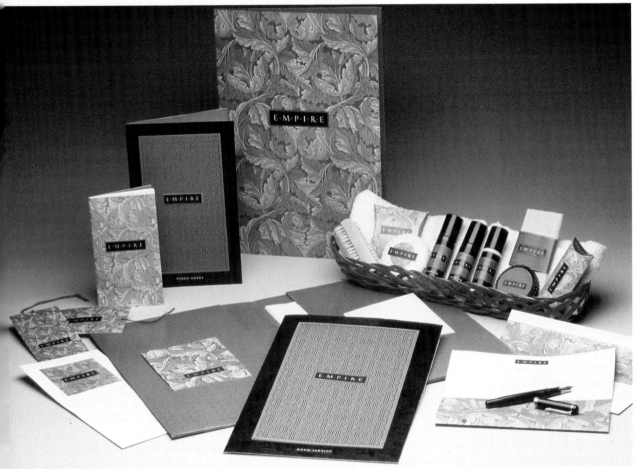

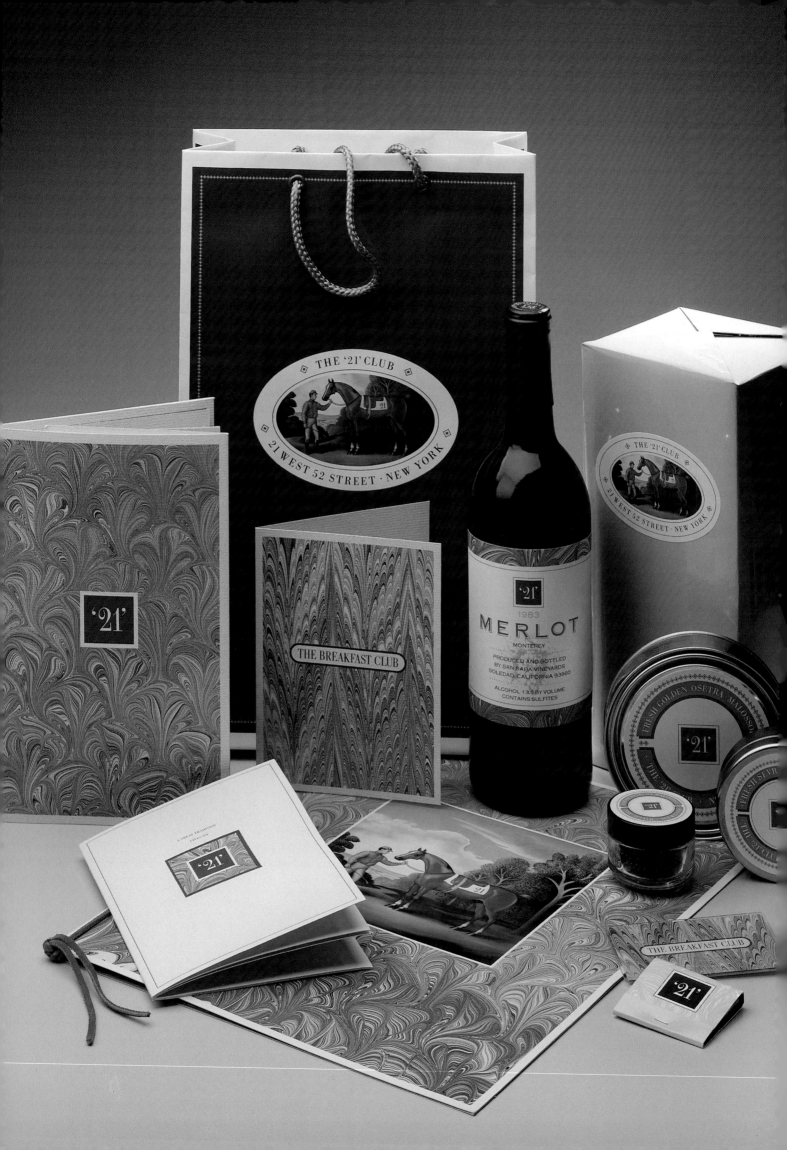

OPPOSITE PAGE:
GRAPHIC IDENTITY PROGRAM FOR
THE 21 CLUB IN NEW YORK
INCLUDES LOGOTYPE, HISTORY
BOOKLET, MENU, BANQUET
PACKAGE, WINE LABEL AND
STATIONERY. THROUGH UPDATING
THIS TRADITIONAL LANDMARK
RESTAURANT, THE WELL-KNOWN
'21' JOCKEY REMAINED A GRAPHIC
REFERENCE TO ITS HISTORY.

DESIGN FIRM, PENTAGRAM,
NEW YORK, NEW YORK;
PARTNER, PETER HARRISON;
ASSOCIATE PARTNER AND
DESIGNER, SUSAN HOCHBAUM;
ILLUSTRATOR, PAUL DAVIS.

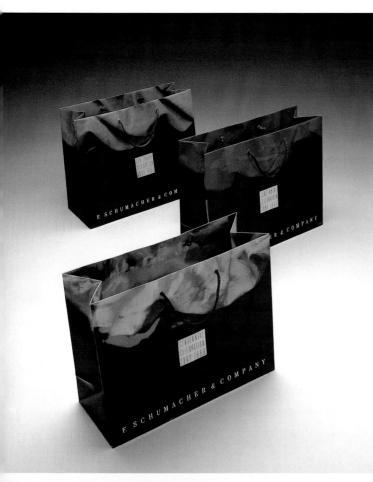

SHOPPING BAG DESIGNS COM-
MEMORATING THE 100TH ANNI-
VERSARY OF F. SCHUMACHER &
CO. TEXTILES. THE INSIDE OF
THE BAG IS PRINTED WITH AN
IMAGE OF THE COMPANY'S
SIGNATURE SILK DAMASK
OVERFLOWING ONTO THE FRONT.
DESIGN FIRM,
DESIGNFRAME INC.,
NEW YORK, NEW YORK;
DESIGNERS, JAMES SEBASTIAN,
JOHN PLUNKETT, DAVID REISS,
KATHLEEN WILLS,
JUNKO MAYUMI;
PHOTOGRAPHER,
NEIL SELKIRK.

SHOPPING BAG SYSTEM FOR
BARNEYS NEW YORK.
DESIGN FIRM,
DONOVAN AND GREEN,
NEW YORK, NEW YORK;
ART DIRECTOR,
NANCYE GREEN;
DESIGNERS, JULIE RIEFLER,
JENNY BARRY; IDENTITY,
CHERMAYEFF AND GEISMAR,
INC., NEW YORK, NEW YORK.

149

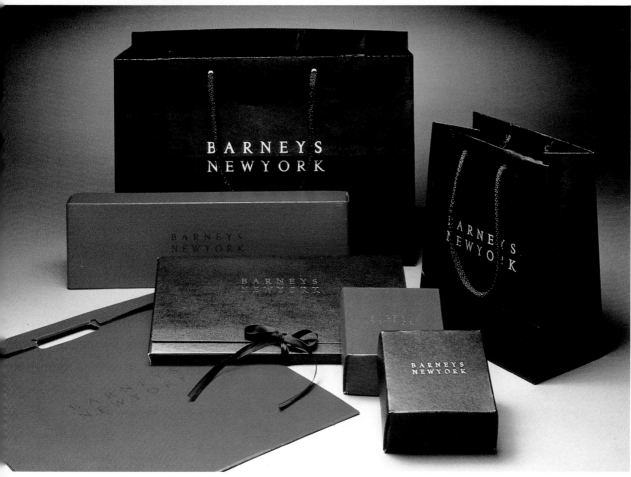

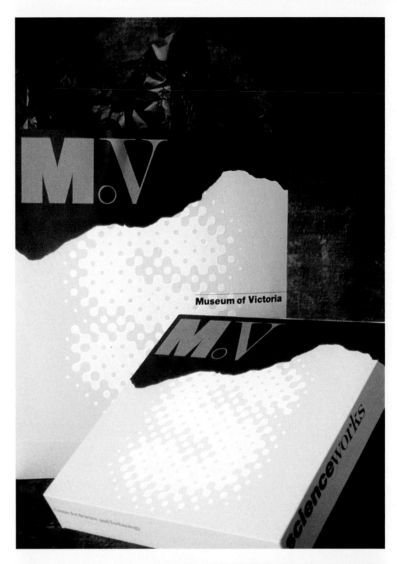

PACKAGE DESIGN FOR THE
MUSEUM OF VICTORIA RETAIL
SHOPS.
**DESIGN FIRM, CATO DESIGN,
RICHMOND, AUSTRALIA;
DESIGNER, KEN CATO.**

150

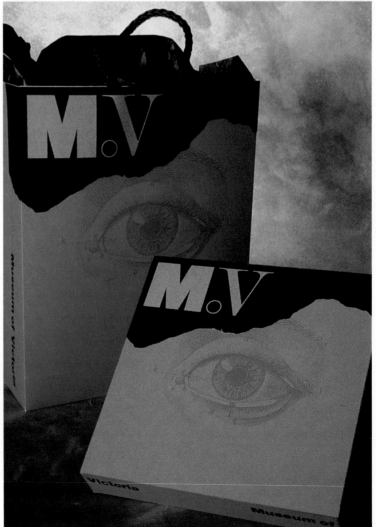

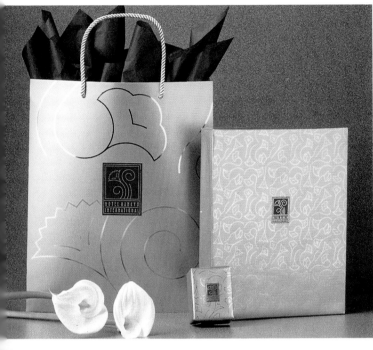

STYLIZED FLOWER SYMBOLS
ARE THE GRAPHIC IDENTITY FOR
THE CHAIN OF HOTEL HANKYU
INTERNATIONAL. A CUSTOM
ALPHABET WAS DESIGNED
AND USED IN ALL APPLICATIONS.
**DESIGN FIRM, PENTAGRAM,
NEW YORK, NEW YORK;
PARTNER, COLIN FORBES;
ASSOCIATE, DESIGNER AND
TYPOGRAPHER,
MICHAEL GERICKE;
DESIGNER, DONNA CHING;
ILLUSTRATOR,
MCRAY MAGLEBY.**

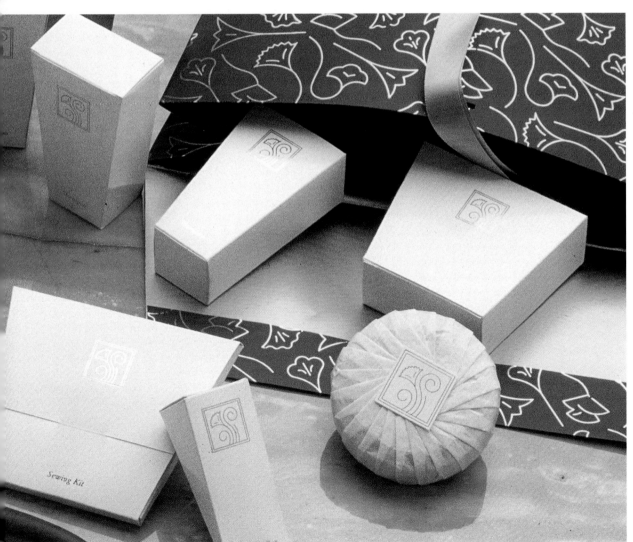

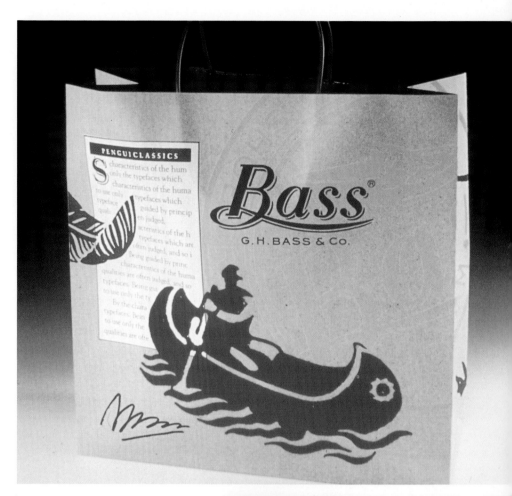

LOGO DESIGN AND BAG FOR
BASS SHOES, NEW YORK.
DESIGN FIRM,
MICHAEL PETERS LIMITED,
LONDON;
DESIGNER AND TYPOGRAPHER,
MARCUS HEWITT; CREATIVE
DIRECTOR, GLENN TUTSSEL.

TUTTO MARE MATCHES FOR
SPECTRUM FOODS.
DESIGN FIRM,
PRIMO ANGELI INC.,
SAN FRANCISCO, CALIFORNIA;
DESIGNER, PRIMO ANGELI.

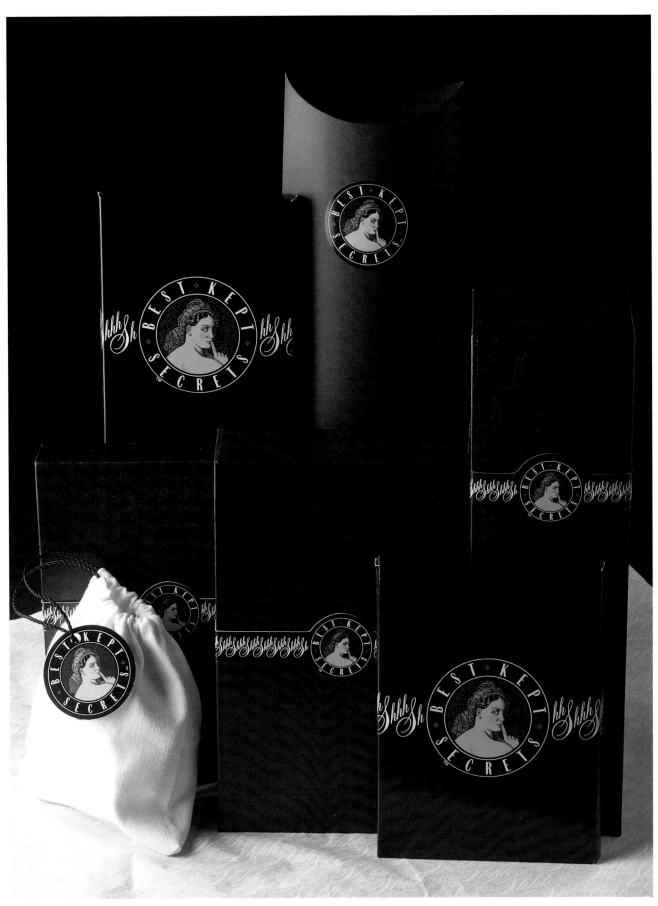

153

Logo, and packaging design for Best Kept Secrets, a mail-order company directed towards women.

Design Firm,
Milton Glaser, Inc.,
New York, New York;
Art Director,
Milton Glaser;
Designers, Milton Glaser,
Chi-ming Kan,
David Freedman,
Suzanne Zumpano;
Lettering, George Leavitt.

COMO PRODUCE SHOPPING BAGS
ARE AN EASY CARRY-ALL FOR
FOOD ITEMS AVAILABLE FROM A
FASHIONABLE FOOD STORE.
**DESIGN FIRM, CATO DESIGN
INC., RICHMOND, AUSTRALIA
DESIGNER, CHRIS PERKS**

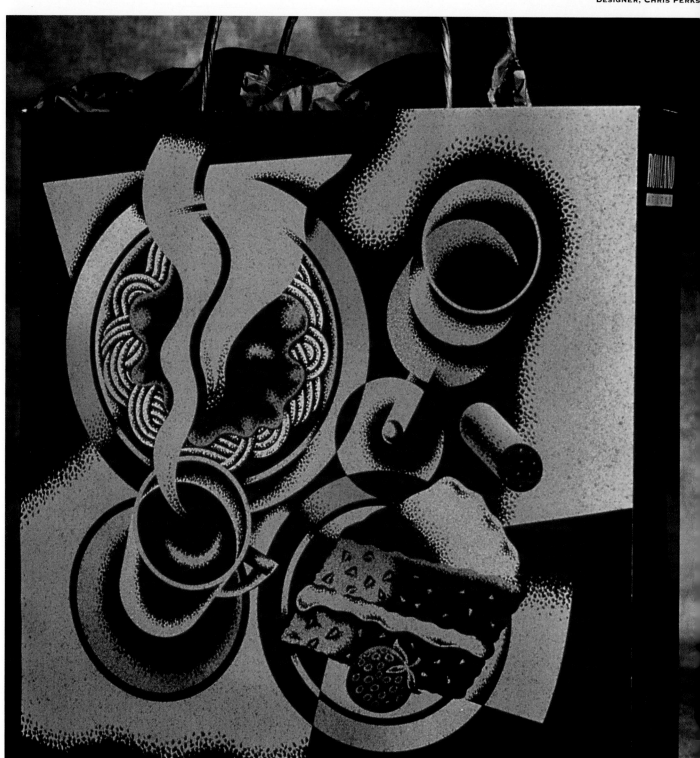

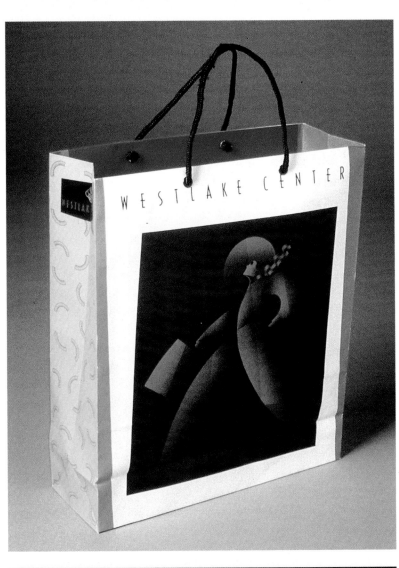

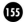

WESTLAKE CENTER/
THE ROUSE COMPANY
SHOPPING BAG DESIGNS.
**DESIGN FIRM,
SULLIVAN PERKINS,
DALLAS, TEXAS; ART DIRECTOR,
RON SULLIVAN;
DESIGNER AND ILLUSTRATOR,
JON FLAMING.**

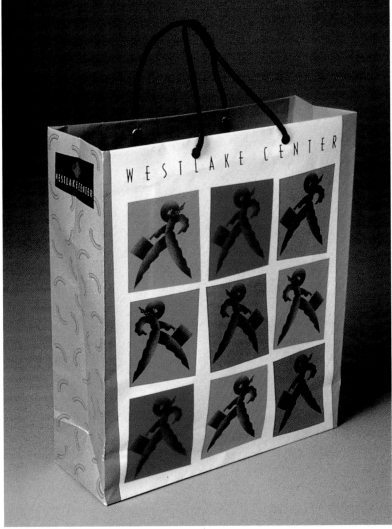

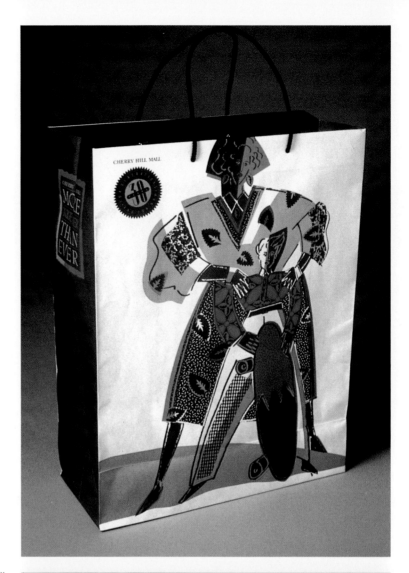

SHOPPING BAG FOR CHERRY
HILL MALL/THE ROUSE
COMPANY.
**DESIGN FIRM,
SULLIVAN PERKINS,
DALLAS, TEXAS; ART
DIRECTOR, RON SULLIVAN;
DESIGNER AND ILLUSTRATOR,
JON FLAMING.**

OPPOSITE PAGE:
BAG DESIGNS FOR NORTH STAR
MALL/THE ROUSE COMPANY,
SAN ANTONIO, TEXAS.
**DESIGN FIRM,
SULLIVAN PERKINS,
DALLAS, TEXAS;
ART DIRECTOR, RON SULLIVAN;
DESIGNER, LINDA HELTON.**

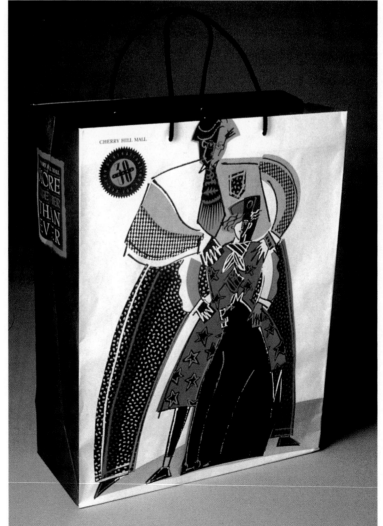

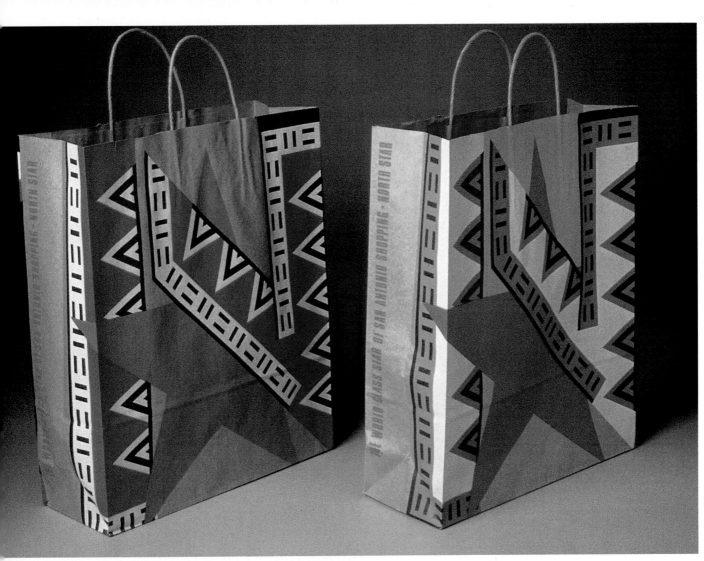

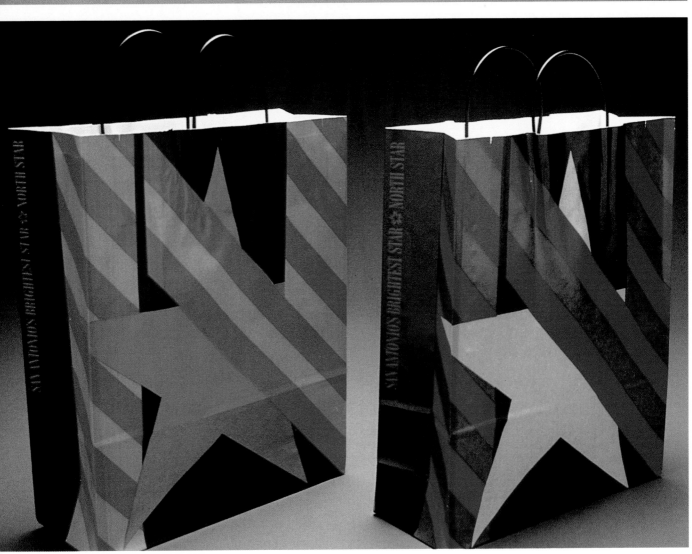

This logo was applied to all packaging and signage throughout Neuman & Bogdonoff. **Design Firm, Lewin/Holland, Inc., New York, New York; Designer and Illustrator, Cheryl Lewin.**

Graphic identity and in-store development for Tommy Hilfiger, Murjani International. **Design Firm, Landor Associates, San Francisco, California; Creative Director, Kenneth Cooke; Designer, Courtney Reeser.**

Opposite page: SF Clothing shopping bags. The design was produced with a can of spray paint to reflect the 'punk' and youthful character of the store's customers. **Design Firm, George Tscherny, Inc., New York, New York; Designer, George Tscherny.**

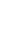

158

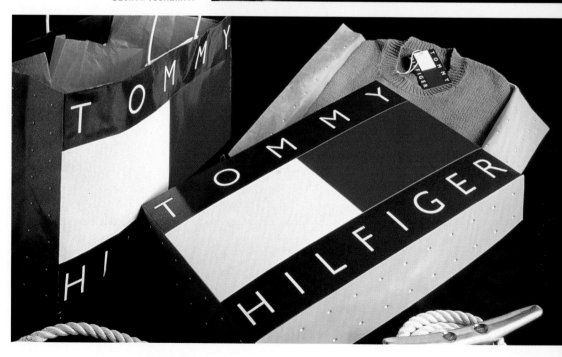

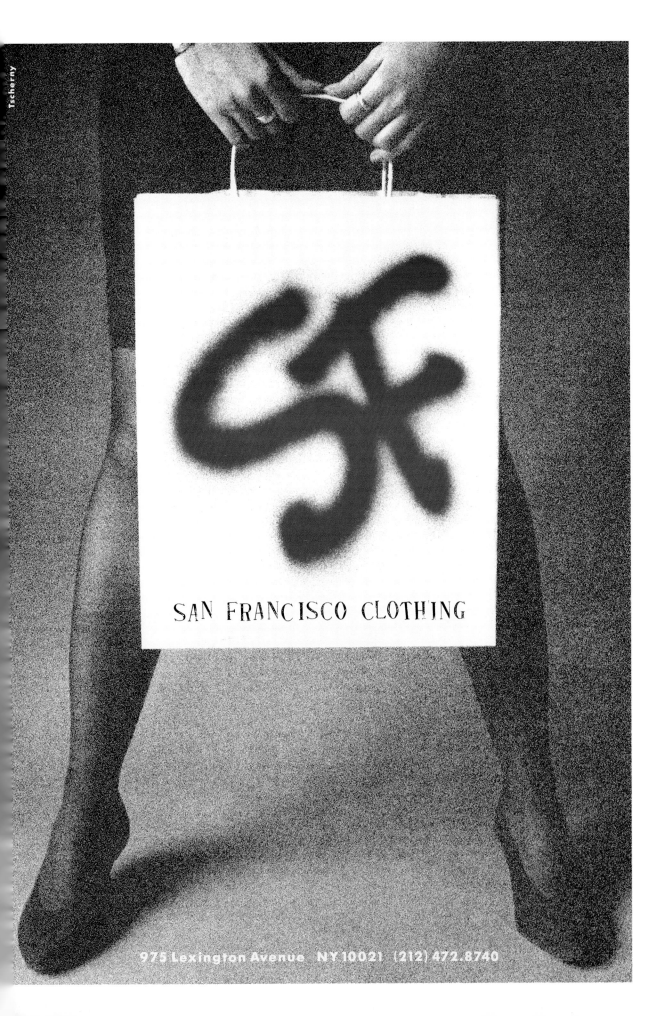

SAN FRANCISCO CLOTHING

975 Lexington Avenue NY 10021 (212) 472.8740

Robert Valentine, principal
Robert Valentine Inc.

IN GOOD TASTE

Robert Valentine's retail designs for Conran's Habitat and Bloomingdale's are stunning and innovative.

Did you always want to be a designer?

I would rearrange furniture at the age of four. I gave my mother fashion advice when I was in kindergarten. I drove my parents nuts. So I always knew I'd do something involved in a creative field when I grew up.

A few years after I graduated from Milwaukee Institute of Art & Design, I formed my own company and Dayton Hudson was my primary client. I was responsible for all of their advertising, storewide promotions, product development, department logos and catalogs. Soon, Bloomingdale's became aware of my work. They wanted me to move to New York. I figured, I'm young; I can always come back to Minneapolis, so I moved to New York. What did I have to lose? I've never regretted it.

I worked at Bloomingdale's for three years and started the in-store graphic design department that was responsible for nationwide store promotions, including all collateral material and videos. Then in 1990, I went to London and worked for Conran's Habitat for eight months. I now have my own design firm in New York's Tribeca.

You seem to have had great opportunities to express yourself in the time you've been in retail.

Retail is very unstructured; totally crazy. And I found that I work very well in that kind of environment. It's very seat-of-your-pants design. Not a lot of layers of approvals. If you get it, you get it. You have to think very fast and on your toes. I've seen a lot of people come out of retail who can think quickly. You have to—in order to survive. Retail's also very seasonal. You know the same thing's going to come around again. You have more than one opportunity to do something, and then maybe do it better. You're art director, photo stylist, designer all wrapped up in one.

All this has worked to my advantage. I'd go in there and say "This is it!" I learned not to be afraid of failing. I learned to move on. There were 100 projects waiting in the wings that needed my attention, so I couldn't dwell on one decision. It's a great learning experience. I highly recommend as a way to learn about design—to anyone who can take the pressure.

Do you consider environmental concerns in your designs?

I think that's a band wagon everyone should get on. I find that clients, more and more, expect me to know about environmental issues. But it's not that easy to find a very good printer that uses soy-based inks. I would like to see more white papers produced that are environmentally safe. Everything doesn't have to look brown either. The recycled look is getting a bit tired.

Do you have a design philosophy?

Good taste is an essential ingredient to great packaging. I approach packaging projects using myself as the audience. What would get me excited if I saw it on the shelf? It goes back to taste. I'm trying to educate and elevate the viewer through my work by creating a look that appeals to the consumer without compromising my own standards. I want to make my work accessible, yet give more than is asked for.

I don't see my work as having a particular style. When someone gives me a project, I figure out what's going to work best for them based on my "intuition." Of course, each project has a look, but one that's appropriate to the project's needs. If the style overpowers the message, that's not good design. I have a real problem with designers who force feed their style on a client. When you see something you know who designed it without even seeing a credit. To me, that's no longer style, but a "gimmick" applied to the surface of the work. It's a big ego trip. It tells me the designer was not listening to the needs of the client. On the other hand, I don't understand a client who approaches a designer and says, "Make it look like that." Why would they want to look like someone else?

Eric Smith, owner
World Love Productions

GLAMOURIZING THE SOCK

E.G. Smith is known for his wonderful socks, but is not just a sock designer. E.G. Smith received the Cutty Sark Award (the fashion industry's Oscar) in 1988 for Best Menswear Accessories.

Why socks?

My family had been in socks for three generations: My grandfather was a mill rep; my father sold tube socks to the mass market. But I was a rebel—I went to law school —where I realized there was a void in the market for fashion socks. It seemed an interesting idea to me, how do you market something people are so unconscious of—a sock—and make it exciting?

So around 1981 I found myself involved in making socks glamorous and creating them as a product that people wanted to show off. How do you seduce the customer into buying your product over someone else's? Actually, it's not so much a seduction, since I certainly don't mean it in a sexual sense. My whole theory is the antithesis of the Calvin Klein approach, which is putting gorgeous, rich people in limousines and making these the images we're supposed to aspire to. But then this somehow leaves *you* somewhere down here. You need to address your audience with person-al, humorous, *human* messages.

I didn't want a designer name for the product. I felt that names were becoming a replacement for quality. So it was natural for me to ask Seth Jaben to come up with a fun logo—something with a party-like atmosphere. So we made the name, World Love, small and I established E.G. Smith as the name for the company. I wanted to communicate something positive. It was exciting to package it. And, while some manufacturers were spending two cents a label, we were spending 12 cents a label for it.

I also wanted to do a foot-shaped shopping bag. But I had to go to many different manufacturers before I could find someone who would work with me. I finally hired a paper engineer to figure out and design the construction. It's become the ultimate bag. I don't think I could top it.

I can look at just about any product out there and think, "Isn't that boring?" I couldn't tear myself away from socks a few years ago because I had a tiger by the tail, but now I'm exploring other things.

The reply cards you insert into your packaging reach out to the people who buy your socks.

I love those. The first thing I do when I come in in the morning is check the mail.

You see, we started out with no advertising budget. And the best way to advertise is to get to consumers in the store when they're ready to make a decision. They're not making a decision sitting at home flipping through some magazine. It's a long shot that they're really going to a certain store to buy a particular product. So if I'm going to be in a store I have to make sure that my socks are beautifully packaged and have the best visibility, best "real estate"—the parts of a store that are more valuable than others.

With no money for advertising, we decided to create gifts for our consumers. When people bought a few pairs of socks they would get a piece of art, a beautiful bag, a gift box. And included with these things was a consumer participation card. We ask all sorts of questions on these reply cards. People tell us their dreams, their turn-ons, their turn-offs. So we're creating a personal relationship with them. We add them to our mailing list and each year they get a mailer from us. It's like having a pen pal. Nothing we do is to be filed away. People keep it out. They hang it from their ceiling. I believe that my consumer is a real person who can think for himself or herself. People in business sometimes think that the consumer is part of a mindless mass consciousness—an automaton. I really don't treat people like that. Everyone's different.

Did the stores cooperate with you?

It was tough at first. It wasn't standard. I had to say, "Try something different." People don't want what's standard. I was saying this to retailers—to Macy's, small specialty stores in Greenwich Village. Not everyone went for it, but most people did because they realized it did make us different. People were saying, "This is hip." And the retailers didn't have to pay for it. They loved that! We give stores suggestions about how to display our merchandise. At first they were skeptical, but we earned their respect—I had to prove myself. Luckily, it worked.

CLOUD REPLY CARD WAS
ENCLOSED IN THE SECOND
ANNUAL GIFT TO E.G. SMITH
SOCK CUSTOMERS.
**DESIGN FIRM;
SETH JABEN DESIGN,
NEW YORK, NEW YORK.**

EG SMITH RESPONDS WITH A
"POSTAL THERAPY" SESSION
AFTER CONSUMERS RESPOND
TO HIS "THERAPY" INSERTS
FROM TIGHTS PACKAGES.
**DESIGNERS,
ERIC SMITH, MARK RANDALL,
NEW YORK, NEW YORK.**

THE WORLD LOVE SHOPPING
BAG IS THE WORLD'S FIRST
FOOT-SHAPED SHOPPING BAG.
**DESIGNER, ERIC SMITH;
ILLUSTRATOR, JOHN PIRMAN;
CONSTRUCTION,
GOODMAN LEEDS.**

OPPOSITE PAGE:
"THE SOCK," CUSTOM
PACKAGING FOR COLOR SOCKS.
**DESIGNERS,
ERIC SMITH, MARK RANDALL
NEW YORK, NEW YORK.**

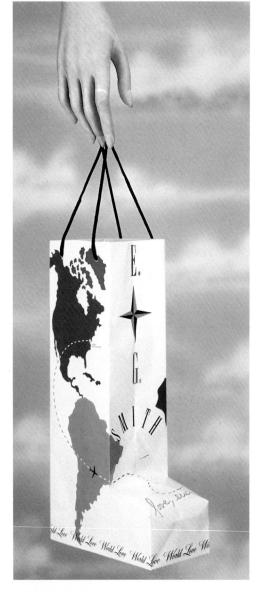

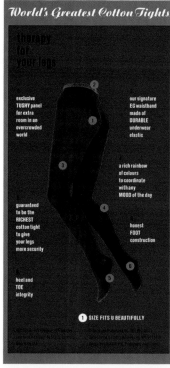

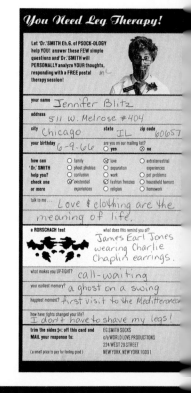

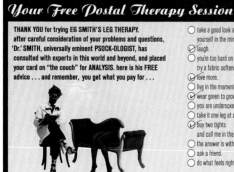

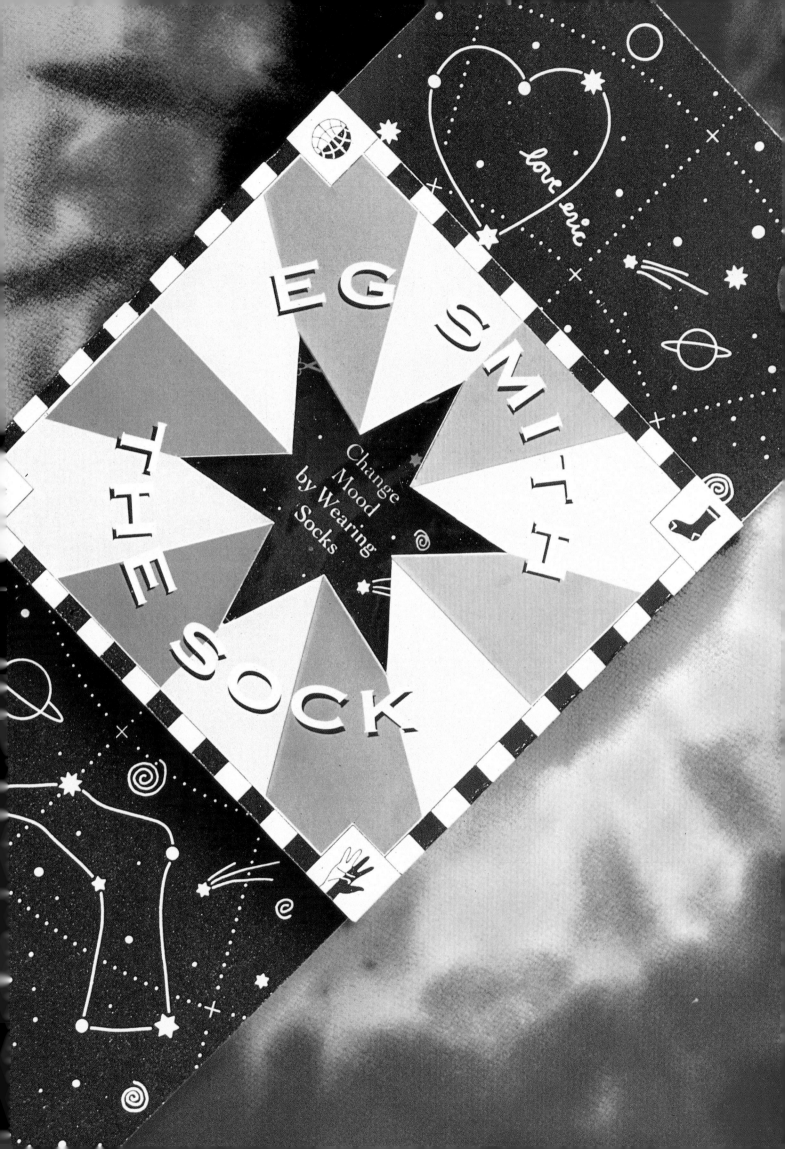

EG SMITH
THE SOCK

Change
Mood
by Wearing
Socks

love eric

GÉLINÀS

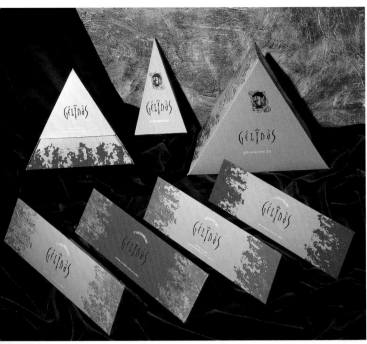

PRODUCT PACKAGING DESIGNS
FOR GELINAS HAIR CARE LINE.
BOXES ARE PRINTED IN SIX
METALLIC COLORS AND ARE
COLOR-CODED TO EACH
PRODUCT.
**DESIGN FIRM,
MARGO CHASE DESIGN,
LOS ANGELES, CALIFORNIA.**

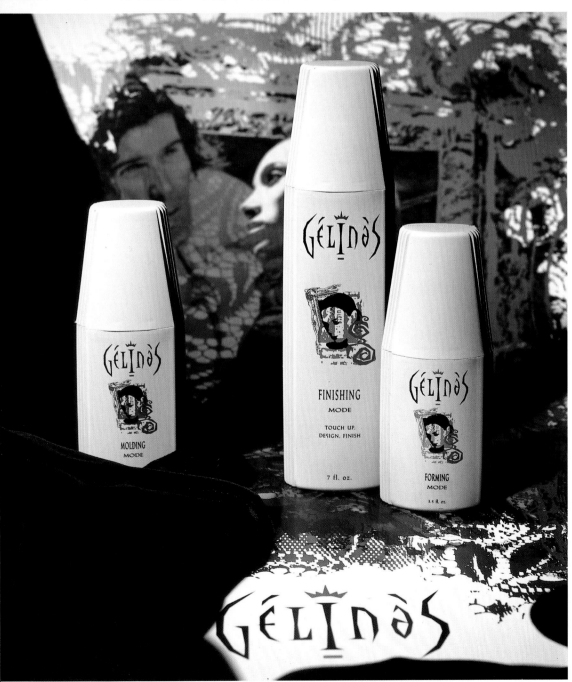

THE WHITE GINGER
COLLECTION OF GROOMING
PRODUCTS USES ONLY NATURAL
INGREDIENTS
**DESIGNED BY
LESLIE ROSS OF
THE THYMES LIMITED**
MINNEAPOLIS, MINNESOTA

OPPOSITE PAGE
PACKAGING DESIGNS FOR BABY
THYMES™ SKIN CARE PRODUCTS
INCLUDE GENTLE SHAMPOO
AND BABY WASH, TENDER BABY
LOTION, BABY BARRIER CREME
BABY POWDER AND NURSERY
FRAGRANCE MIST. ALL PRO-
DUCTS ARE CLINICALLY AND
DERMATOLOGIST TESTED
**DESIGNED BY
LESLIE ROSS OF
THE THYMES LIMITED**
MINNEAPOLIS, MINNESOTA

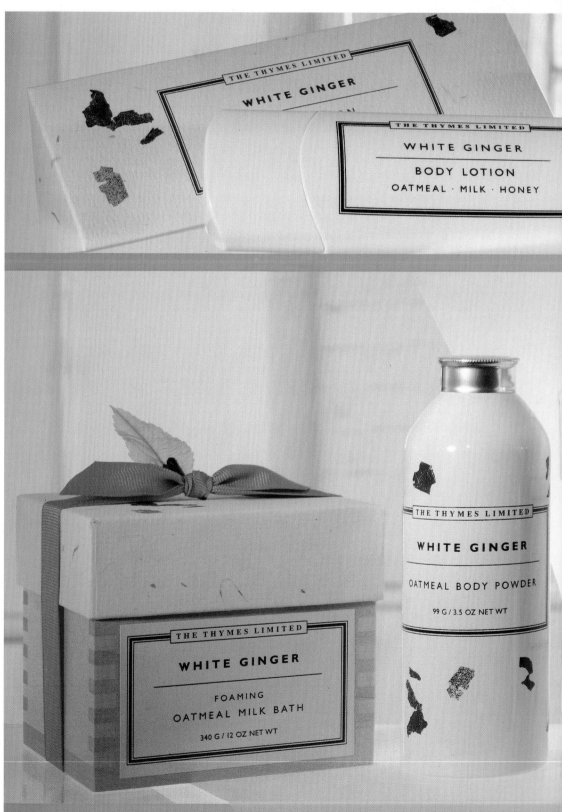

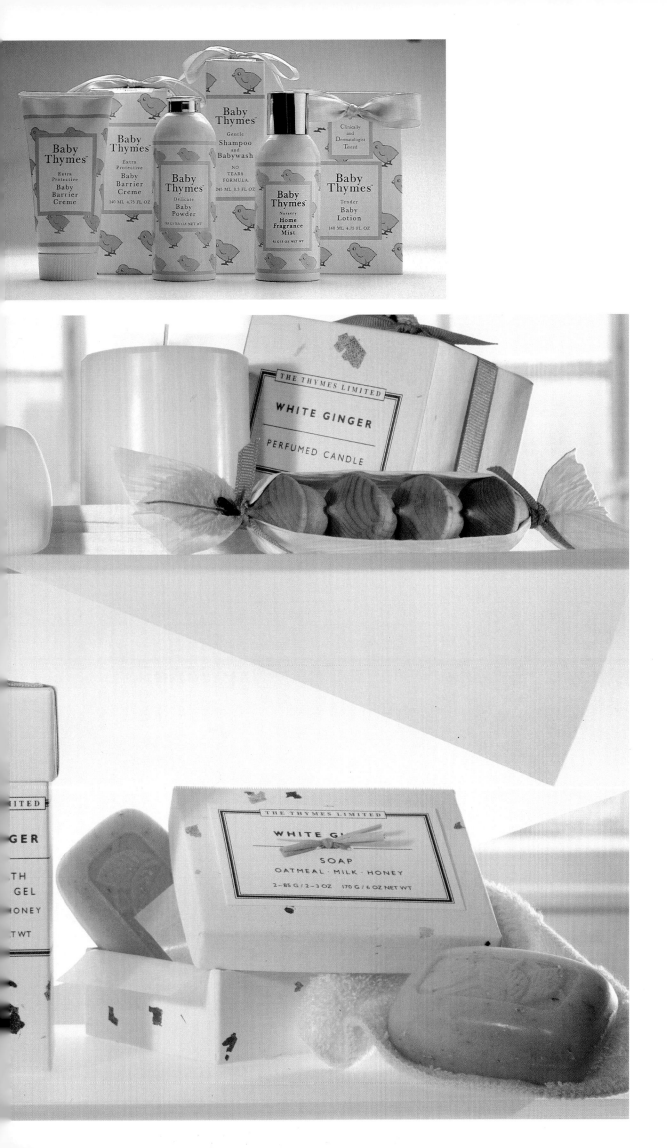

Baby
Thymes™

Extra
Protective
Baby
Barrier
Creme

Baby
Thymes™

Extra
Protective
Baby
Barrier
Creme

140 ML 4.75 FL OZ

Baby
Thymes™

Delicate
Baby
Powder

99 G/3.5 OZ NET WT

Baby
Thymes™

Gentle
Shampoo
and
Babywash

NO
TEARS
FORMULA

245 ML 8.3 FL OZ

Baby
Thymes™

Nursery
Home
Fragrance
Mist

81 G/15 OZ NET WT

Clinically
and
Dermatologist
Tested

Baby
Thymes™

Tender
Baby
Lotion

140 ML 4.75 FL OZ

THE THYMES LIMITED

WHITE GINGER

PERFUMED CANDLE

THE THYMES LIMITED

WHITE GINGER

SOAP

OATMEAL · MILK · HONEY

2–85 G / 2–3 OZ 170 G / 6 OZ NET WT

167

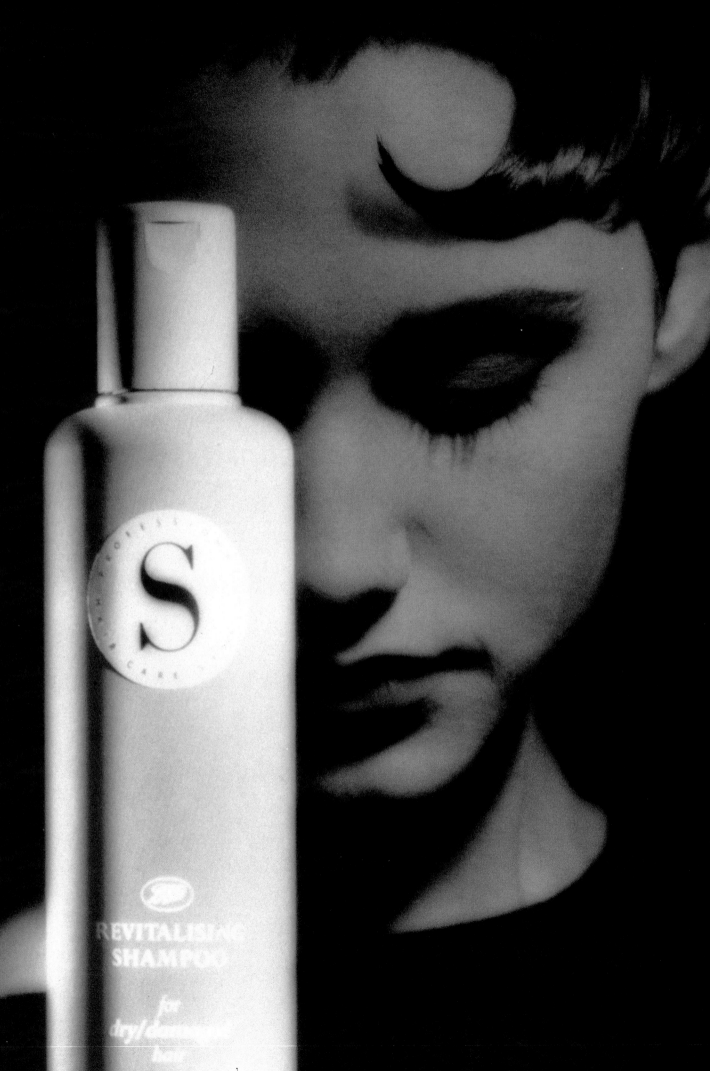

OPPOSITE PAGE:
BOOTS PREMIUM HAIR CARE
SYSTEM.
DESIGN FIRM,
NEWELL AND SORRELL, LTD.,
LONDON; CREATIVE DIRECTOR,
FRANCES NEWELL;
DESIGNERS, HARRY PEARCE,
SIMON WRIGHT.

PACKAGE DESIGN FOR
ESSENTIEL ELEMENTS
AROMATHERAPY BODY CARE
PRODUCTS REFLECTS CLIENT'S
USE OF NATURAL INGREDIENTS.
DESIGN FIRM,
NOMURA UNO DESIGN,
FOSTER CITY, CALIFORNIA;
ART DIRECTOR AND DESIGNER,
KAREN KIMI NOMURA;
ILLUSTRATOR, LINDA ROSS.

PACKAGE DESIGN FOR
PENHALIGON'S FLORAL
FRAGRANCE, BLUEBELL. THE
SHAPE OF THE BOTTLE IS
IDENTICAL TO THE ORIGINAL
BOTTLES USED IN 1870.
THE STORE IS A WELL-KNOWN
LONDON SPECIALTY RETAILER.
DESIGN FIRM,
MICHAEL PETERS ASSOCIATES,
LONDON; UPDATED DESIGN BY
FLO BAYLEY OF
FOTHERGILL BAYLEY.

Fashion, Cosmetics & Toiletries

OPPOSITE PAGE
SUNTAN OILS BY THE
BODY SHOP ARE TARGETED
TOWARD THE ENVIRONMENTALLY
CONSCIOUS EUROPEAN
AUDIENCE.
DESIGN FIRM
NEWELL AND SORRELL, LTD.
LONDON

HOSIERY PACKAGING FOR
THE BOOTS COMPANY PLC.
DESIGN FIRM, LEWIS MOBERLY,
LONDON; DESIGNERS,
DAVID BOOTH, MARY LEWIS,
LUCILLA SCRIMGEOUR,
AMANDA LAWRENCE;
ILLUSTRATOR,
LUCILLA SCRIMGEOUR.

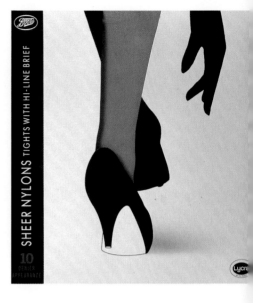

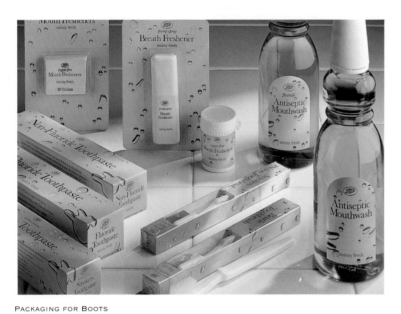

PACKAGING FOR BOOTS
COMPANY, PLC'S BASIC
TOILETRIES RANGE IS
COMPRISED OF 110 PRODUCTS
IN EVERY CATEGORY FROM
TOOTHPASTE TO BUBBLE BATH.
DESIGN FIRM,
NEWELL AND SORRELL, LTD.,
LONDON; CREATIVE DIRECTOR,
FRANCES NEWELL; ART
DIRECTOR, HARRY PEARCE;
DESIGNER, STEPHEN BELL;
PHOTOGRAPHERS,
RICHARD FOSTER,
CHRIS McGUIRE.

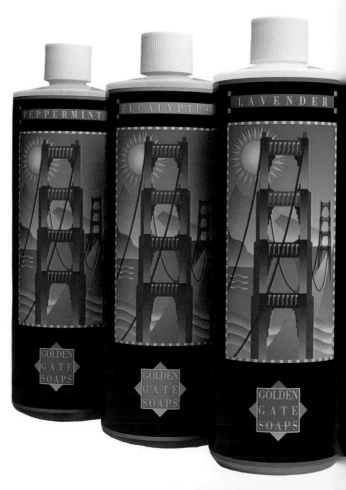

PURE AND NATURAL SOAPS
PACAKGED IN BIODEGRADABLE
CONTAINERS. ARTWORK
WAS CREATED USING
ADOBE ILLUSTRATOR.
DESIGN FIRM,
WOODS + WOODS,
SAN FRANCISCO, CALIFORNIA;
DESIGNER AND ILLUSTRATOR,
PAUL WOODS.

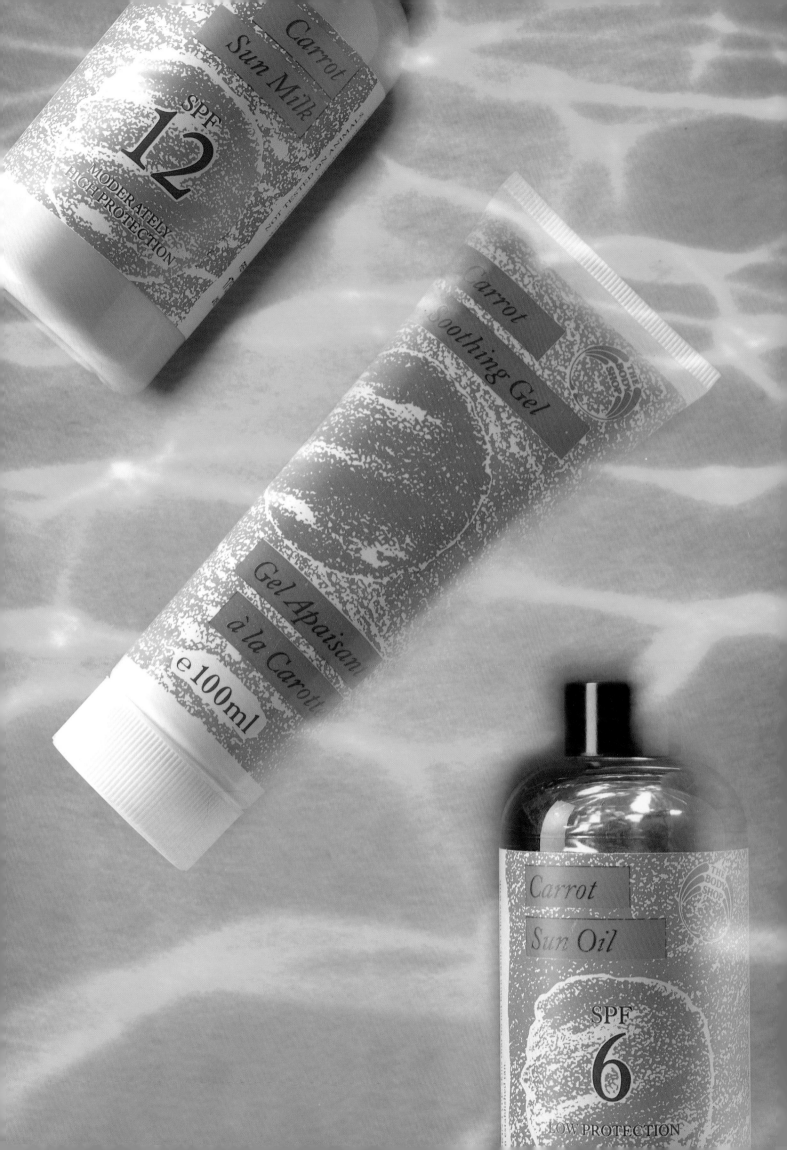

HUE
ImprovedFIT

COTTON TIGHTS

HUE

COTTON CAPRI

HUE

COTTON STIRRUP

HUE

THE BODYSOCK™

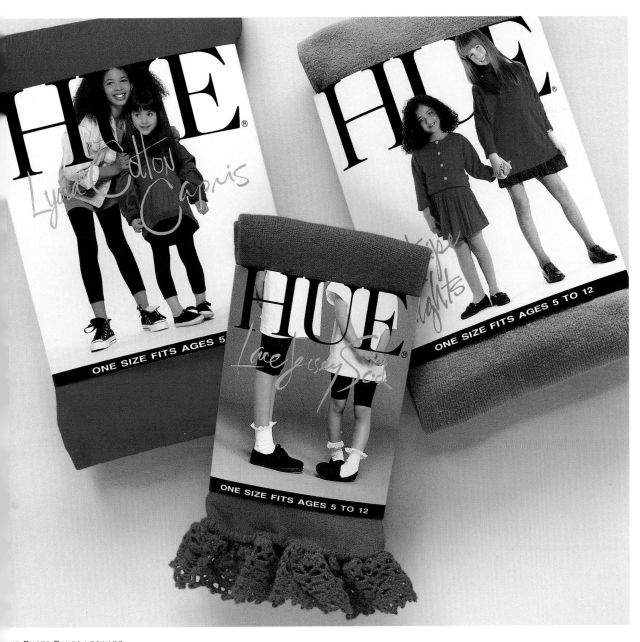

JE PHOTO BANDS LEGWARE
CKAGING DESIGN FOR WOMEN,
D THE NEW LINE FOR
ILDREN'S LEGWEAR.
SIGN FIRM,
AVANAGH DESIGN,
EW YORK, NEW YORK;
ESIGNER, BRIGID KAVANAGH;
OTOGRAPHER,
ROTHY HANDELMAN.

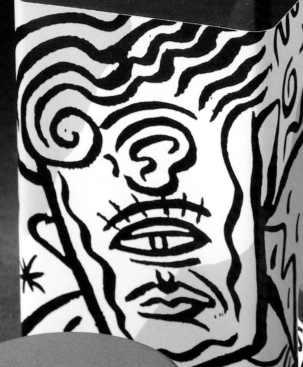

POO

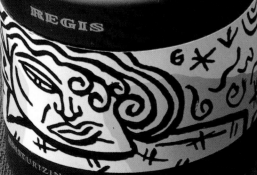

MOISTURIZING CONDITIONER
(2 OZ)

SCULPTING LOTION
(4 FL OZ)

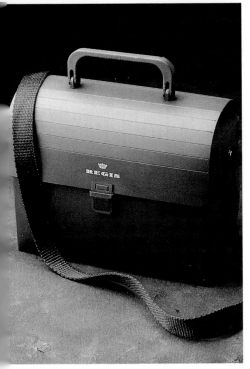

PROPOSED PACKAGING DESIGNS
FOR REGIS HAIR SALON
PRODUCTS, TARGETED TO
WOMEN 18-30.
DESIGN FIRM,
CHARLES S. ANDERSON
DESIGN, MINNEAPOLIS,
MINNESOTA; ART DIRECTORS
AND DESIGNERS,
CHARLES S. ANDERSON,
DANIEL OLSON;
ILLUSTRATORS,
RANDALL DAHLK,
DANIEL OLSON,
CHARLES S. ANDERSON.

FOSSIL TINS IS A SERIES OF
SIXTEEN SILKSCREENED TIN
BOXES DESIGNED FOR FOSSIL
WATCHES
DESIGN FIRM
CHARLES S. ANDERSON
DESIGN, MINNEAPOLIS
MINNESOTA; ART DIRECTORS
AND DESIGNERS
CHARLES S. ANDERSON
DANIEL OLSON
HALEY JOHNSON
ILLUSTRATORS
HALEY JOHNSON
RANDALL DAHLK
CHARLES S. ANDERSON
DANIEL OLSON

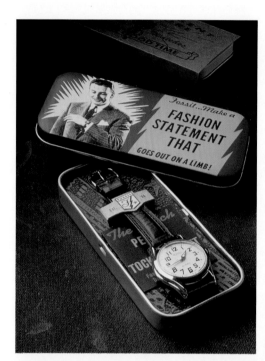

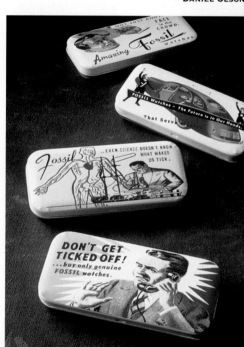

TO BOOT LINE OF WORK
FOOTWEAR FOR AREZZO SHOES
FACTORY AND STORES.
DESIGN FIRM,
P & B COMUNICAÇÃO, BRAZIL;
ART DIRECTOR, JOÃO DELPINO.

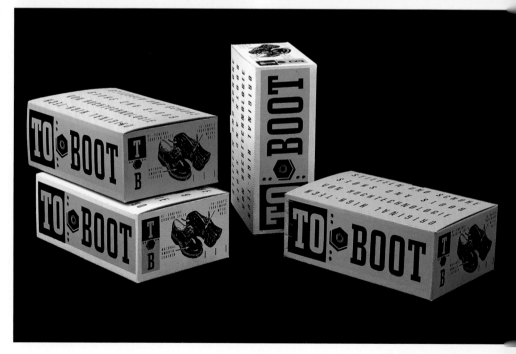

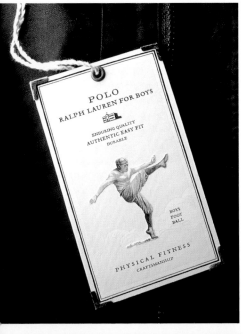

Hang tag designed for Ralph Lauren Polo For Boys line has metal edges, steel grommets, heavy paperboard, and a braided cotton string. **Design Firm, Charles S. Anderson Design, Minneapolis, Minnesota; Art Directors and Designers, Charles S. Anderson, Daniel Olson.**

Lee Jeans labels and hang tag designs for Lee Apparel Company. **Design Firm, WRK Design, Kansas City, Missouri; Designer, Phyllis Pease**

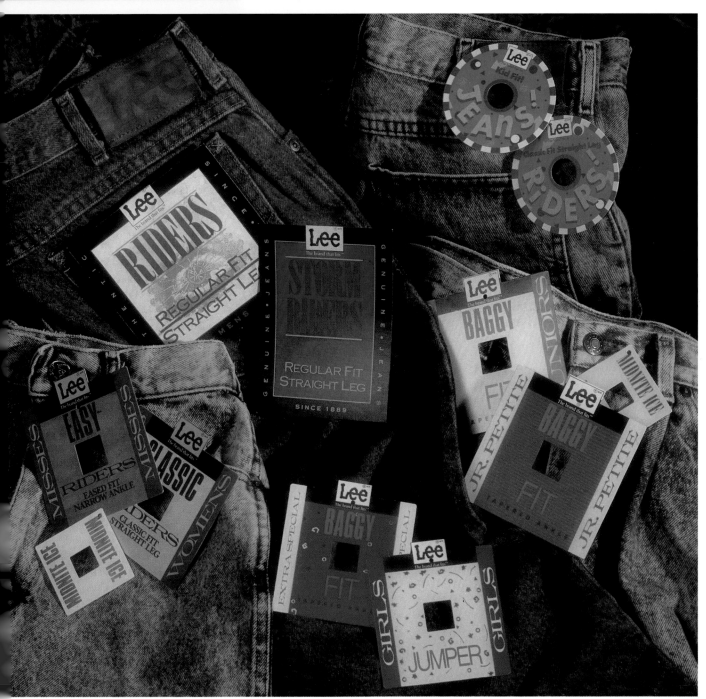

SHOE PACKAGING DESIGNED
FOR CONVERSE, INC.
**DESIGN FIRM,
FITCH RICHARDSONSMITH,
LONDON.**

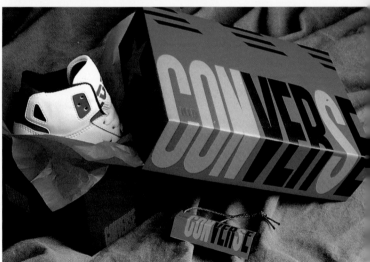

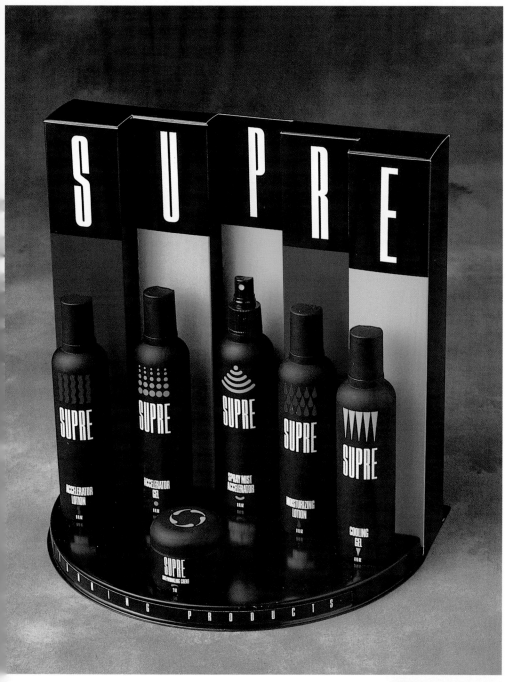

SUPRE IS AN INDOOR TANNING
AND SKIN CARE PRODUCT LINE
INTERNATIONALLY SOLD. THE
DESIGNERS WERE INVOLVED
IN ALL AREAS OF PRODUCT
DEVELOPMENT.
DESIGN FIRM,
SWIETER DESIGN,
DALLAS, TEXAS;
ART DIRECTOR, JOHN SWIETER;
DESIGNERS, JOHN SWIETER,
JIM VOGEL.

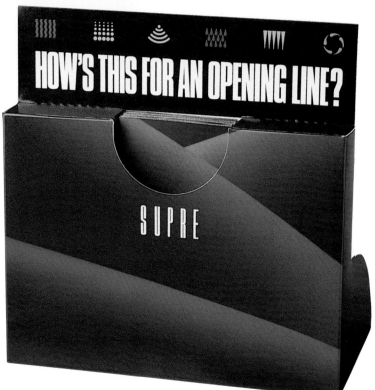

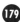

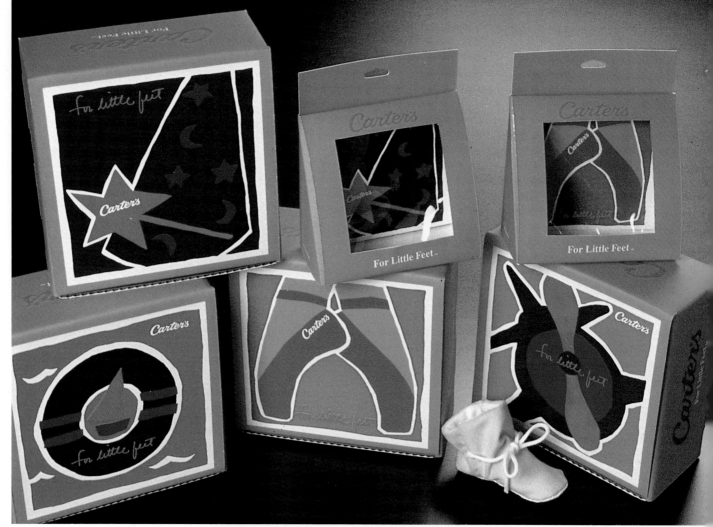

PACKAGING SYSTEM FOR
STONEMARK INDUSTRIES,
SALEM, MASSACHUSETTS.
**DESIGN FIRM,
FITCH RICHARDSONSMITH,
BOSTON, MASSACHUSETTS.**

PACKAGING DESIGN FOR
STRIDE RITE CHILDREN'S
FOOTWEAR, FOR STRIDE RITE
CORPORATION, CAMBRIDGE,
MASSACHUSETTS.
**DESIGN FIRM,
LANDOR ASSOCIATES,
SAN FRANSCISCO, CALIFORNIA;
PRINCIPAL DESIGNER,
KAREN CORELL; DESIGN
ASSISTANT, DOUGLAS LLOYD.**

OPPOSITE PAGE:
KAEPA ATHLETIC SHOES ARE
DISTINCTIVE FOR THEIR TWO-
LACES-PER-SHOE DESIGN THAT
IS INCOPORATED INTO THE
KAEPA, INC. GRAPHIC SYMBOL.
**DESIGN FIRM,
BRIGHT AND ASSOCIATES,
VENICE, CALIFORNIA;
CREATIVE DIRECTOR,
KEITH BRIGHT; DESIGNER,
RAYMOND WOOD.**

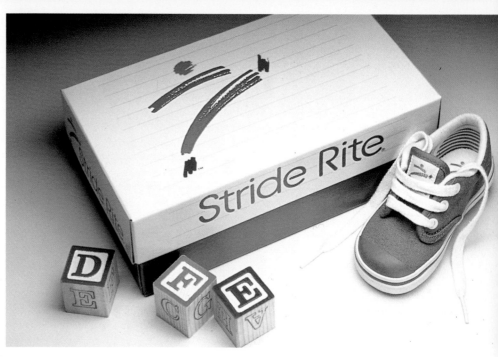

BANFF TEENAGERS SHOE
PACKAGING DESIGN AND POINT-
OF-PURCHASE FOR AREZZO
WOMEN'S SHOES FACTORY AND
STORES.
DESIGN FIRM,
P & B COMUNICAÇÃO, BRAZIL;
ART DIRECTOR,
ANGELA DOURADO.

LOGO DESIGN AND SHOEBOX
FOR BASS SHOES, NEW YORK.
DESIGN FIRM,
MICHAEL PETERS LIMITED,
LONDON;
DESIGNER AND TYPOGRAPHER,
MARCUS HEWITT; CREATIVE
DIRECTOR, GLENN TUTSSEL.

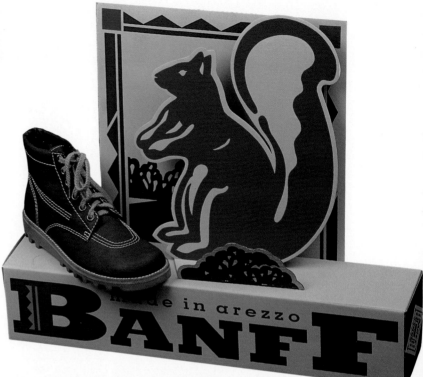

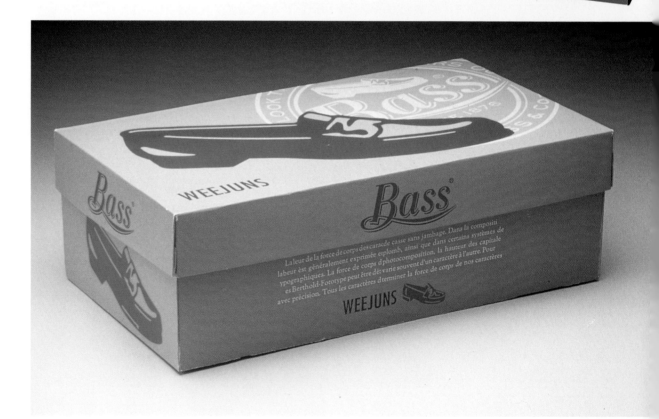

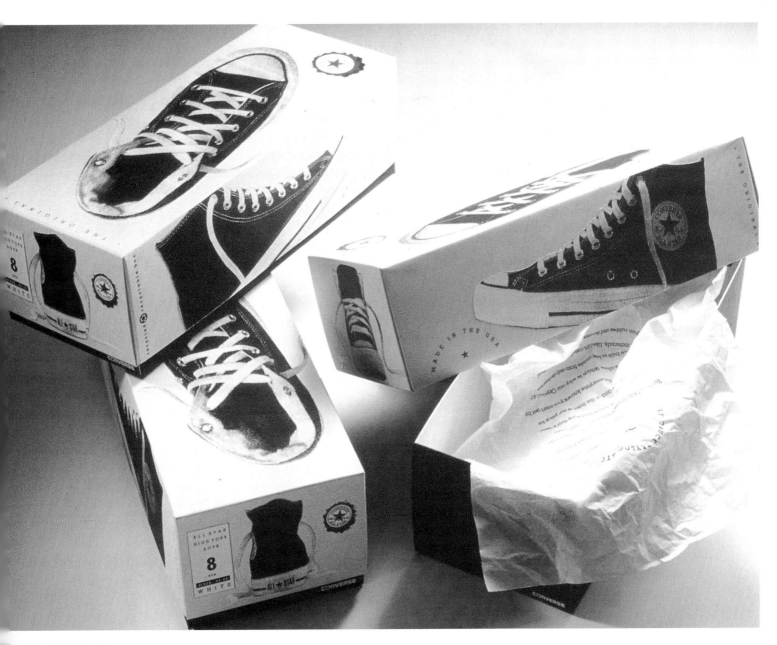

PRODUCT PACKAGING FOR
CONVERSE SNEAKERS. RECYLCED
CARDBOARD WAS USED FOR THE
BOXES.
DESIGN FIRM,
CLIFFORD SELBERT DESIGN,
CAMBRIDGE, MASSACHUSETTS;
ART DIRECTOR,
CLIFFORD SELBERT;
DESIGNERS, MELANIE LOWE,
LINDA KONDO.

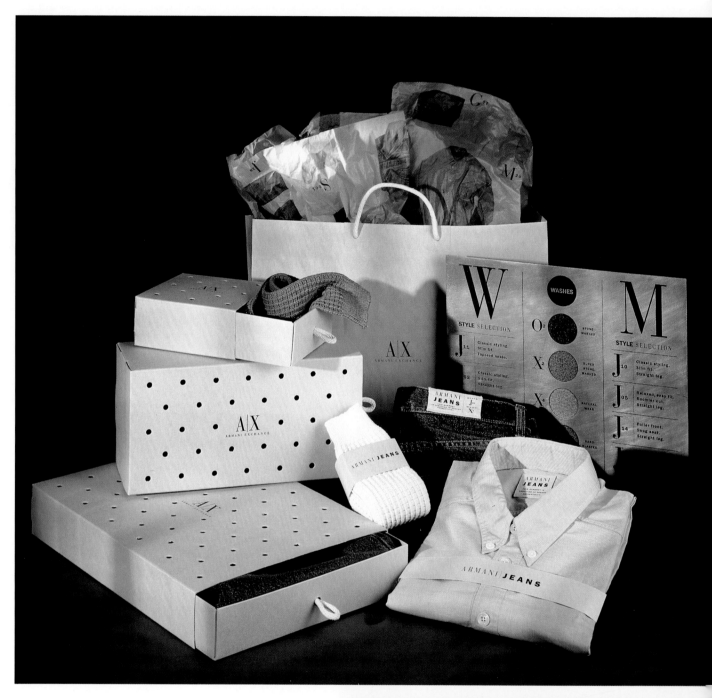

184

In-store graphics and packaging program for Giorgio Armani's A/X Armani Exchange. Custom-milled recycled paper and board were used. **Design Firm, Alexander Isley Design, New York, New York; Art Director, Alexander Isley; Designers, Alexander Isley, Tim Convery, Bruno Nesci.**

Packaging for Converse Evolo footwear is targeted to athletically-oriented women. The lid is die-cut to echo and emphasize the perforations on the shoe. **Design Firm, Fitch RichardsonSmith Inc., Boston, Massachusetts; Art Director, Ann Gildea; Designers, Kate Murphy, Fred Weaver.**

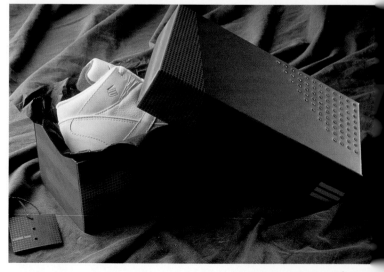

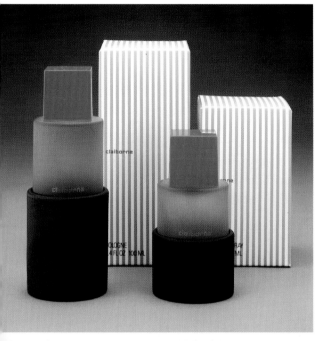

PACKAGE DESIGNS FOR
LIZ CLAIBORNE FOR MEN
FRAGRANCE AND GROOMING
PRODUCTS. PACKAGE DESIGNS
FOR THE REALITIES LINE OF
PRODUCTS FOR WOMEN
CONNOTES SOPHISTICATION,
ELEGANCE, AND FEMININITY.
**DESIGN FIRM,
CHERMAYEFF & GEISMAR
ASSOCIATES, NEW YORK,
NEW YORK; DESIGN DIRECTOR,
IVAN CHERMAYEFF;
DESIGNERS,
LORRAINE FERGUSON,
PIERA GRANDESSO,**

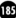

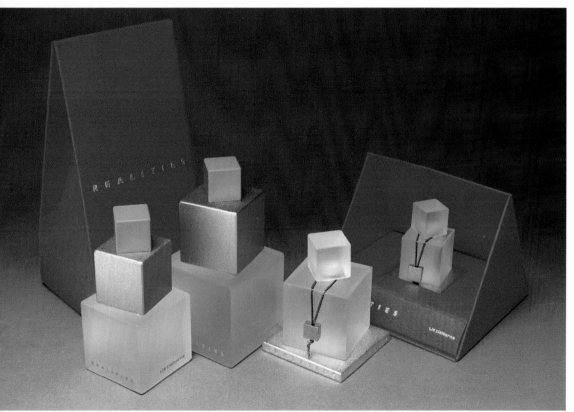

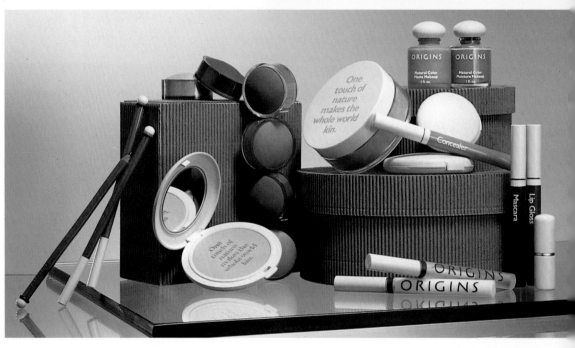

ORIGINS SKIN CARE LINE AND
ORIGINS COLOR LINE
DESIGNED BY ORIGINS DESIGN
GROUP, LAUDER, INC.
NEW YORK, NEW YORK

ACKAGING DESIGN FOR
RIGINS "SPECIALISTS"
NE OF NATURAL COSMETICS.
ESIGNED BY ORIGINS DESIGN
ROUP, LAUDER, INC.,
EW YORK, NEW YORK.

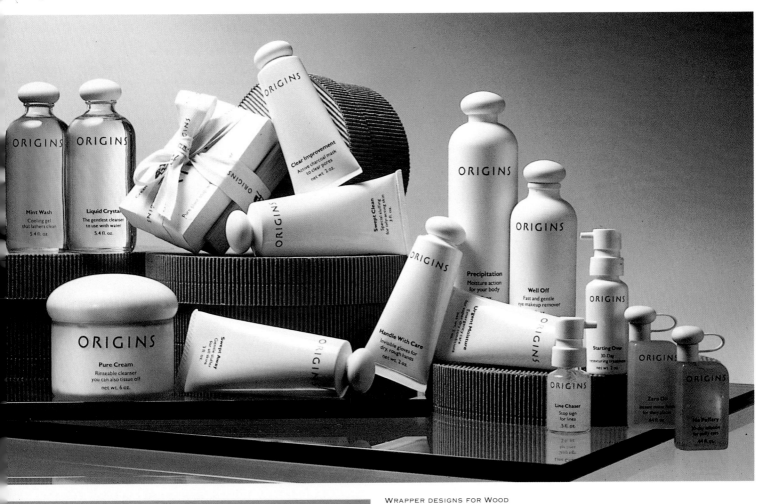

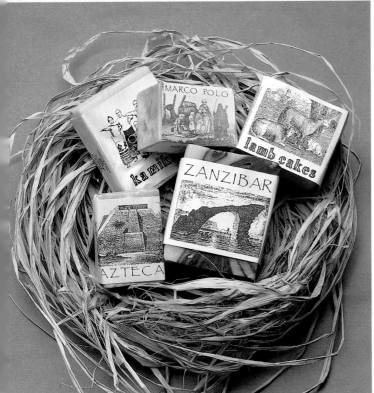

WRAPPER DESIGNS FOR WOOD
SPIRITS SOAPS, SOLD AT WOOD
SPIRITS HERB SHOP. THE PRO-
DUCT IS MINIMALLY PACKAGED
IN ENVIRONMENTALLY SAFE
MATERIALS.
**DESIGNED BY
BARBARA K. BOBO OF
WOOD SPIRITS HERB SHOP,
ST. PARIS, OHIO;
CLIP ART, LETRAGRAPHICA.**

Index to Design Firms & Manufacturers

Although all products are included in the index, in some cases it's the designer's, in some the manufacturer's address that's listed.